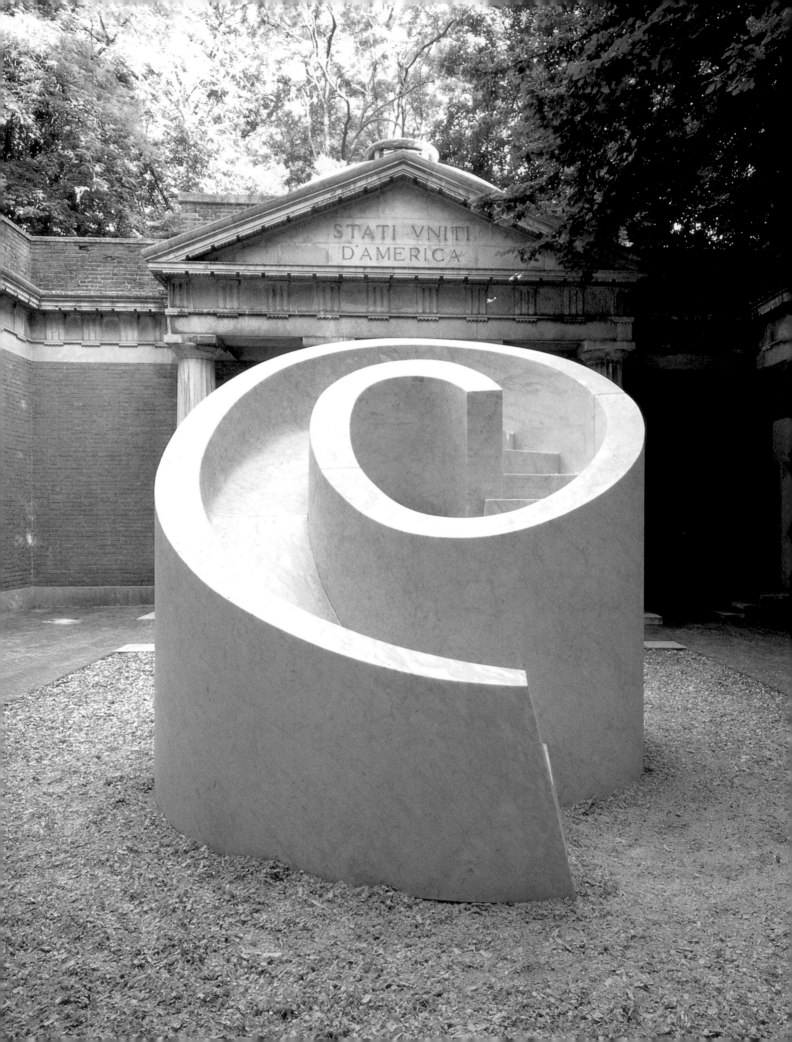

MODERN MASTERS

ISAMU NOGUCHI

BRUCE ALTSHULER

Abbeville Press Publishers
New York London Paris

Isamu Noguchi is volume 16 in the Modern Masters series.

ACKNOWLEDGMENTS: My understanding of Noguchi's work has benefited enormously from the knowledge of many individuals who worked closely with the artist and from the opportunity to have daily contact with the work at his museum. I particularly want to thank Shoji Sadao for sharing his unique insights, as well as my other colleagues at the Isamu Noguchi Foundation—especially Bonnie Rychlak and Amy Hau—for their knowledge and encouragement. Priscilla Morgan provided much information and a rare perspective, the product of years of friendship with the artist, and Masatoshi Izumi generously spoke with me about his work with Noguchi. I also have learned a great deal from the research of Bert Winther on Noguchi's reception in Japan during the early 1950s. In terms of realizing this project I thank my editor Nancy Grubb, and I am grateful to Adrien Glover for her assistance with the manuscript. And for help in my efforts to understand the world of art and the artist, I thank Holly Hughes for her intelligence and support.

FRONT COVER: *Black Sun,* 1960–67. Swedish granite, diameter: 30½ in. (80 cm). Private collection, Japan
BACK COVER: *Strange Bird (To the Sunflower),* 1945. Cast in aluminum, 1972. Aluminum, 56¼ x 22½ x 20 in. (144.1 x 57.2 x 50.8 cm). The Isamu Noguchi Foundation, Long Island City, New York
FRONT ENDPAPER, left: Berenice Abbott, *Isamu Noguchi,* 1930s
FRONT ENDPAPER, right: Domon Ken, *Isamu Noguchi,* c. 1951
BACK ENDPAPER, left: André Kertész, *Isamu Noguchi,* c. 1945
BACK ENDPAPER, right: Michio Noguchi, *Isamu Noguchi,* 1978–79
FRONTISPIECE: *Slide Mantra,* 1986. Marble, 10 ft. (3 m), Bayfront Park, Miami. Shown during its installation at the Venice Biennale, 1986

Series design by Howard Morris
Editor: Nancy Grubb
Designer: Steven Schoenfelder
Production Editor: Owen Dugan
Picture Editor: Kim Sullivan
Production Manager: Matthew Pimm

Marginal numbers in the text refer to works illustrated in this volume.

Library of Congress Cataloging-in-Publication Data

Altshuler, Bruce.
 Isamu Noguchi / Bruce Altshuler.
 p. cm. — (Modern masters, ISSN 0738-0429 : vol. 16)
 Includes bibliographical references and index.
 ISBN 1-55859-754-9 (cloth)
 ISBN 1-55859-755-7 (paper)
 1. Noguchi, Isamu, 1904–1988. —Criticism and interpretation.
 I. Noguchi, Isamu, 1904–1988. II. Title III. Series: Modern masters series : v. 16.
 NB237.N6A86 1994
 709'.2—dc20 93-36608

First edition, 15 14 13 12 11 10 9 8 7 6 5 4 3

Contents

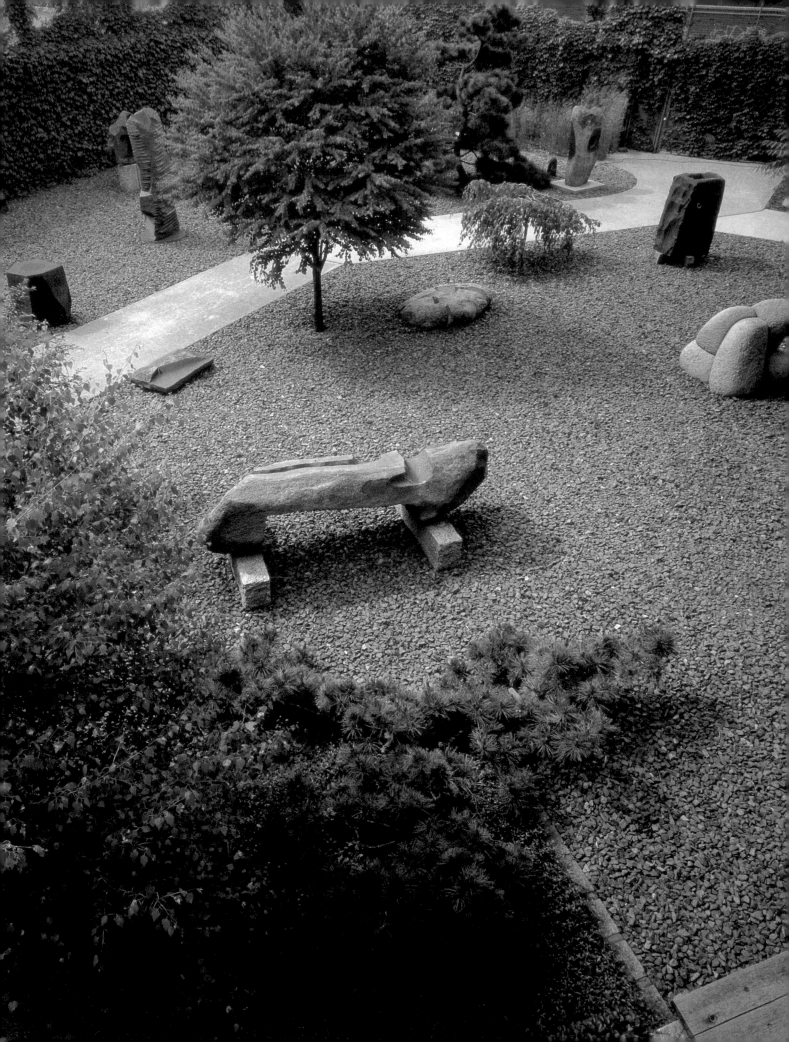

Introduction

Born in the United States of mixed parentage, Isamu Noguchi had a Japanese childhood and an American adolescence. His notion of modern art was forged in the Paris studio of Constantin Brancusi and modified through the technological utopianism of R. Buckminster Fuller. Combined with his experience of the traditional Japanese house and garden and with his work on the avant-garde stage of Martha Graham, these influences led him toward a broadened conception of sculpture as the creation of social space. In pursuit of this modernist project, Noguchi would create plazas and gardens, furniture and interiors, ignoring the boundary between art and design. But he also continued the carving of stone and wood that brought him critical attention in New York during the 1940s. In his last decades this carving was deeply influenced by his work in Japan, and a new aesthetic emerged from his years of conversation with stone, in what he called "the sculpture of spaces." Understood in this way, Noguchi was a modernist of the New York School, an artist who synthesized East and West in service to an innovative vision of what sculpture could be. And this view, as far as it goes, is an accurate one.

But in the details of Noguchi's life and career are many other issues of special interest in the late twentieth century. His mixed ethnicity and his family circumstances prompted a frustrating search for cultural identity within a world of rigid cultural assumptions. His work outside traditional means of making sculpture questioned the model of the creator alone in the studio and made collaboration as central to his sculptural production as it was to his landscape and design projects. Needing to garner and execute these projects, and distrustful of art dealers, he operated as a free agent in the art world, devising a means of survival within a system that did not readily accept such independence. To maintain this nonstandard career Noguchi had to orchestrate activity of enormous scope over long periods of time, which required a staff and, in effect, made a business of his artistic enterprise. Focused on garden and architectural projects, and also wanting to make useful sculptural objects for manufacture, Noguchi was set apart by his

1. Garden of the Isamu Noguchi Garden Museum, Long Island City, New York

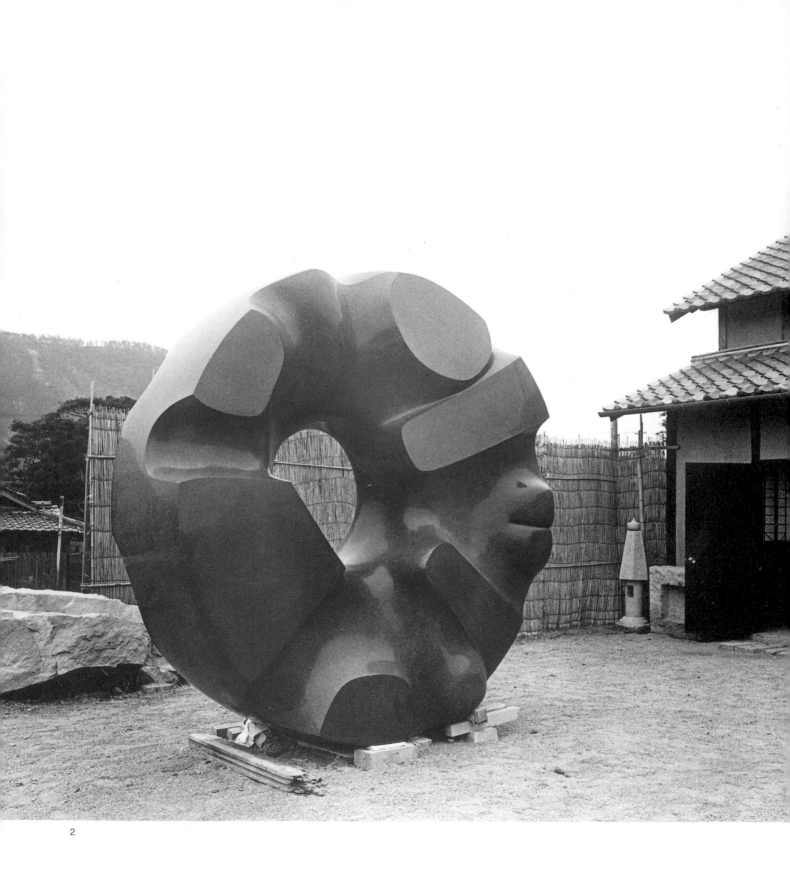

unconcealed relationship to commerce and capital. From this perspective his modernist project takes on a postmodern cast, and this apparent insider looks like an artistic outsider.

Noguchi was well aware of his peripheral status, both culturally and artistically. He was viewed as a Japanese artist in the United States, and until quite recently, in Japan he was regarded as too American. Because of his many design projects and his involvement with the patrons needed to support them, he was derided by some of his New York School peers and dismissed as less serious than those who remained cloistered in the studio. In a system oriented toward specialization and the single focus, the diversity of his activities worked against him with every constituency. So, despite many moments of notice, the public remained largely unaware of the full range of his achievement. Noguchi's peripatetic nature—his inability to rest secure in any place or situation, or in any kind of work or mode of working—made him, and kept him, a marginal figure. This was especially painful for someone as estranged from cultural and familial roots as Isamu Noguchi.

Noguchi said that he could feel at home everywhere because he was at home nowhere, and this issue became a central theme of his life and work. His sense of homelessness and his longing to redress it became a source both for his creation of places for social connection and interaction and for some of his most poignant carving. And it led this New York artist to seek meaning abroad. The confluence of Noguchi's sculptural project and his search for identity through place can be seen in the two special situations that he created for himself toward the end of his life: a museum of his work in New York and a studio complex in Japan. As he had taken control of his career in order to accomplish his work, so Noguchi founded sites of personal myth to govern how he would be seen by the public, and how he would appear to himself. In such dichotomy Noguchi regularly found strength—in tensions between Asia and the West, ancient and modern, the practical and the utopian, social engagement and personal isolation. In the end, he could think of no fewer than two places as home.

Those who knew Noguchi rarely fail to mention that he was always in motion, a man of incredible energy and ambition. His working life extended for more than sixty years, and much of that time he was engaged simultaneously in many fields. Ranging across some of the dominant cultural movements of the century and intersecting crucial persons and places, his is an amazing story, apparently larger than life. But it begins at the outset of the century with a small boy in Japan, who soon would have to make his way alone.

2. *Black Sun,* 1969
Brazilian granite, diameter: 9 ft. (2.7 m);
depth: 30 in. (76.2 cm)
Permanently installed at Seattle Art Museum
Photographed on Shikoku, Japan

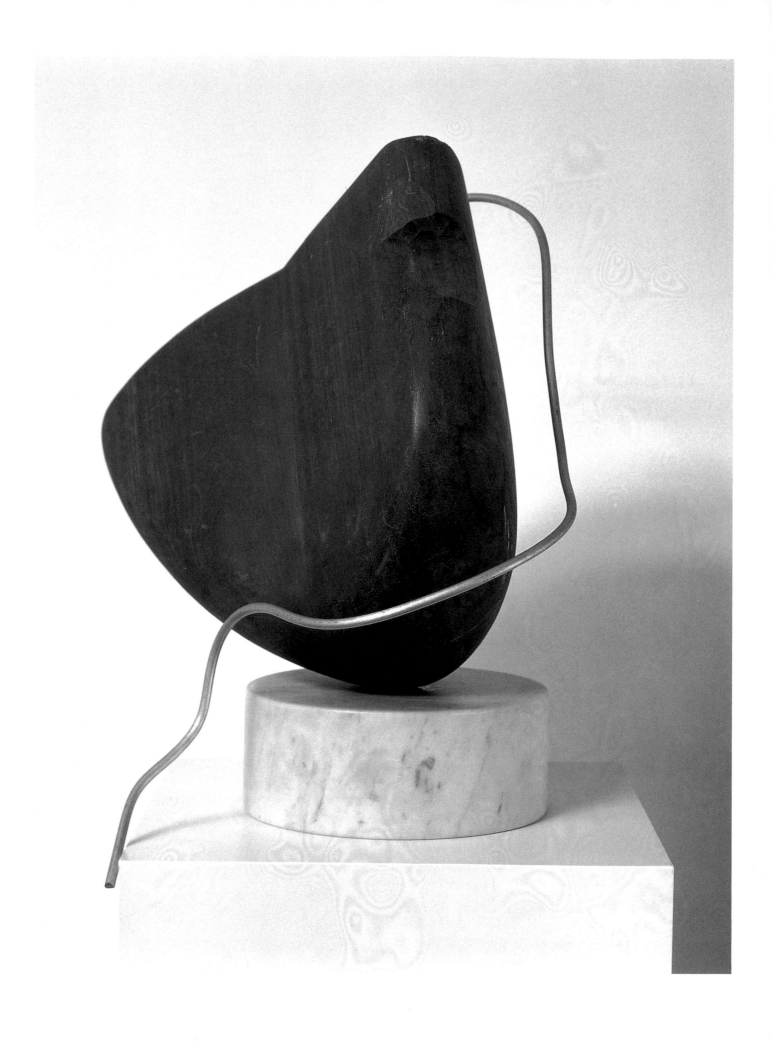

1 Toward Modernism

Conceived in New York and born in Los Angeles, Isamu Noguchi was the child of a Japanese-American relationship. His mother, Leonie Gilmour, had answered an advertisement in February 1901 to assist a young Japanese poet with his English prose. His father, Yonejirō (Yone) Noguchi, had recently arrived in New York from San Francisco with the beginning of an American reputation, the first native Japanese to publish poetry in English. By the time Isamu was born, in November 1904, Yone had returned to Tokyo and a teaching position at Keiō University. In fundamental ways, his abandonment of Gilmour and their son laid the ground for Isamu's unsettled nature and for important aspects of his artistic career.

Leonie Gilmour was an extraordinary woman, with a Bryn Mawr education and subsequent study in Paris, making her way as a writer in New York. Deserted by Yone, she went west to her mother and sister to bear her child. When Isamu was two years old, Gilmour, after much correspondence with Yone, traveled to Tokyo.[1] She and Isamu moved in with the poet, but the relationship lasted for only a few years. By 1908 Yone was living much of the time in a temple in Kamakura and seeing little of Gilmour and Isamu. She remained in Japan, supporting herself as a teacher of English. Soon Isamu no longer saw his father, who by the fall of 1913 was married and beginning a traditional Japanese family.

Isamu grew up with Japanese playmates, absorbing the culture and its aesthetic dispositions. He and his mother moved out of Tokyo in 1910, going first to Ōmori and then south to Chigasaki on the sea. When he was nine Isamu helped with the construction of their new house on an odd, triangular lot, informally apprenticed to the carpenter while Gilmour tutored him at home. Through this experience Isamu developed an abiding love of hand tools, of natural materials, and of simple methods of construction, attitudes that would be recast as modernist tenets in the studio of Brancusi.

Concerned that Isamu would face difficulty in Japan due to his mixed parentage and unhappy with the Jesuit academy that he was

3. *Red Seed*, 1928
Wood and metal, 11¾ x 13⅜ x 10 in.
(29.8 x 33.8 x 25.4 cm)
The Isamu Noguchi Foundation, Long Island City, New York

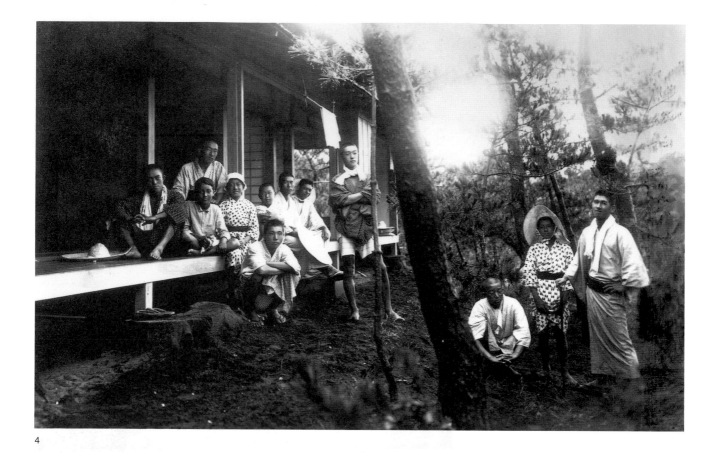

4

attending in Yokohama, Gilmour decided to send him back to the United States for schooling. On the basis of a *Scientific American* article, "The Daniel Boone Idea in Education," she dispatched her thirteen-year-old son to the Interlaken School in Rolling Prairie, Indiana. Shipped off alone to a strange land, Isamu felt spurned by his mother as he had by his father. But he found adventure in Indiana, first at a school that emphasized learning through doing and then on his own some months later, after Interlaken was converted into a military training facility during World War I. After a winter of living with the caretakers, Isamu was rescued by Interlaken's founder, Dr. Edward Rumely. Rumely placed him in the home of a Swedenborgian minister in La Porte, Indiana, where Isamu went to the local high school. Known as Sam Gilmour in the La Porte High class of 1922, he had become a Hoosier.

Rumely maintained an active interest in Isamu, and he managed to raise funds from his friends to send him to Columbia University for premedical studies. But from his early years Isamu had wanted to be an artist, and the summer after graduation Rumely arranged for him to tutor the son of sculptor Gutzon Borglum in Connecticut. In exchange Borglum provided some sculptural training, yet the future creator of Mount Rushmore dismissed Isamu as without talent. That fall he entered Columbia with the goal of becoming a doctor.

In 1923 Gilmour returned to California after seventeen years in Japan, and the next year she moved to New York. She urged Isamu to turn his attention to art, encouraging him to enroll in a sculpture course at the Leonardo da Vinci School of Art, on Avenue A,

4. Noguchi (seated second from left) with friends in Japan, c. 1916–17

5. Noguchi with *Undine* (*Nadja*), New York, c. 1926

run by Onorio Ruotolo. With the incredible facility that Noguchi would display throughout his artistic life, he became an instant success as an academic sculptor. (Ruotolo took credit for having taught him by psychic means.) He left Columbia to commit himself to sculpture. Ironically, having been spurred to art by his mother, he began to use his father's name as he embarked on the career of an artist. Isamu Gilmour became Isamu Noguchi.

Soon Noguchi would exhibit traditional figures at the conservative salons of the National Academy of Design and the Pennsylvania Academy of the Fine Arts. With Rumely's financial assistance he established a studio at 127 University Place, at the corner of Fourteenth Street. Here he modeled the first of the portrait heads that later would provide him financial support, an image of Mrs. Rumely's deceased father done from a photograph. And he created the tour de force of his academic style, the life-size nude *Undine* (*Nadja*). 5

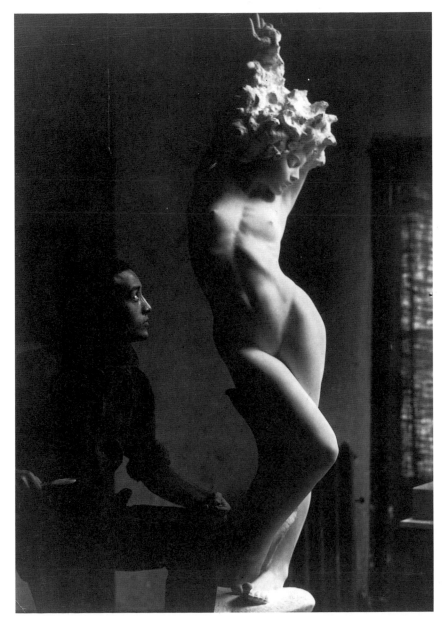

5

The restless Noguchi roamed through the New York art world, and in the progressive galleries of J. B. Neumann and Alfred Stieglitz he found the work that would transform his ambitions. There he saw the kind of modern art that had assaulted New York over a decade before at the Armory Show, and its effect on him was equally tumultuous. Most inspiring was the exhibition of Brancusi's sculpture that Marcel Duchamp organized for the Brummer Gallery at the end of 1926. Events would soon bring the young artist together with his new hero.

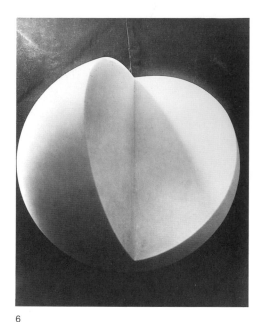

6

Earlier that year Noguchi had been told that Harry Guggenheim had admired his work, and he was encouraged to apply for one of the newly established Guggenheim Fellowships. With a supporting letter from Stieglitz, Noguchi proposed a three-year program: a first year in Paris to study the carving of stone and wood and to attain some cultural maturity, then two years of work in India, China, and Japan. Having assumed his father's name, he now sought to deepen this identification by engaging in an enterprise analogous to Yone's. Just as his father had interpreted the East to the West through poetry, Isamu stated in his fellowship application, so he would attempt to do the same through sculpture. Noguchi's early ambition is evident throughout his application. The future maker of gardens and sculptor of the land sought "to view nature through nature's eyes," necessitating that the artist become one with nature, "a part of the very earth." He would eschew symbolism along with realism and, inspired by Brancusi, attempt to realize his aspirations through abstraction.[2]

Soon after his March 1927 arrival in Paris, following an introduction arranged by the American writer Robert McAlmon, the twenty-two-year-old artist found himself working every morning at 8, impasse Ronsin. The example of Brancusi and his studio would inspire Noguchi throughout his life, from the affirmation of particular values and specific ways of working to the application of sculpture to the lived environment. Here Noguchi reentered the world of saws and chisels that he had known as a youth in Japan, tools of the kind of premodern culture that he shared with his Romanian mentor. The direct carving of natural materials became more than a technique, it became a value, the triumph of the honest over the artificial. Brancusi's contempt for clay—he referred to it as *bifteck* (beefsteak)—and for every manner of indirection confirmed Noguchi's recent rejection of the modeling and casting of academic sculpture. Equally important was the environment of Brancusi's studio, in which the sculptural enterprise included the design of objects for daily use. Here again what Noguchi had seen in Japan was reclad in modernist garb. With Brancusi's bases, tables, stools, and everyday utensils around him, Noguchi had no need of the Bauhaus to point him toward the unity of modern art and design.

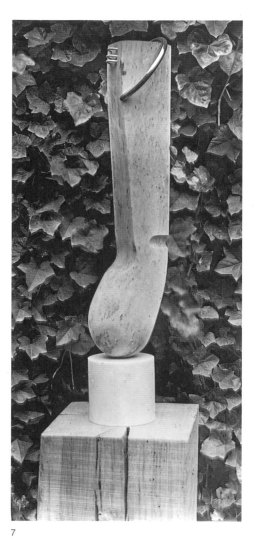

7

Although Brancusi had taken English lessons in preparation for two trips to the United States in 1926, his lack of facility in English and Noguchi's lack of French meant that most of their communication was nonverbal. Through example Brancusi taught Noguchi how to hold a chisel and how to work with his large saws and axes. Noguchi observed how the mark of these tools could be

14

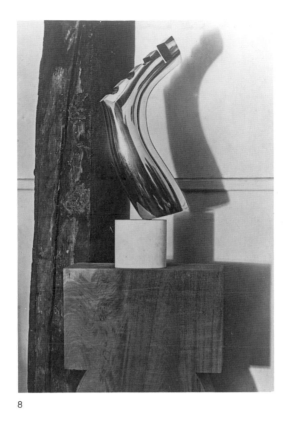

8

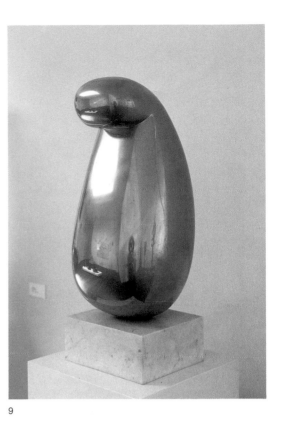

9

left in the wood or stone as a sign of the relationship between man and material—a lesson whose effect would be most fully realized in the stone works of his last two decades.

The charms of Paris also engaged the social young man, and Noguchi led an active life in the bohemian community of artists. He had introductions to the artists Jules Pascin and Tsuguharu Foujita through Michio Itō, a Japanese innovator of modern dance who had known his father. (Isamu had designed masks for Itō's 1925 New York performance of William Butler Yeats's Noh drama, *At the Hawk's Well*—the first of many Noguchi works for the theater.) Given his lack of French, his closest contacts were among American expatriates, including the artists Morris Kantor, Stuart Davis, and Alexander Calder, whom he assisted in presenting his miniature *Circus* (now in the Whitney Museum of Art, New York). He also met young artists as he drew each afternoon at the Académie Colarossi and the Académie de la Grande Chaumière. Apart from these drawing sessions, Noguchi made no art during his months with Brancusi.[3]

It was only after Noguchi left Brancusi that he felt able to start his own sculpture, in a studio that Foujita found for him at 7, rue Belloni (now rue d'Arsonval).[4] He began with a paradigm of formal reduction, a marble sphere with a quarter of its mass removed—his first sculpture in stone. Reacting against the severity of this geometry, Noguchi went on to carve wood and stone into more organic abstractions. He made bases as integral to his sculpture as they were to those of his mentor, often using similar forms. And he made pieces in gold-plated brass that he shined as brightly as he had polished Brancusi's *Leda*. But not all of the twenty-four abstract sculptures that he made mimicked Brancusi, and many of

6

7, 8

6. *Sphere Section*, 1927
Marble, diameter: 16 in. (40.6 cm)
Location unknown

7. *Anna Livia*, 1928
Wood, bronze, and zinc, height: 30¾ in.
(78.1 cm)
Location unknown

8. *Foot Tree*, 1928
Gold-plated brass, 29 x 10¼ x 8¾ in.
(73.7 x 26 x 22.2 cm)
The Isamu Noguchi Foundation, Long Island
City, New York

9. *Globular*, 1928
Polished brass, 20 x 11⅜ x 9 in.
(50.8 x 28.7 x 22.9 cm)
The Isamu Noguchi Foundation, Long Island
City, New York

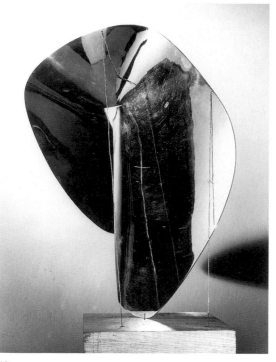

10

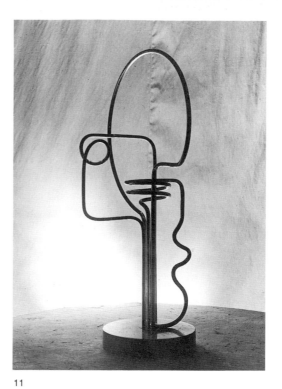

11

them displayed the experimental spirit that would remain an essential element of Noguchi's work.

In works such as his own *Leda*, Noguchi bent brass plate and connected the elements through an interlocking structure that anticipated his stone-slab pieces of the 1940s, which similarly refused to disguise their means of assembly. Here Brancusi's honesty to materials was transposed into an honesty of structure, revealing function as directly as the Japanese joinery that Noguchi had learned as a boy. He would maintain this attitude toward the display of structure throughout his career, disposing him against welding and reinforcing his love of R. Buckminster Fuller's tension-compression systems.

Other experiments involved motion and spatial reorientation, as well as the use of new materials.[5] His *Abstraction in Almost Discontinuous Tension* (location unknown) was a kinetic work with two elements, made three years before his friend Calder's first effort in this direction. Another piece, *Positional Shape*, was a curved planar form that could be oriented in any of three directions. He seems also to have proposed the first neon sculpture, *Zing (Power House)*. Even working with standard materials the young artist was liable to add a novel element. Prefiguring his mature works that combine traditional stone with industrial metals, the carved wood *Red Seed* sprouts an undulating metal tube.

A contemporary interview quotes Noguchi describing these sculptures as "images of moods—moods of flowers, of the vegetative and non-animate aspects of nature."[6] His work moved toward the organic and away from the strictures of geometry that Noguchi would nonetheless continue both to value and to resist. This same tension can be seen in the numerous abstract drawings that he produced in Paris. Flat forms of mat black and/or white gouache, they frequently play off the imagery of his sculpture, shifting between the geometric and the organic.

10. *Positional Shape*, 1928
Gold-plated brass, 23 x 21 x 8¾ in.
(58.4 x 53.3 x 22.2 cm)
The Isamu Noguchi Foundation, Long Island City,
New York

11. *Zing (Power House)*, 1928
Zinc, height: 14 in. (35.6 cm)
Study for neon-tube sculpture
Location unknown

12. *Leda*, 1928
Brass, 23⅜ x 14¼ x 11 in. (59.2 x 36.2 x 27.9 cm)
The Isamu Noguchi Foundation, Long Island City,
New York

13. *Untitled*, 1927
Gouache on paper, 25¾ x 19¾ in.
(65.4 x 50.2 cm)
The Isamu Noguchi Foundation, Long Island City,
New York

14. *Untitled*, c. 1927–28
Gouache on paper, 25⅝ x 19¾ in. (65 x 50.2 cm)
The Isamu Noguchi Foundation, Long Island City,
New York

16

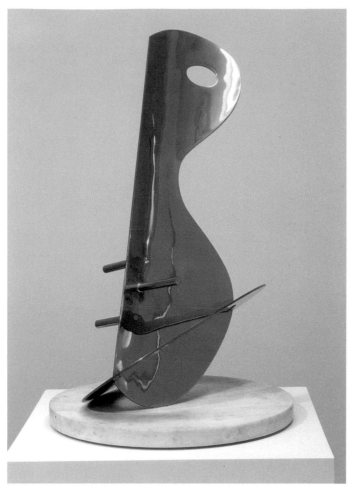

12

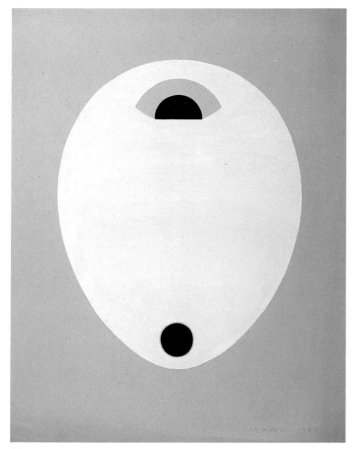

13

14

This dynamic between two kinds of imagery is the first instance of what would become an essential aspect of Noguchi's mature work: his tolerance for, and use of, polarity. Though related to his bicultural background, his use of dichotomy extended far beyond the combining of East and West to include his choice of themes and working processes. In his use of opposites—sometimes blending, sometimes alternating them—Noguchi was able to make use of more materials and more different ways of working than those taking a less diverse course.

Well into his second year in Paris, Noguchi had made little progress toward the East (although he did spend a month in the British Museum reading about India in preparation for his travels), and his fellowship was not renewed for a third year. Having returned to New York early in 1929, he exhibited his Paris abstractions—both sculpture and drawings—at the Eugene Schoen Gallery in April. The work seems to have been well received, but nothing sold. For Noguchi, it was the end of abstraction for over a decade. In addition to the financial disappointment, the powerful example of Brancusi left the young artist feeling too immature, and insecure, to continue working with abstract forms.[7] In Oedipal confusion, he rejected the mode of this new father and embraced the skills that Ruotolo had provided.

Noguchi returned to representational portraiture, sculpting the heads of wealthy sitters for income and those of other artists for friendship (and practice). In a studio on the top floor of Carnegie Hall, and then in an unused laundry room atop a building at Madison Avenue and Twenty-ninth Street, he made more than twenty-four heads in 1929, modeling in clay five portraits at a time and finishing each work in about seven sittings.[8] His style was no longer an academic one, for he employed avant-gardist experimentation even within this traditional form. Most significantly, he did so without identifying himself with any one style, using style itself to display the personality of his sitters and asserting the freedom from uniformity that would become a hallmark of his work. For choreographer Martha Graham, whom he had met through his mother, Noguchi made a rough, expressive image of deep emotional intensity. George Gershwin was presented in black bronze with all the elegance of his music, socialite Edla Frankau in Art Deco stylization. The most striking image was the futuristic chrome head of R. Buckminster Fuller, whose visionary talk had entranced the young artist at Romany Marie's tavern in Greenwich Village and with whom he developed a fast friendship.

After seventeen of Noguchi's portrait sculptures were shown at the Marie Sterner Gallery in New York in February 1930, he and Fuller loaded a collection of the heads and a model of Fuller's Dymaxion house into the architect's station wagon and headed north. Their first stop was Harvard University's Society for Contemporary Art, where Fuller lectured and Noguchi exhibited, and where the artist sculpted the head of one of the society's organizers, student Lincoln Kirstein. From Cambridge they drove west to a similar event at the Chicago Arts Club.

This was Noguchi's last activity in the States for a while, as these efforts had been directed at raising enough money to complete his

15. *Lincoln Kirstein,* 1929
Bronze, height: 14 in. (35.6 cm)
Wadsworth Atheneum, Hartford, Connecticut;
Gift of Henry and Walter Keney and
James J. Goodwin

16. *R. Buckminster Fuller,* 1929
Chrome-plated bronze, 13 x 8 x 10 in.
(33 x 20.3 x 25.4 cm)

18

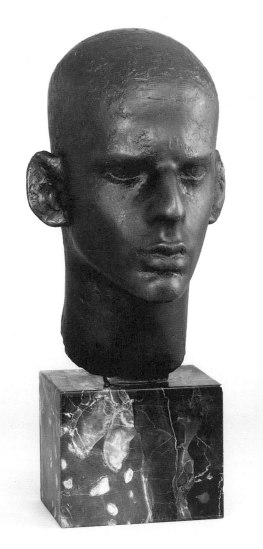

15

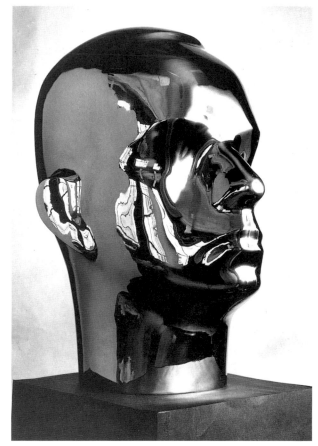

16

19

travels. In mid-April he set sail on the *Aquitania* for Paris, en route to the Far East. Returning to Paris and a studio in suburban Gentilly for two months, Noguchi maintained his resistance to abstraction. He continued figure drawing and made a sculpture with outstretched limbs entitled *Glad Day*, after a poem by William Blake. As he waited for a visa for Siberia, through which he planned to travel to Japan, Isamu received a letter from his father saying that he should not come to Tokyo using the name of Noguchi. Stung by this renewed rejection, he changed his destination to Beijing. On the way he stopped in Moscow, searching in vain for Vladimir Tatlin's *Monument to the Third International*, which he mistakenly believed had actually been constructed.

Noguchi stayed in Beijing for seven months, living well and discovering ancient palaces and gardens that fed his fascination with public spaces as sculptural forms. He found another mentor in the distinguished painter Ch'i Pai-shih, with whom he studied the traditional use of Chinese brush and ink. Continuing to focus on the figure, Noguchi created expressive images of local models on great expanses of rice paper. He drew children, young boys, men and women, some alone and others in pairs. His natural facility was never more clearly displayed than in his quick mastery of the difficulties of ink-brush painting and in the large number of scrolls that he produced in such a short time. These are dramatic works, combining long, restrained lines with dynamic ink washes of great agitation. They are unique in scale and ambition among Noguchi's many drawings, which after this point would consist primarily of travel sketches and ideas for sculpture.

Despite Yone's warning, the lure of Japan held strong, and Isamu landed at Kōbe early in 1931 and headed for Tokyo. A Japanese

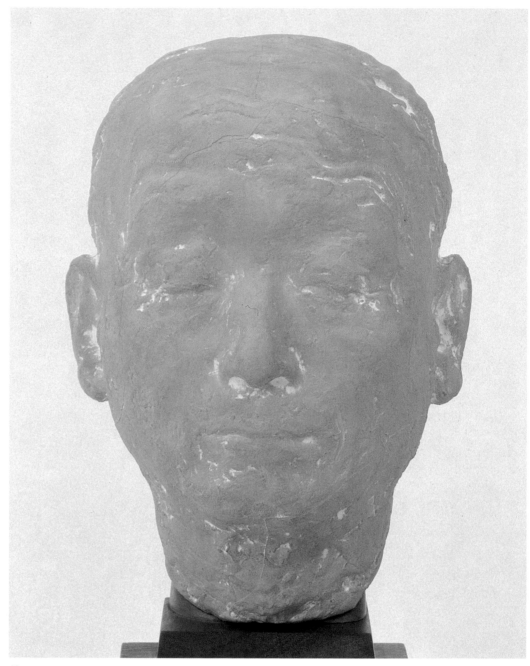

18

17. *Untitled*, 1930
Ink on paper, 38 x 58⅝ in. (96.5 x 148.8 cm)
The Isamu Noguchi Foundation, Long Island
City, New York

18. *Uncle Takagi (Portrait of My Uncle)*, 1931
Terra-cotta, 11¾ x 7¾ x 7½ in.
(29.8 x 19.7 x 19 cm)
The Museum of Modern Art, New York; Gift of
Edward M. M. Warburg

reporter had learned of his identity aboard the ship from China, and Isamu was greeted on arrival as the accomplished son of a famous father. The public welcome did not serve to warm Yone's feelings, but Isamu's uncle Totaro Takagi provided him with comfortable lodging and much kindness. The terra-cotta portrait of 18 Uncle Takagi that Isamu soon modeled displays the respect and affection he felt for his father's benevolent brother.

Although Yone remained cool, he made artistic contacts for his son in Tokyo, and Isamu began to work in ceramics. After two months the emotional difficulties of the situation proved unbearable, however, and he left for Kyoto with an introduction to the master potter Jinmatsu Unō. It was in Kyoto that Noguchi the artist first confronted the aesthetic achievements of old Japan. In

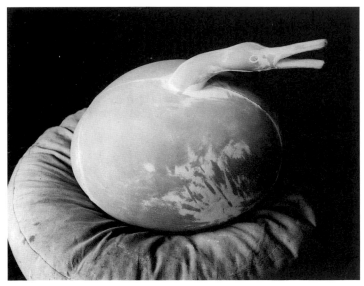

19

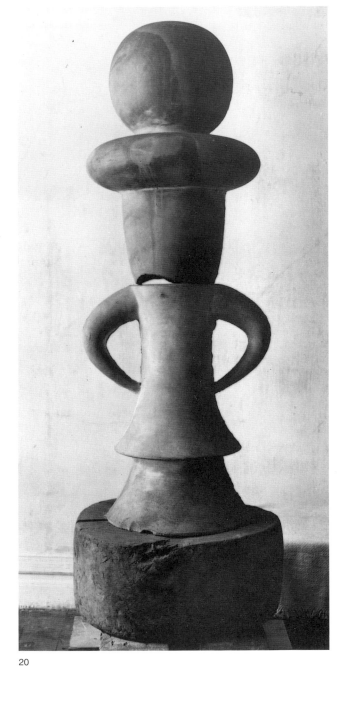

20

the museum he discovered ancient *haniwa* funerary figures—cylindrical clay images that would play a role in his development as a modernist in the same way that tribal art influenced the avant-garde in Paris, becoming models of formal reduction and direct expression. And it was in Kyoto that Noguchi first saw the Zen gardens that would broaden his conception of what sculpture could be. Wandering alone and in silence in these poorly maintained temple gardens—so different in mood in 1931 from what they are today—he "perceived an art which was beyond art objects."[9]

Noguchi spent much of his five months in Kyoto working in Unō's pottery, where he fired dozens of cast terra-cotta figures in the master's great kiln. Few of these works survive; those that do, resemble archaic Chinese figurines that have undergone modernist simplification. Two portray powerful characters, evocations of strength that Noguchi must have sought in his difficult emotional circumstances: *Tamanishiki*, the most famous Sumo wrestler of the day, and *Kintaro*, a mythical child of the forest with supernatural powers. The largest is the most abstract, and the closest to ancient *haniwa: The Queen*, towering over the others at 45 ½ inches (115.6 centimeters) in height.

With militarism on the rise and his father moving in a more nationalistic direction, Isamu left Japan in September 1931. It would be nineteen years before he returned. During those two decades Noguchi would establish himself as a modernist innovator and a recognized member of the New York avant-garde. But the idiosyncrasy of his upbringing and of his formative experiences had set him on a unique course. That path would incorporate the methods and values of Brancusi and the sculpted environments of Japan. It would intersect the experimental space of the stage and the public space of the park and playground. And it would traverse the boundary between fine and applied art as readily as Noguchi himself crossed international borders.

Returning to New York in October 1931, just before his twenty-seventh birthday, Noguchi was ready to enter artistic maturity. He exhibited his Beijing brush drawings and Japanese ceramics at two galleries in February 1932, but his work was already moving elsewhere. After he made his first sculpture back in New York, a futuristic invocation of *haniwa* named *Miss Expanding Universe* by Fuller, Noguchi transmuted its flowing form into a sacklike costume for the dancer Ruth Page. He also proposed that the experimental composer Leon Theremin—for whom he had enthusiastically played his records of *gagaku* (Japanese court music)—position his sound-generating rods across a stage, to be activated by the movements of dancer Martha Graham. Noguchi now would seek to unify his art with a broader range of human experience, combining the aesthetics of modernism with more social aspirations.

19

20

21

19. *Peking Duck (Bird and Egg)*, 1931
Terra-cotta, height: 12 in. (30.5 cm)
Location unknown

20. *The Queen*, 1931
Terra-cotta, 45½ x 16 x 16 in.
(115.6 x 40.6 x 40.6 cm)
Whitney Museum of American Art, New York;
Gift of the artist

21. Noguchi with one of his Beijing brush
drawings, New York, c. 1932

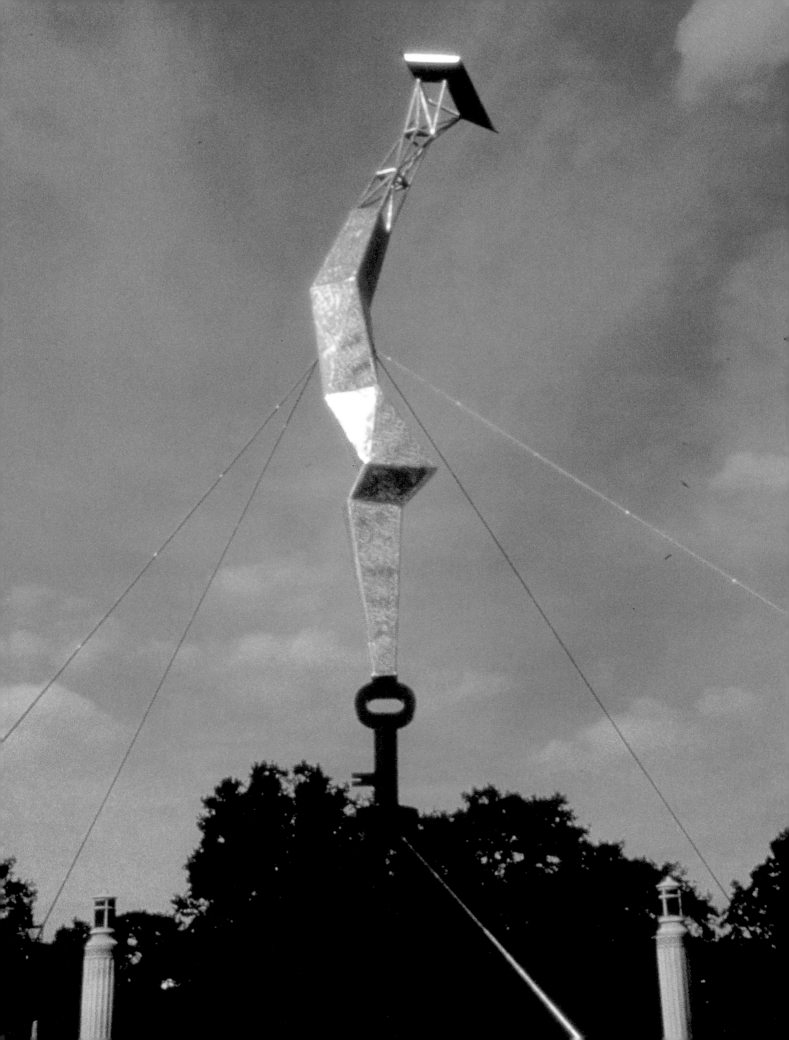

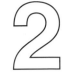 # 2 Sculpture and Society

Like other artists of the future New York School, Noguchi was caught up in the rising social consciousness of the 1930s. He designed workers' memorials, proposed public art projects, signed political manifestos, and even executed a great polemical mural in a Mexican market. This orientation did more than give him a new range of subjects; it reinforced what he had seen both in Brancusi's studio and in Japan—the application of art to the lived environment. It was this combination of his unique background and the politics of the Depression years that would yield Noguchi's broadened conception of sculpture, what he later would call the sculpture of spaces.

There are two ironics in this development. First, the kind of ambitious projects that resulted from Noguchi's radical new course could be realized only under the corporate capitalist boom of the 1950s and 1960s. The social skills that he had developed in supporting himself with portrait sculpture served him well in dealing with these new patrons, despite a deep ambivalence toward the wealthy. In another twist, this focus on the lived environment dispelled the inhibitions that had prevented his creation of abstract aesthetic objects. Making functional forms enabled Noguchi to move away from the figure, providing a different sort of anchor to reality and clearing the way for his achievements in abstraction.

Noguchi's new direction became clear in 1933, when he envisioned two major environmental projects. Grand in proportion and utopian in aspiration, *Monument to the Plow* and *Play Mountain* were audacious designs. Yet, as would be the case with many of Noguchi's most ambitious works, they met with derision.

Monument to the Plow was to be a pyramid of earth, twelve hundred feet (366 meters) long on each side of the base, to be surmounted by a great stainless-steel plow. With one face planted in wheat, another plowed, and the third remaining half-fallow, it was to be located at the geographical center of the United States. A tribute to the vast country that had accepted the thirteen-year-old traveler, *Monument to the Plow* also recalled the interest taken in his education by Dr. Rumely, who had taught Isamu about the

23, 24

22. *Bolt of Lightning . . . Memorial to Ben Franklin*, 1984
Stainless steel, height: 101½ ft. (30.9 m)
City of Philadelphia

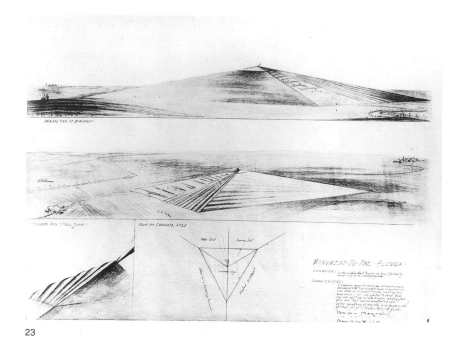

23

24

importance of the steel plow in the settling of the West. It thus was a very personal rebuke when, after submitting his design to the Public Works of Art Project (forerunner of the WPA Fine Arts Project), Noguchi was told that it was unacceptable. Not only that, but his government support would continue beyond the four months that he had already received only if he returned to a traditional sculptural format. Although, not surprisingly, this immense work never was built, the other project he submitted to, and had rejected by, the agency—a 100-foot- (thirty-meter-) tall *Monument to Ben Franklin*—was realized in modified form in Philadelphia fifty years later.

More important than either of these projects, however, was *Play Mountain*. The first of Noguchi's many playground proposals, it also had a more general significance. As he later wrote, this work "was the kernel out of which have grown all my ideas relating sculpture to the earth."[10] *Play Mountain* was the first work in which Noguchi sought to mold the earth itself to create a sculptural environment for human activity, domesticating and urbaniz-

ing the pyramid of *Monument to the Plow* to the proportions and needs of a New York City block. On one side, a long swimming pool separated a bandshell from a triangular terraced hillside; on the other, the basic pyramid form transmuted into a spiral slope for winter sledding. Between the two, water cascaded into a shallow pool. Particular elements of this design would recur in later environmental projects, both Noguchi's own and those done in collaboration with others.[11] And like many of these later projects, *Play Mountain* was never built.

In this, *Play Mountain* set a pattern that would be regularly repeated. In 1934 *New Yorker* art critic Murdock Pemberton helped Noguchi present his *Play Mountain* design to New York City Parks Commissioner Robert Moses. The response, the artist remembered, was "thorough sarcasm,"[12] and Moses and his department would later foil other Noguchi proposals for his home city. When the New York Parks Department rejected as too dangerous the innovative play equipment that he had recently designed for Honolulu's Ala Moana Park,[13] Noguchi proposed for Central Park a completely safe play area of undulating earth forms, *Contoured Playground*. A biomorphic relief that introduced his surreal imagery of the 1940s, it was never seriously considered

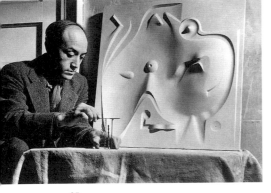

25

23. *Monument to the Plow*, 1933
Drawing
Location unknown

24. *Model for "Play Mountain,"* 1933
Plaster, 29¼ x 25¾ x 4½ in.
(74.3 x 65.4 x 11.4 cm)
Location unknown

25. Noguchi with *Model for "Contoured Playground,"* c. 1941

26. *Model for Playground Equipment for Ala Moana Park, Hawaii*, 1939
Metal
Location unknown

26

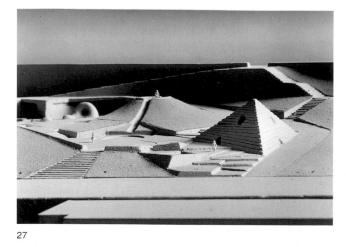

27

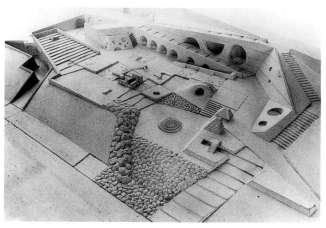

28

because of the outbreak of World War II. Ten years later Noguchi was asked by Audrey Hess (wife of the editor of *Artnews,* Thomas B. Hess) to create a playground alongside the United Nations headquarters in New York. Despite substantial private financing and the territorial autonomy of the United Nations, Moses again managed to prevent the construction of a Noguchi playground, whose design he compared to a rabbit warren. Defended vehemently in the pages of *Artnews,* the 1952 model of the United Nations playground was put on display at the Museum of Modern Art in futile protest.[14]

In another attempt to have a Noguchi playground built in New York, eight years later Audrey Hess convinced him to design a playground, in honor of her aunt, along Riverside Drive between 101st and 104th streets. He chose as collaborator the modernist architect Louis I. Kahn, and between 1961 and 1966 they created five plans designed for a hillside site overlooking the Hudson River. The plans featured activity rooms beneath a sculpted landscape, play hills and waterscapes, slides and crawling holes, geometrical terraces and amphitheaters. The playground inched its way through repeated redesigns toward construction—enduring protests by community members afraid of an invasion of youth from Harlem, the demands of New York City building codes, the raising of half a million dollars in private funds to supplement city money—until the project finally was approved by the outgoing mayor, Robert Wagner. Yet in the end, the Riverside playground fell victim to election promises of the new administration of John Lindsay, whose young parks commissioner, Thomas Hoving (later director of the Metropolitan Museum of Art), canceled the plan. No Noguchi playground has yet been built in New York City, although the undulating forms of his many unrealized proposals have become a staple of postwar playground design.[15]

Noguchi's ongoing involvement with playgrounds and play equipment has its root in his memories of childhood at the side of an indulgent mother, who filled him with stories of mythic heroes and set him on his artistic course. For Isamu, childhood was a prelapsarian time of unlimited possibility, to be fostered in public spaces. Modern artists like Wassily Kandinsky and Joan Miró had concerned themselves with childhood as a period when art was

116

27, 28

27. *Model for Riverside Drive Playground,* c. 1963
Designed in collaboration with Louis Kahn
Plaster
The Isamu Noguchi Foundation, Long Island City, New York

28. *Final Model for Riverside Drive Playground,* 1966
Designed in collaboration with Louis Kahn
Plaster
The Isamu Noguchi Foundation, Long Island City, New York

29. *Model for "Carl Mackley Memorial (United Hosiery Workers Memorial),"* 1933
Plaster
Location unknown

made as untainted primitive expression. But Noguchi expressed his interest in childhood in a more practical and more social direction, bringing it into the world of daily activity.

Noguchi's move toward the sculpture of spaces was derided not only in government offices but also in the press. In January 1935 he displayed a variety of work in his twelfth one-person exhibition of the decade, at the Marie Harriman Gallery. The prominent *New York Sun* critic Henry McBride chose to focus his review on the 1933–34 public projects, which included the *Carl Mackley Memorial,* an abstract enlargement of sewing machinery for the United Hosiery Workers Union. These designs were snidely described by McBride as "wily" attempts by a "semi-oriental" to manipulate American sentiments, the consequence of Noguchi's "studying our weakness with a view of becoming irresistible to us." McBride picked out one other sculpture for racist complaint—a close-to-full-size Monel-metal figure of a lynched black man. This he called "just a little Japanese mistake."[16]

Suspended from the frame by a thick piece of rope, Noguchi's *Death (Lynched Figure)* was derived from a grisly photograph of a burned, lynched body that had appeared in a 1930 issue of *International Labor Defense*. Its violence is unique in Noguchi's oeuvre. *Death* displays the degree of political awareness, and the inclination to political statements, that characterized the art world of the mid-1930s. It was exhibited again the month following Noguchi's show in an exhibition devoted to this gruesome subject, *An Art*

29

30

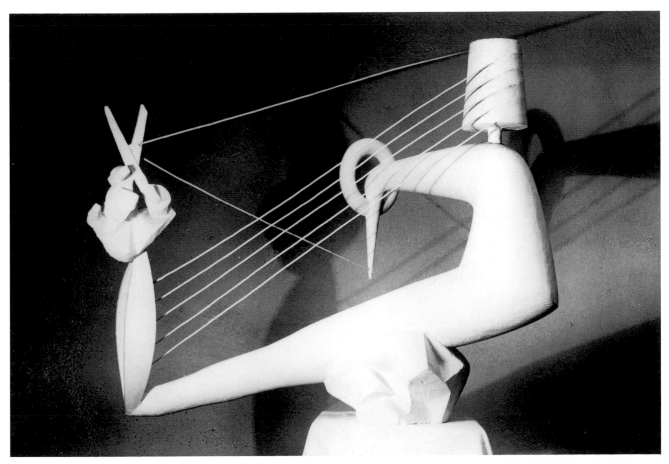

29

30

Commentary on Lynching, along with works by Paul Cadmus, Reginald Marsh, Thomas Hart Benton, José Clemente Orozco, and others.[17]

Death is one of two explicitly political works that Noguchi created during this period, and the other was his first large-scale accomplishment. Disgusted with the New York art world after McBride's review and after another project, for a land sculpture in front of Newark Airport, was rejected by the WPA, Noguchi left the city, en route to Mexico.[18] Having met Orozco soon after returning from Japan and being well informed of the activities of the radical muralists—as were most New York artists—he wanted to see for himself the role of art and artists in revolutionary Mexico. Through Marion and Grace Greenwood, whom Noguchi met in Paris, he became involved in the decoration of the Abelardo Rodriguez Market in Mexico City.

Filled with communitarian feeling, Noguchi agreed to make a mural in high relief for the same pay per square meter as his fresco-making companions, and he was allocated the walls of an upstairs room in the market building. Here he created *History Mexico,* a narrative cycle six and a half feet (two meters) high and seventy-two feet (twenty-two meters) long. The imagery is aggressive, and the composition energetic with diagonals. Atop bags of money and

31, 32

30. *Death (Lynched Figure),* 1934
Monel metal, 39 x 29⅜ x 21 in.
(99 x 74.9 x 53.3 cm)
The Isamu Noguchi Foundation, Long Island City, New York
Photograph by Berenice Abbott

31, 32. Details of *History Mexico,* 1936
Colored cement on carved brick, 6½ x 72 ft.
(2 x 22 m)
Abelardo Rodriguez Market, Mexico City

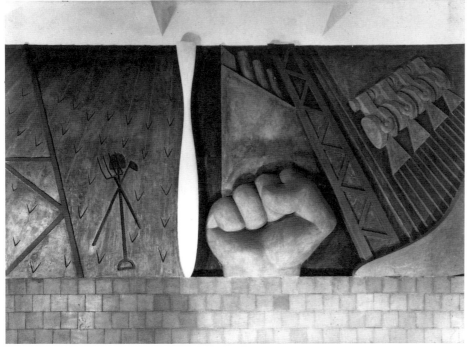

31

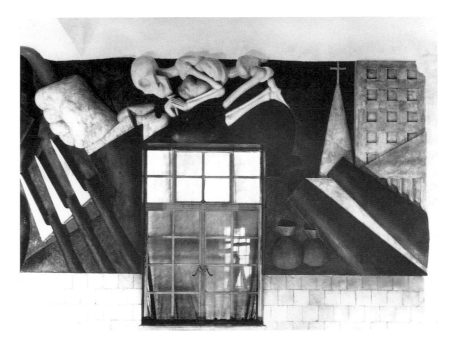

32

pointed bayonets, a fat capitalist is attacked by a skeleton. A giant swastika bears down on rebellious workers, a man lifts his fallen comrade, fists are raised in defiance. Hope is held out at the end, as an Indian boy gazes at Albert Einstein's mass/energy equation: salvation promised by scientific and technological advance. It took Noguchi seven months to complete the work, first carving into the bricks and building up the deep relief, then covering and molding the forms with colored cement. The result was his first great public sculpture, and the artist's pride in it was evident in his polemical essay "What's the Matter with Sculpture?" (1936).[19]

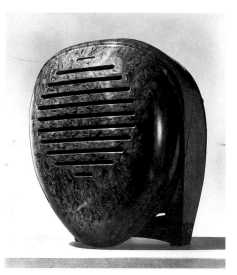

33

This essay, in which Noguchi complained that contemporary sculpture had too little involvement with everyday life, was published in *Art Front*, the journal of the Artists' Union.[20] He involved himself with the union on returning to New York but soon became disaffected with the organization and its infighting. Nonetheless, he took the advice of his own article and oriented his work toward social use during the rest of the 1930s. In 1937 he designed his first mass-produced object, the elegant Bakelite *Radio Nurse*. Commissioned by Zenith in response to the concern over child safety that followed the Lindbergh kidnapping, this nursery intercom had two parts—Noguchi's abstract headlike form of the nurse itself, which enclosed the speaker, and a metal "Guardian Ear" containing the microphone for the child's room.[21]

Much of Noguchi's time during the 1930s was taken up with more ambitious public works. He made three proposals for the 1939 New York World's Fair—two were unsuccessful, but the third enabled him to construct the first of his many fountains. The two remaining unbuilt were a frieze for the Medical Building (a work whose imagery recalled his short period of premedical studies) and the Union Building, designed in collaboration with Paul Goodman and Philip Guston. His fountain for the Ford Motor Company Building *was* erected, at the bottom of a half-mile (eight-hundred-meter) ramp—the Road of Tomorrow—on which visitors drove the newest Fords. Combining out-of-scale auto parts, Noguchi placed an abstract engine block atop a huge connecting rod, which descended to a turning rear wheel that splashed water inside a curved fender. In the middle was an eighteen-foot- (five-and-a-half-meter-) tall spiral gear down which water flowed, feeding the wheel. In Noguchi's *Art Front* article about the problems of contemporary sculpture he had advocated using the newest materials and tools, inspired by Fuller. The Ford fountain gave him a chance to do this on a grand scale. In it he first used the cementlike material magnesite, which he would employ in his illuminated Lunar interiors and light sculptures during the 1940s.

Noguchi's largest project from this period also took him the longest, and though it would garner much publicity he soon bemoaned the time and effort involved. This was *News*, a monumental relief for the entrance to the Associated Press Building in Rockefeller Center. His model, to which he had devoted only three

34

34

33. *Model for "Medical Building Frieze,"* 1938
Plaster, 18¼ x 59½ x 2 in. (46.4 x 151 x 5 cm)
Private collection

34. *Radio Nurse,* 1937
Bakelite, 8¼ x 6½ x 6 in. (21 x 16.5 x 15.2 cm)
Manufactured by Zenith Radio Corporation

35. *Fountain for the Ford Motor Company Building, 1939 New York World's Fair,* 1938
Magnesite, height: 18 ft. (5.5 m)
Destroyed

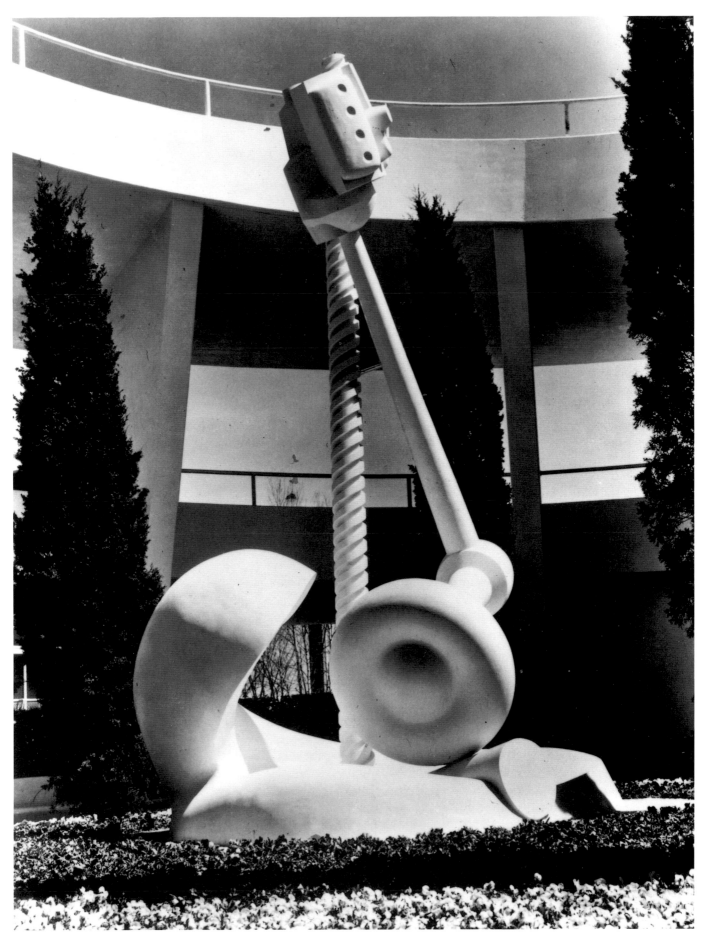

35

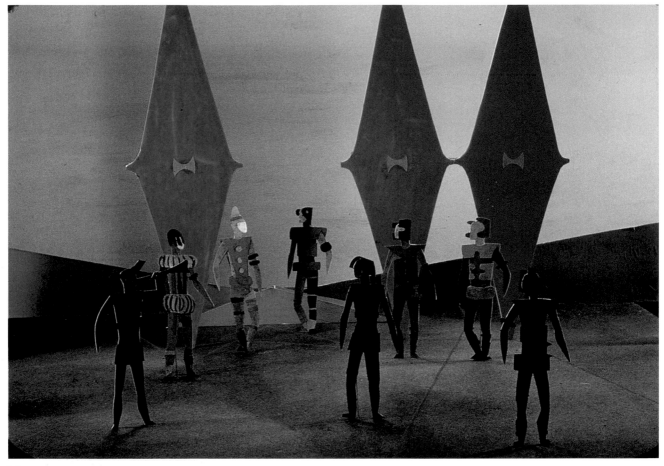

38

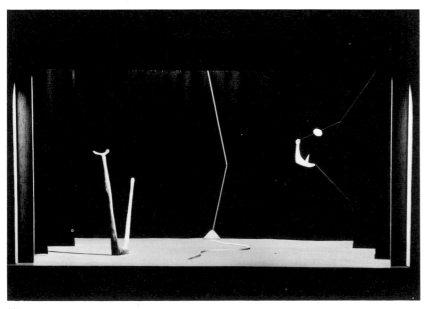

39

38. Model of stage set and costumes for the Royal Shakespeare Company production of *King Lear*, 1955

39. Model of stage set for *Errand into the Maze*, 1947
Choreographed by Martha Graham

40. Stage set for *Orpheus*, 1948
Choreographed by George Balanchine for the New York City Ballet

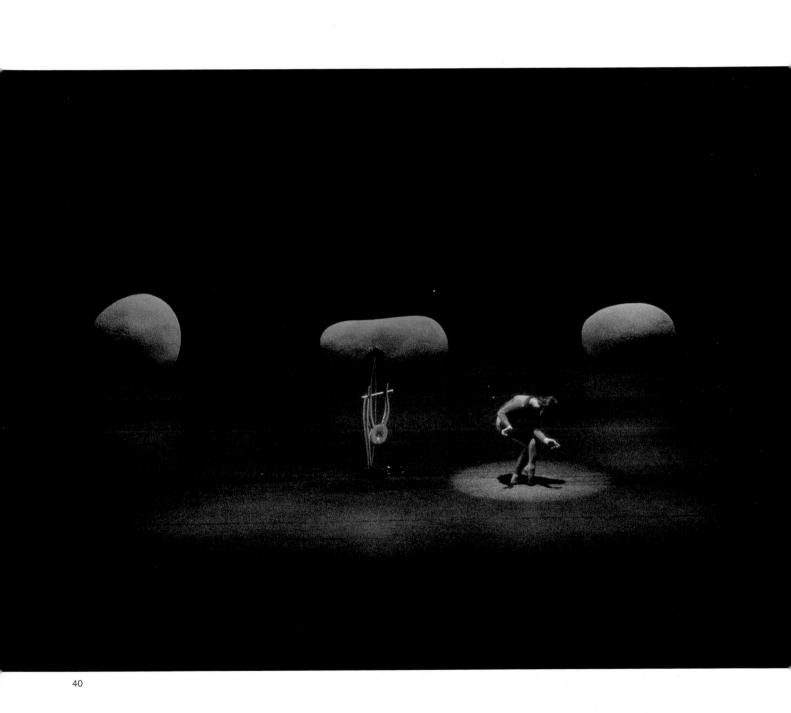

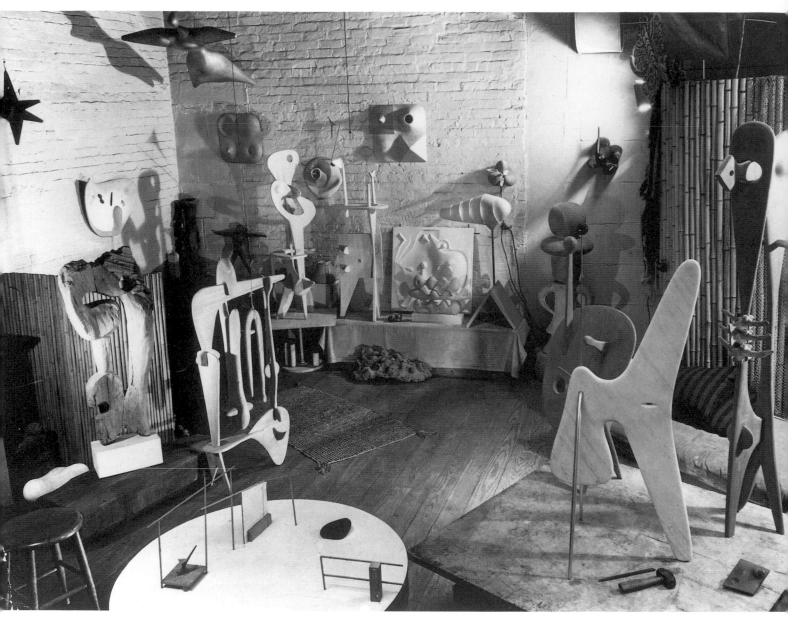

41

tempted by material possession. By the date of its creation, 1948, Noguchi himself was experiencing doubts about the ill effects of art-world success.

At the beginning of the 1940s, however, Noguchi still focused on the public uses of his art and held out hope for socially productive projects. Discouraged by the New York City Parks Department's neglect of his *Contoured Playground,* in 1941 he sought a new beginning out west, and he drove across the country to California with some friends, including the painter Arshile Gorky. The attack on Pearl Harbor abruptly changed everything, and the half-Japanese Noguchi found himself viewed as an alien threat. Rather than the American that he had tried so hard to become, now he was Nisei. Shocked into political involvement by this new status, in January 1942 he organized the Nisei Writers and Artists Mobilization for Democracy, a group seeking to mitigate the anti-Japanese hysteria by demonstrating the patriotism of the Japanese-

41. Noguchi's studio at 33 MacDougal Alley, New York, c. 1945
Photograph by André Kertész

American community. In March, following the government decree ordering all West Coast Japanese-Americans to internment camps, Noguchi flew to Washington, D.C., seeking assistance from some of the influential individuals he had met through his years of making society portraits. Soon he was convinced by John Collier, an idealist who headed the American Indian Service, to voluntarily enter the camp at Poston, Arizona. There, Noguchi was led to believe, he could effect real change and improve the lives of the internees.

The reality, of course, was very different, and the seven months that Noguchi spent in the Colorado River Relocation Center put him off public projects for close to ten years. The situation was discouraging from the first month, but Noguchi engaged himself in the life of the community, organizing woodworking and ceramics projects. He formulated a master plan for park and recreation areas and, more darkly, he was assigned to lay out a cemetery—a solemn shrine of concentric right-angled walls. None of these projects was built, and that fall Noguchi left Poston on a temporary pass, never to return.[26]

After his further attempts to help with the war effort were rebuffed by the authorities, Noguchi gave up and retreated to a studio at 33 MacDougal Alley in Greenwich Village. Here he 41 would focus on studio sculpture, creating art objects that would bring him widespread recognition within the emerging New York School. Certain works made during his first year back in New York still display strong political feelings, albeit in aestheticized form. Most indirect is the wall relief *My Arizona*, an abstraction repre- 42 senting the Poston desert, its sharp red hook an intense evocation of Noguchi's painful experience there. More direct is *This Tortured* 43 *Earth*, which was both a sculptural relief and a model for a landscape project lamenting the effects of war. Inspired by a photograph of the bombed North African desert, it was intended to be an earth sculpture created by military bombardment. Most explicit is *Monument to Heroes*, a cardboard tube in which carved pieces 44 of wood and a human bone are suspended by strings in tension— a somber, somewhat gruesome tension-compression structure anticipating those later developed by the American sculptor Kenneth Snelson. It was a study for a great work to be set on a mountaintop; the wind rushing through it would create a series of mournful tones, a dirgelike transformation of Noguchi's 1933 notion of a *Musical Weathervane*.

The use of the atomic bomb in August 1945 deeply reinforced Noguchi's growing pessimism. After the frustration of his political ideals of the 1930s and the discouragement of Poston, the onset of the Cold War promised little hope. In 1947 Noguchi impressed an abstract image of a face in sand on a one-foot- (30.5-centimeter-) 45 square board. Photographed to create an illusion of grand scale— the nose was to be one mile (1.6 kilometers) long—the work was entitled *Memorial to Man*, forecasting the situation after the next atomic war. With sardonic humor, he eventually changed the name of this immense earthwork to *Sculpture to Be Seen from Mars*. It was a human face to be observed from space, informing others that a civilized life form had once existed on Earth.

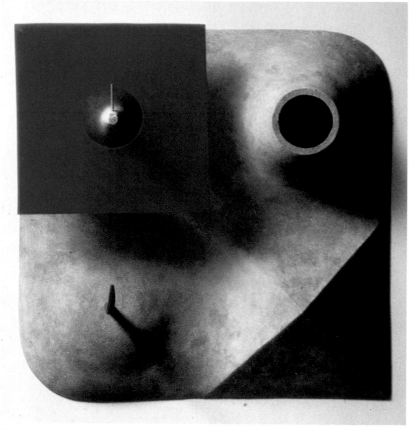

42

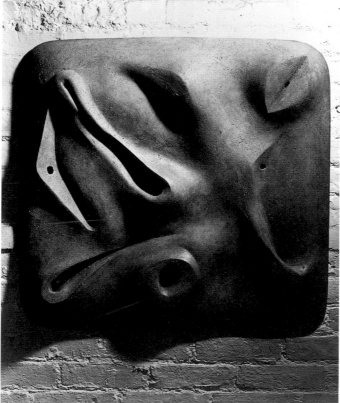

43

42. *My Arizona,* 1943
Magnesite and plastic, 18¾ x 18 x 4 in.
(47.6 x 45.7 x 10.2 cm)
The Isamu Noguchi Foundation, Long Island
City, New York

43. *This Tortured Earth,* 1943
Bronze, 28 x 28 x 4 in. (71 x 71 x 10.2 cm)
The Isamu Noguchi Foundation, Long Island
City, New York

44. *Monument to Heroes,* 1943
Wood, cardboard, thread, and bone,
28¼ x 15½ x 14 in. (71.8 x 39.4 x 35.6 cm)
The Isamu Noguchi Foundation, Long Island
City, New York

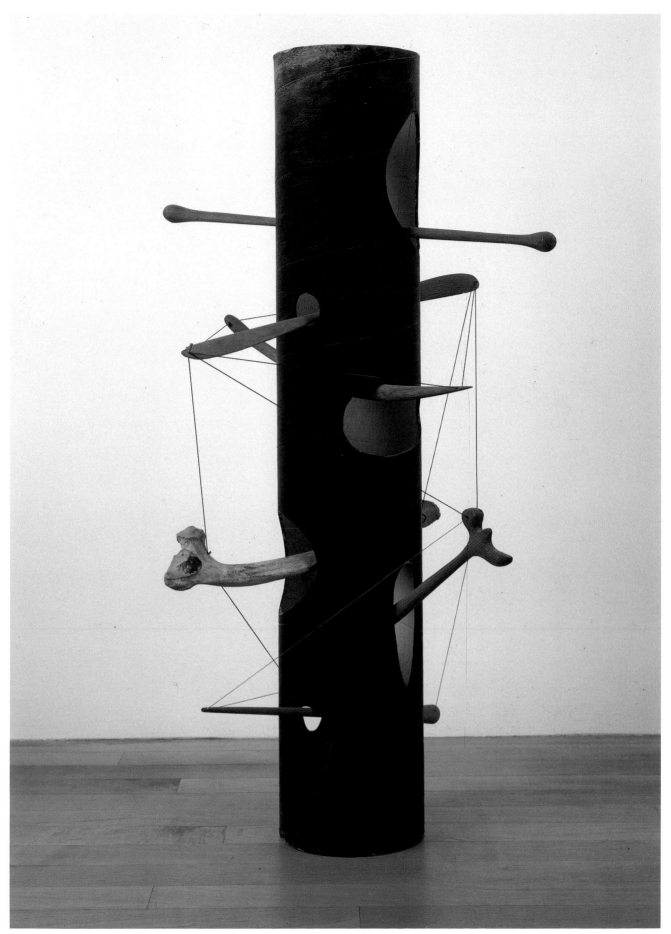

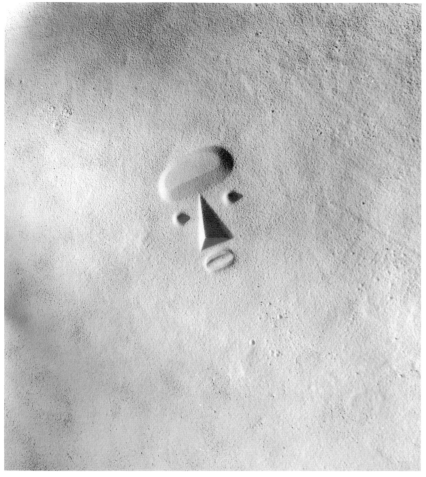

45

The success that Noguchi was achieving with his freestanding sculpture during the late 1940s, however, pulled him away from politically charged projects. His biomorphic works in stone were a hit at the 1946 exhibition *Fourteen Americans* at the Museum of Modern Art, and he had his first one-person gallery show in fourteen years in March 1949, at the Charles Egan Gallery. Yet the July 1948 suicide of Arshile Gorky, a few days after Noguchi drove the distraught painter to his Connecticut house, disturbed him deeply, and he believed that the pressure of art-world success was in part responsible for Gorky's death. Soon his own increasing fame and involvement in the New York art scene precipitated a personal crisis, and he applied for a travel grant from the Bollingen Foundation to study what he called "environments of leisure." Two months after his Egan show Noguchi left the country to investigate the modes and meanings of sculpture in the premodern world.

The crisis that Noguchi experienced was not merely a personal one but one that he viewed as affecting sculpture as a whole. With the demise of fundamental systems of value—religion in the premodern world, utopianism in the twentieth century—sculpture had lost the social role that had inspired its greatest achievements. With Bollingen support he would survey what sculpture had accomplished before its modern crisis, searching for a new path for his own work. Questioning the validity of the purely aesthetic object,

46

45. *Model for "Sculpture to Be Seen from Mars,"* 1947
Sand on board, 1 x 1 ft. (30.5 x 30.5 cm)
Destroyed

46. Noguchi exhibition at Charles Egan Gallery, New York, 1949, showing (left to right): *Open Window, Avatar, Bird's Nest, Night Land, The Mountain, Plus Equals Minus,* and *Insects in Rice Field*

Noguchi returned to his earlier conception of sculpture as the spatial structuring of the lived environment.

His Bollingen travels took Noguchi to see the prehistoric stones of England and Brittany; the monuments of ancient Egypt, Greece, and Rome; the temples of India, Cambodia, and Indonesia. And in the spring of 1950, at the age of forty-five, he returned to Japan. There Noguchi was greeted with great fanfare as an eminent modernist, and he fell in with the young architects and artists who would revive the country's postwar culture. At a welcoming party, the architect Kenzo Tange described his master plan for Peace Park in Hiroshima, and Noguchi expressed interest in contributing to it.[27] He made two models of a seventy-foot (twenty-one-meter) memorial bell tower for Hiroshima, one of which he displayed in August in his exhibition at the Tokyo department store Mitsukoshi—another monument that would emit sounds in the wind. His active involvement with Tange's project came the next year, with an invitation to design the railings for two bridges into the memorial park, which lay on an island in the Ōta River, alongside the epicenter of the atomic blast.

At the request of Hiroshima's mayor, Shinzo Hamai, in June 1951 Noguchi first visited the city with Tange to see the bridges, and he received the railing commission the next month. He soon left for Los Angeles to join his future wife, Japanese film star Yoshiko (Shirley) Yamaguchi, and completed his final designs there. The artist sculpted models of the railings in clay; these were cast in concrete, with some difficulty, by Tange's engineers in 1952. The resulting works are dramatic pieces of functional public art,

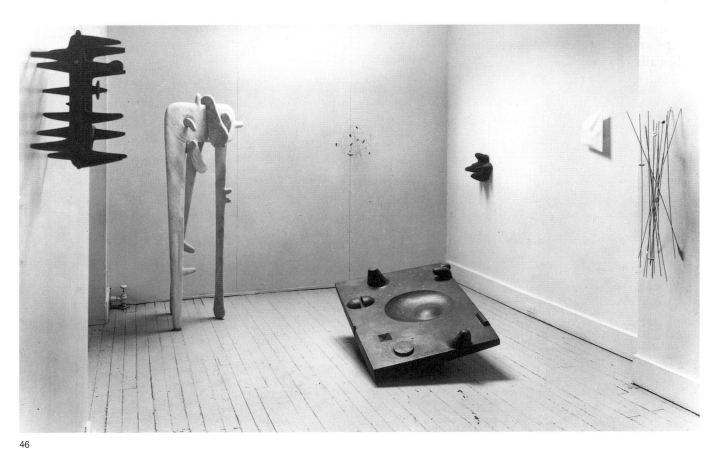

46

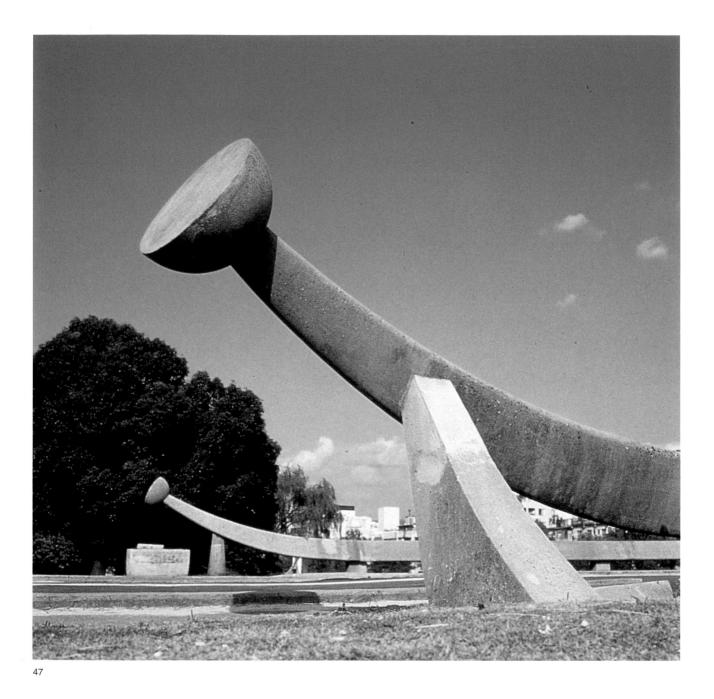

47

47. *Ikiru (To Live),* 1952
Concrete bridge railings, Hiroshima, Japan

48. *Shinu (To Die),* 1952
Concrete bridge railings, Hiroshima, Japan

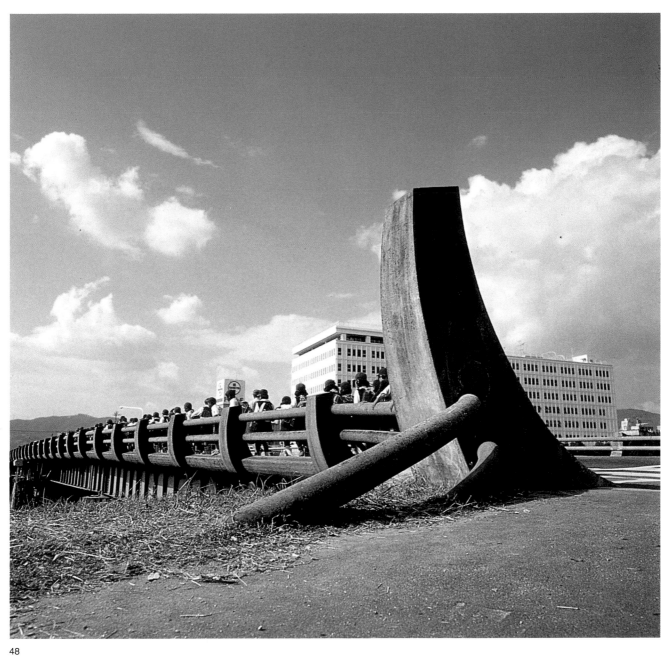

48

one evoking life and the other death. The former, which ends in abstract images of the rising sun, was called *Ikiru (To Live)*. The latter, employing forms reminiscent of the ribs of a boat, was named *Shinu (To Die)*.[28]

Tange's plan for Peace Park, which was based on the layout of the ancient Ise Shrine, called for an immense memorial arch at the center. The proposed arch far exceeded the available budget, so with the mayor's approval, Tange asked Noguchi to design an alternative memorial structure. This was the greatest opportunity

47
48

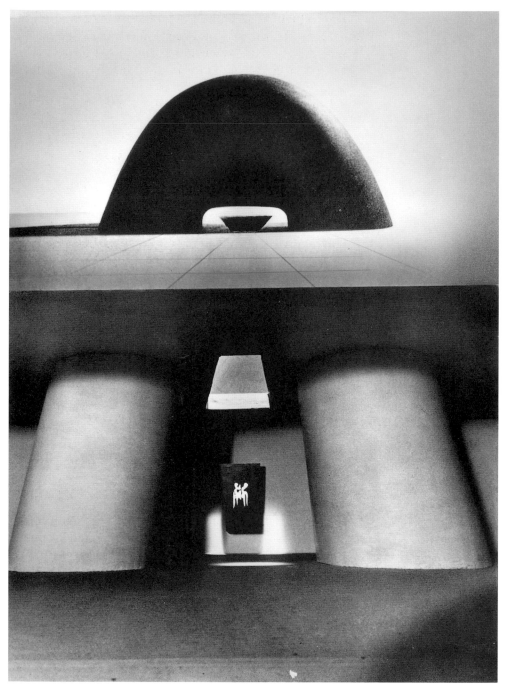

49

of Noguchi's career, and one of intense emotional resonance—as a returned Nisei seeking acceptance after abandonment by his Japanese father, as an American doing penance for his nation's atomic attack, and as a utopian modernist aspiring to put art to work in society. His Bollingen travels had been directed toward finding a way for sculpture to perform an integrative social function in a secular age, a role that it previously had served only in the context of religious belief. Creating his *Memorial to the Dead, Hiroshima* 49 offered Noguchi a chance both to achieve this public goal and to heal his early psychic wounds.

This challenge pushed Noguchi to the height of his powers, and working in Tange's office at Tokyo University he constructed a model rooted in both archaic and modern sources. The commission specified that there be an underground repository of names of those who had died in the atomic blast, and these he placed in a granite casket mounted on the wall in a dark room lit from above. (In a proud gesture, on its face Noguchi wrote in his own calligraphy the character *isamu*, Japanese for "courage."[29]) Framing this box were two huge pillars, subterranean extensions of the great black form above ground. This was a twenty-foot- (six-meter-) tall domed granite arch, whose shape referred to the roofs of *haniwa* mortuary models and to the nearby remains of a structure, the "Atomic Dome," that was the only sign of nuclear destruction to be permitted in the reconstructed city.[30] As he had in his ceramic works of 1930, Noguchi combined the archaic forms of prehistoric Japan with the formal reduction of modern sculpture. But now he did so on a monumental scale, applying the lessons of his unrealized earth projects to create a public sculpture that would memorialize, heal, and unify.

Sadly, at the last moment the Professional Committee for the Peace Memorial City Construction rejected Noguchi's design. The justification given was that the form was too abstract for the average person to pray to, but the real reason was that having an American create a monument to those who had died from an American bomb seemed wholly inappropriate. Tange was forced to throw together a small parabolic concrete shell in less than a week, so that a monument was ready for the August anniversary of the atomic attack. Noguchi, rejected once again, would not attempt another public project in Japan until the mid-1960s.

49. *Model for "Memorial to the Dead, Hiroshima,"* 1952
Plaster
Location unknown

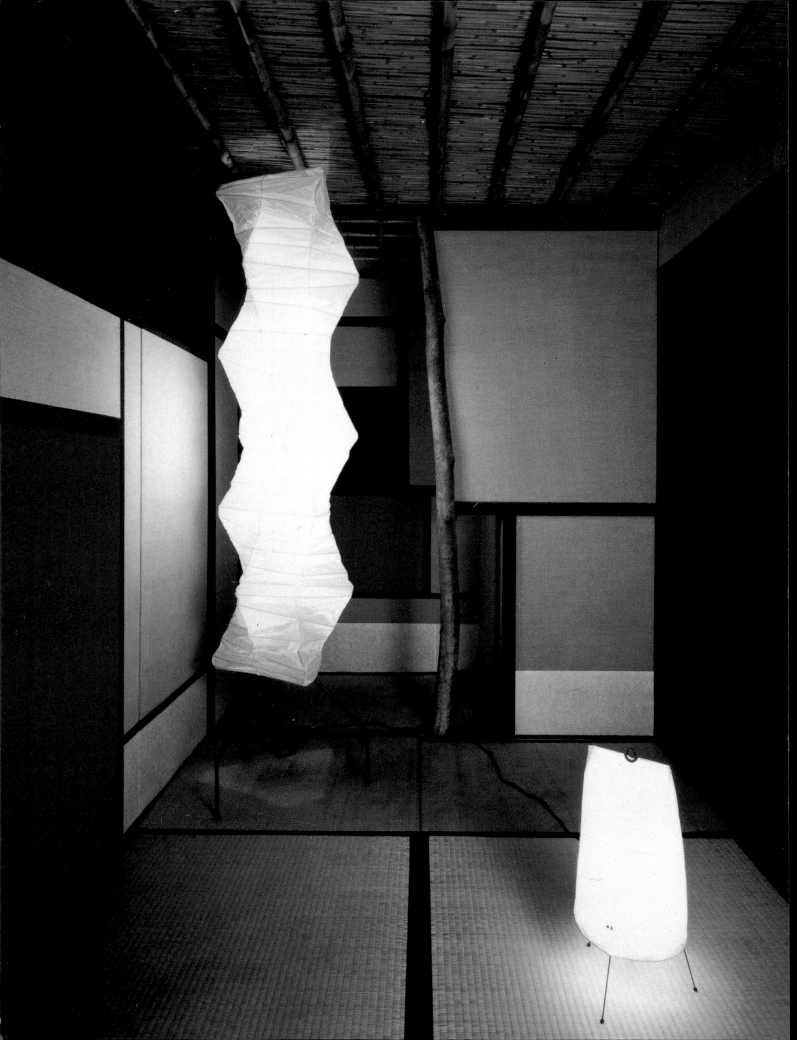

③ Search for Identity

When Noguchi's work was shown in the important Museum of Modern Art exhibition *Fourteen Americans* (1946), his catalog statement indicated a change in mood from his political disillusionment of the war years. Whereas he had written earlier of employing art for the betterment of society, now he addressed more inward needs: the "adjustment of the human psyche to chaos" and the "transfusion of human meaning into the encroaching void."[31] Like many other artists in the postwar period, Noguchi had moved from social to personal issues, seeking existential meaning from art in a world bereft of stable values.

Utilizing the Surrealist imagery of the émigré Europeans who spent the 1940s in New York, Noguchi directed his efforts toward making aesthetic objects intended to authenticate personal significance in the face of the meaningless. He called his MacDougal Alley studio an "oasis," and there he embraced the security of traditional carving, the honesty of immediate connection with stone that he had learned from Brancusi. Significantly, the first work that he made on returning to New York from Poston was an abstract carving in alabaster entitled *Leda* (1942), in which he reconnected with the ideals of Paris and of his Paris mentor. In this work, though, carving had a significance beyond its modernist association. Noguchi's mood at MacDougal Alley is indicated by his 1968 comment about another sculpture of this period, *Time Lock* (1944–45)—its image "locked against time's erosion."[32]

Although Noguchi worked some in nonclassical materials—driftwood collected in California, desert wood from Poston, string, feathers, plastic—for the most part he utilized stone. About 1944 he began the series of interlocking-slab constructions that was his major sculptural achievement of the decade. Noguchi started using slabs of marble and slate because those materials were inexpensive and readily available at the stone yards that supplied architectural facing. Working with these sheets of stone, which he cut with a power saw in his studio garden, allowed him to continue the formal experiments that he had initiated in Paris close to twenty years before. He combined stone slabs to generate three dimensions from

51, 52

50. *Akari,* 1985
Paper, bamboo, and metal
Installation designed by Arata Isozaki for
the exhibition *Noguchi: Space of Akari and
Stone,* organized by the Seibu Museum
of Art, Tokyo, 1985

51

planar elements, as he had done in his early works of brass plate,
12 and as in that first *Leda* (1928), he made the parts interlocking.
These new pieces, however, employed the biomorphism of the
European Surrealists, the most influential artists in New York at
the time.[33] In fact, James Johnson Sweeney reportedly refused to
52 acquire *Kouros* for the Museum of Modern Art because of its
resemblance to shapes in paintings by Yves Tanguy.[34]

But *Kouros* and its companions were anything but generic Sur-
realist sculptures. A hieratic figure almost ten feet (3 meters) tall,
whose elegant formality evokes the archaic Greek *kouroi* (frontal
male figures) of its title, *Kouros* also presents in three dimensions
the calligraphic imagery that Isamu had learned in childhood.[35]
And in addition to contemporary Surrealism, *Kouros* recalls the
spatial construction of Cubism (in which forms are completed in
the experience of the viewer), as well as Pablo Picasso's figures of
the late 1920s and early 1930s. Like Picasso, Noguchi would never
be able to completely escape the figure through abstraction, and
virtually all of his interlocking-slab sculptures are figurative. They
also are very fragile.

51. *Fish Face,* 1946
Black slate, height: 29¾ in. (75.6 cm)
Milly and Arne Glimcher

52. *Kouros,* 1945
Georgia marble, height: 117 in. (297.2 cm)
The Metropolitan Museum of Art, New York;
Fletcher Fund, 1953

53. *Table for A. Conger Goodyear,* 1939
Rosewood and glass, 30 x 84 in.
(76.2 x 213.4 cm)
Dr. Alexander Schure

52

53

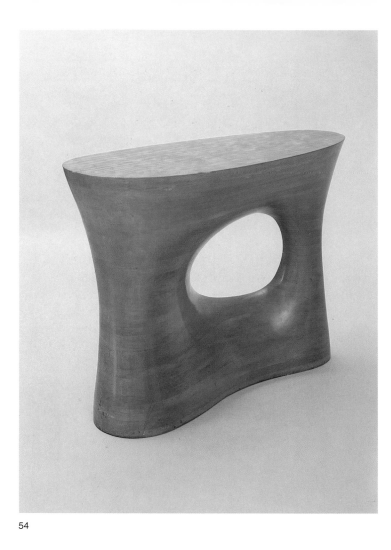

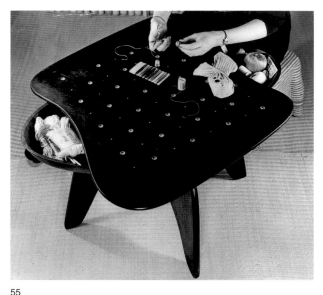

This fragility points to something common throughout Noguchi's career—the reinforcing of a given aspect of his work by both Japanese and Western concepts and precedents. Rather than being antagonists, these two influences often pushed him in the same direction and provided mutual support. In the interlocking-slab sculptures the embrace of the fragile in Japanese aesthetics, with its sense of the ephemeral nature of all things, is reinforced by, and reinforces, the existentialist ethos that dominated postwar intellectual life in Europe and America. Early expressions of the angst that would engender the gestural painting of the New York School (and, across the Atlantic, the lonely figures of Alberto Giacometti), these interlocking constructions were, for Noguchi, as poignant in their fragility as the cherry blossom.[36]

Biomorphism also dominated Noguchi's furniture designs of the 1940s, which would be seen by a much larger public.[37] In 1939 he
53 designed his first piece of furniture as a commission for A. Conger Goodyear, president of the Museum of Modern Art—a low glass-topped table with articulated rosewood supports. Simplified and transformed, by 1944 this design had become Noguchi's well-known biomorphic coffee table, which would be manufactured from 1947 by Herman Miller, Inc. Under George Nelson as director of design, Herman Miller also began producing other Noguchi pieces during the late 1940s—including a free-form sofa, three-legged tables and stools, and a chess table. Pushing biomorphism
55

54. *Table*, c. 1941
Laminated primavera wood, 30 x 41 x 16 in.
(76.2 x 104.1 x 40.6 cm)
Museum of Modern Art, New York; The Philip
L. Goodwin Collection

55. *Chess Table*, c. 1948
Manufactured by Herman Miller
Shown here in a publicity photo demonstrating
its use as a sewing table

56. *Lunar Infant*, 1944
Magnesite, electricity, and wood,
22 x 16 x 16 in. (55.9 x 40.6 x 40.6 cm)
The Isamu Noguchi Foundation, Long Island
City, New York

toward the baroque, Noguchi had designed this chess table and a set of clear plastic chess pieces for an exhibition at the Julien Levy Gallery. It rotated on a base of two curvaceous forms, exposing hidden pockets for chess pieces, with board positions indicated by alternating red and yellow inset disks. Late in life Noguchi downplayed his involvement with industrial design—stating that the Herman Miller glass-topped coffee table was his only success in the field—but during the 1940s he treated furniture design as part of his unified sculptural enterprise.

Although he designed only a single lamp during this period—a small, three-legged cylinder lamp manufactured by Knoll—Noguchi began working with light in what he called his "Lunars." He had initially envisioned illuminated sculpture in the 1933 *Musical Weathervane* proposal, but it was ten more years before he made his first light sculpture. Using the magnesite that he had discovered while making the Ford fountain, Noguchi molded undu- 35 lating forms over hidden light bulbs. His first such piece was *Lunar Landscape* (1944), a surreal wall relief across which were suspended small cork spheres. Some Lunars were hung on the wall or ceiling; others—like the delicate *Lunar Infant*—were freestanding. 56 He also created a number of Lunars meant to function as lighting

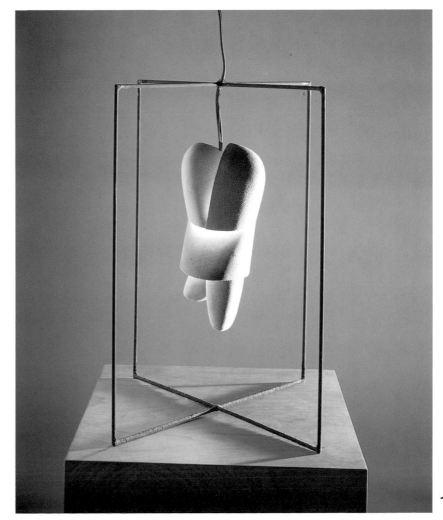

56

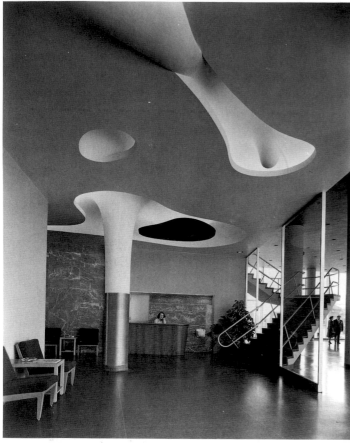

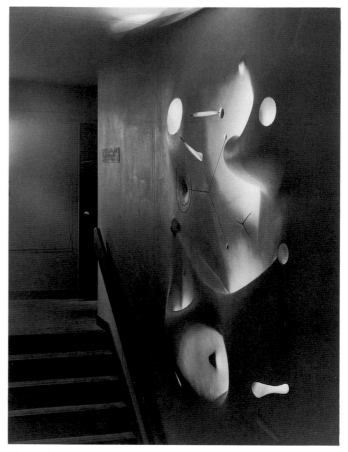

57

58

fixtures, three of which were offered as limited editions by Lightolier in 1952.[38] Most dramatic were the Lunar interiors that Noguchi designed in 1947–48. Unfortunately, only one of these survives, the lobby ceiling of the American Stove Company Building in Saint Louis.[39] The other two have been destroyed: the ceiling of a reception area in New York's old Time-Life Building and *Lunar Voyage,* a stairwell wall on the art-filled S.S. *Argentina,* which was scrapped with the rest of the ship in 1959.

After the Lunar interiors, Noguchi created one more large-scale wall-and-ceiling project: the waterfall wall and undulating lobby ceiling of 666 Fifth Avenue in New York, realized in 1956–58. The waterfall wall, based on a 1952 study for a Dallas bank, is a biomorphic structure of stainless-steel louvers placed before a cascade of falling water. Set in a pedestrian walkway linking Fifty-second and Fifty-third streets, the site is inconspicuous despite its proximity to the Museum of Modern Art. The lack of visual fanfare makes this artwork especially effective, knitting it into the fabric of the city as are few other pieces of public art.

By this time, however, Noguchi's aspirations had moved into the landscape. Central to his 1949 Egan Gallery exhibition was the large marble sculpture *Night Land* (1947), whose diagonal tilt poised it ambiguously between landscape model and aesthetic object. Noguchi's remark in an article published that month suggests which way he was tending: "If sculpture is the rock, it is also the space between the rock and a man, and the communication

57. Ceiling for American Stove Company Building, Saint Louis, 1947

58. *Lunar Voyage,* 1948
Stairwell wall on the S.S. *Argentina*
Destroyed in 1959

59. *Wall for 666 Fifth Avenue,* 1956–58
Stainless-steel louvers, height: 12 ft. (3.7 m)
666 Fifth Avenue, New York

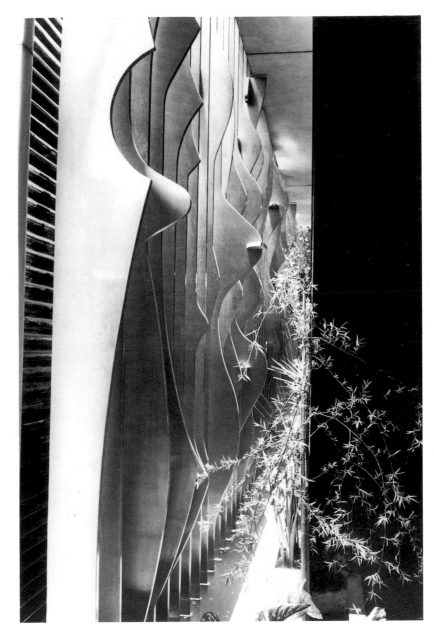

59

and contemplation between."[40] The monumental and architectural spaces that he visited over the next two years on his Bollingen-funded trip would confirm this direction and returning to Japan in 1950 offered opportunity for its expression.

The first project on which Noguchi embarked in Tokyo was a very personal one—a faculty room and garden commissioned as a memorial to his father at Keiō University. (Yone had died in the summer of 1947, after teaching at the university for forty years.) The campus had been severely damaged in the war, and Isamu collaborated with the architect Yoshirō Taniguchi on the reconstruction of a building known as Shin Banraisha (New Building of Welcome). During two weeks of concentrated work, Noguchi designed spaces intended, he wrote, to create a meditative environment akin to that of the classical house and garden of Shisendo in Kyoto.[41] The most prominent feature of the memorial room is a 60

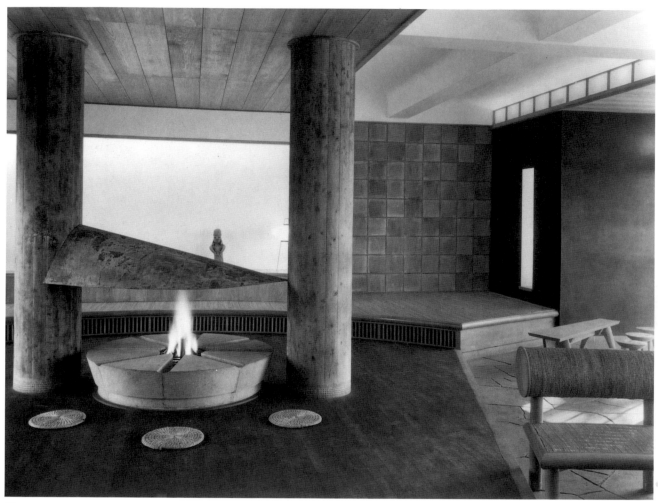

60

round stone hearth placed between two large concrete pillars and covered by an abstract curved metal hood. To one side an ancient bronze bell and a ceramic *haniwa* figure sit on a long recessed shelf, next to a wall of textured brown Bizen tiles. On a stone floor adjacent to the garden is an area of simple wooden furnishings designed by Noguchi: a long oval table with elegant rope-wrapped benches, a hanging light fixture with the bentwood construction of a traditional Japanese kitchen sieve, and a gracefully primitive bench with accompanying three-legged stools.

61 In the small garden—the first garden that Noguchi attempted— are set three sculptures, each in a different style. One is *Wakai Hito (Young Man),* a plate-metal figure of interlocking biomorphic elements, fabricated at half its intended height of twelve feet (3.7 meters). Another is the thirteen-and-a-half foot- (4.1-meter-) tall *Gakusei (Student),* a geometric figurative construction of steel rods.

107 Most striking is the cast-stone *Mu,* named for the Buddhist concept

60. Memorial room, Shin Banraisha (New Building of Welcome), 1951–52 Keiō University, Tokyo

61. Detail of garden, Shin Banraisha, 1951–52 Keiō University, Tokyo *Mu* is at top.

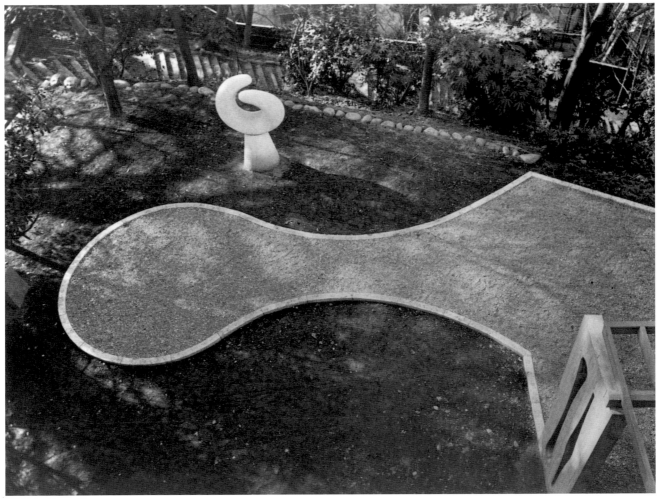

61

of nothingness. A seminal work of postwar sculpture, it was ridiculed, in the best avant-garde tradition, by university critics as resembling a half-eaten donut.

In August 1950 the models for the university room and garden, with some of the furniture and two of the sculptures, were exhibited in Tokyo at the Mitsukoshi department store, in an installation designed by Taniguchi. Noguchi had been invited by an artists' association to show large photographs of his earlier work, but with typical ambition—and desire to impress—he decided that he must have a real exhibition of completely new work. In five frantic weeks he created it all, including the work for Keiō and the model for the Hiroshima memorial bell tower. One week in a ceramics center at Seto yielded ten abstract and figurative pieces. The exhibition also contained Noguchi's frames for abstract paintings by three friends, shown to demonstrate the possibility of modern display in traditional *tokonoma* alcoves. Well received in the critical

press, the show suggested to young artists the variety of what could be achieved in abstract sculpture. For Noguchi, it was an attempt to indicate "the necessity of reuniting art and life."[42]

The Mitsukoshi show also included a chair with a woven-bamboo seat and backrest. Noguchi designed this piece for export, with the bamboo elements—produced in the same way as traditional fish baskets—to be fabricated in Japan and shipped to the United States. There they would be attached to bent-metal frames manufactured in America. The chair remained a unique prototype, but the next year Noguchi was able to realize his ambition of encouraging local production through the export of modern design.

It was on the way to Hiroshima to discuss his bridge proposal that Noguchi first visited the town of Gifu, known for its manu-

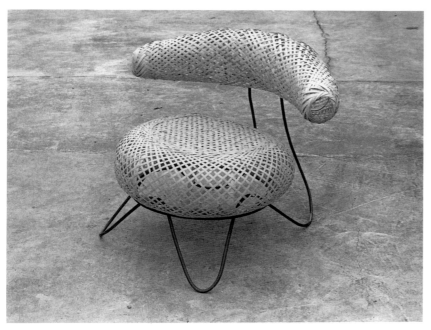

62

facture of umbrellas and lanterns from mulberry-bark paper. Having heard of his design work, the mayor asked him to create contemporary lamps using the traditional paper-and-bamboo construction. That evening Noguchi sketched his first two Akari (the word means "light as illumination") light sculptures, transforming his Lunars into a new mode that looked as much like the 1950s as the Lunars had the 1940s.[43] By electrifying the traditional lanterns and by developing an internal metal frame that allowed these collapsible objects to remain freestanding, Noguchi devised a lighting form that allowed for great variation in shape and size. He viewed each Akari as basically two sculptures, one when light was reflected off it, and another when light was emitted from it. The Akari also had a metaphysical dimension for Noguchi; for him, their essence as light—in the sense both of illumination and of weightlessness—"questions materiality, and is consonant with our appreciation today of the less thingness of things, the less encumbered perceptions."[44] Uniting fine and applied art even more effec-

62. *Chair*, c. 1950
Bamboo and iron
Location unknown

63. *Akari*, early 1950s
Paper, bamboo, and metal

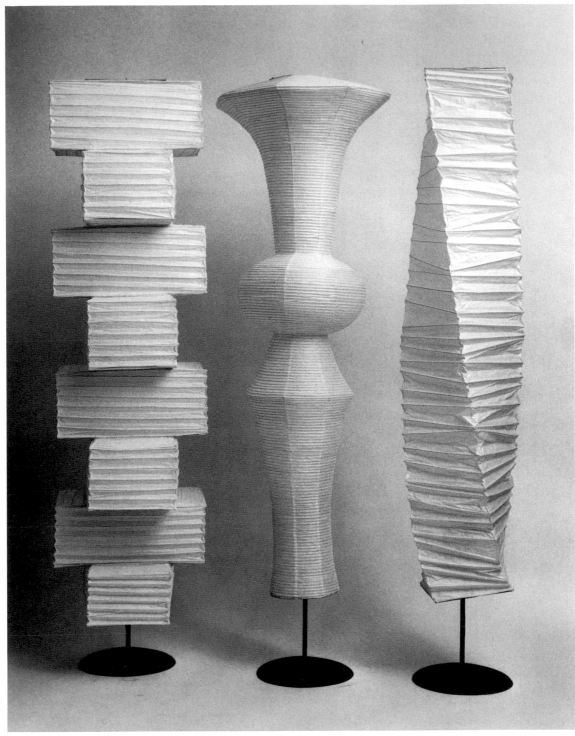

63

tively than had his furniture of the 1940s, they were meant to be inexpensive and therefore available to a wide audience. New designs were produced regularly for over three decades, their shapes changing with Noguchi's sculptural concerns. Shown and sold in Japan starting in 1952, Akari were exported and widely exhibited internationally by 1955. Currently there are over one hundred models available, still manufactured in Gifu by the firm that began production in the early 1950s.

By the time Akari production began, Noguchi was married to

50, 63

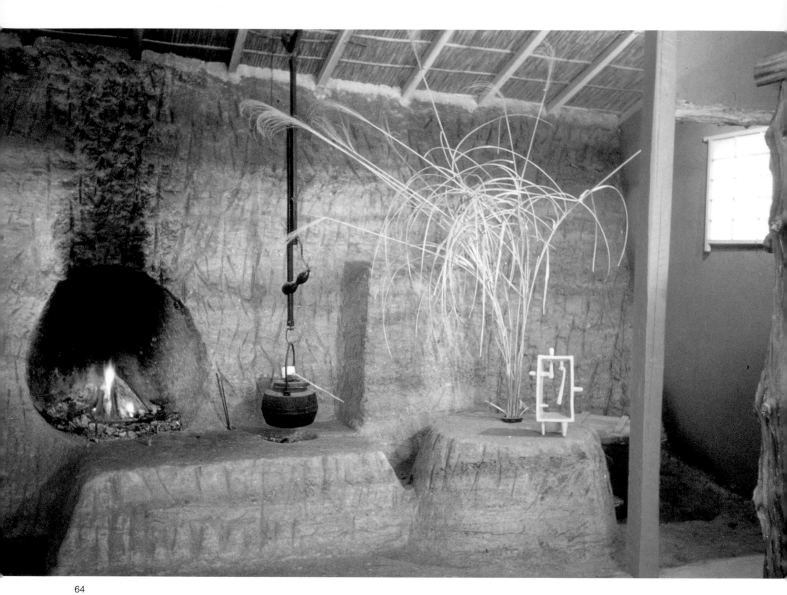

64

64. Noguchi's house and studio, Kita Kamakura, Japan, 1952

65. *1950 No Kodomo (1950s Child),* 1950
Red terra-cotta and wood, height: 18 in. (45.7 cm)
Location unknown

65

the most famous Japanese movie star of the time, Shirley Yama-
guchi. They had met in New York in the fall of 1950, and a year
and a half later their elaborate Tokyo wedding ceremony was a
major media event. For their first real home, the distinguished pot-
ter Kitaoji Rosanjin gave them the use of a two-hundred-year-old
farmhouse in a lovely rice valley in Kita Kamakura. Here Noguchi
embraced the style of old Japan with a vengeance. With a local car-
penter he built a small studio on stilts alongside the house, cutting 64
into the hillside to form a striking earthen wall and fireplace. A rus-
tic but very elegant evocation of peasant life, the studio and house
were featured in the American press.[45]

In this sophisticated mix of nostalgia and modernism—alongside
the mud wall was a wooden column painted bright red—Noguchi
attempted to overcome his father's rejection by re-creating him-
self as Japanese. As an acquaintance noted, in Kita Kamakura
he pursued his vision of a traditional way of life "with insane

perfectionism."[46] Photographs of Isamu and Shirley show them clad in kimonos, with Shirley in the rough wood-and-straw *zori* that he insisted she wear even when they made her feet bleed. To Western eyes this house and mode of life appeared archetypally Japanese, but to Japanese visitors it seemed a bizarre exercise in exoticism that had little to do with postwar Japan.[47]

Along with his modern projects in Tokyo and Hiroshima, Noguchi spent the summer of 1952 working in clay. Using Rosanjin's nearby kiln and traveling south to work with the dark Bizen clay, Noguchi returned to this traditional form as part of his assertion of Japanese identity. But the results were not entirely traditional, and they elicited strong reactions at his show that September, the second one-person exhibition to be held in the new International Style building of the Museum of Modern Art, Kamakura. The exhibition, as was typical for Noguchi, resulted from an intense period of work, and it was a tour de force of 119 ceramic pieces in a wide variety of styles (Seto, Shigaraki, Bizen, Karatsu, and Kasama).[48] Ranging from functional flatware, tea bowls, and vases to freestanding sculptures, these ceramics manifested a spontaneity and humor rarely seen in his work.

Although the relationship between Noguchi's sculpture of the 1940s and Surrealism was a matter of biomorphic form rather than the use of chance—as in the work of many of his peers—quite a few of the Kamakura sculptures exemplify the unplanned and the spontaneous. Certainly this had much to do with the characteristics of clay as a medium made unpredictable by its viscous state and by the contingencies of firing and glazing. But it also reveals the freedom that Noguchi felt to improvise and to accept the happy results of accident. Here again was a confluence of Asian and Western art, for these ceramic sculptures relate to the improvisational gesture that characterized contemporary New York School painting, although Noguchi's gesture at this moment was an uncharacteristic one of joyful exuberance rather than existential distress. It is not surprising that the dealer Eleanor Ward made the connection, for her New York gallery hosted the yearly salon of gestural abstraction, the Stable Annual. The ceramic pieces that did not sell in Japan were shipped to New York and exhibited at the Stable Gallery in 1954.

Although these sculptures received strong praise from the eminent Rosanjin, a number of progressive Japanese artists were more mixed in their reactions. Noguchi's reliance on traditional forms and materials seemed, like his Kita Kamakura studio, a romantic obsession with the exotic. To many, these pieces appeared too "Japanese" to be Japanese.[49] Rather than the emergence of Noguchi's essential Japanese nature, they were thought to display a distinctly Western fascination with old Japan. Finally feeling at home, Noguchi was again confronted with the irony that always had marked his homelessness—in Japan he was viewed as an American, and in America he was treated as Japanese.

Now married to a Japanese woman and having built a Japanese studio, Noguchi found himself without the acceptance of his new community. His design for the Hiroshima cenotaph had just been

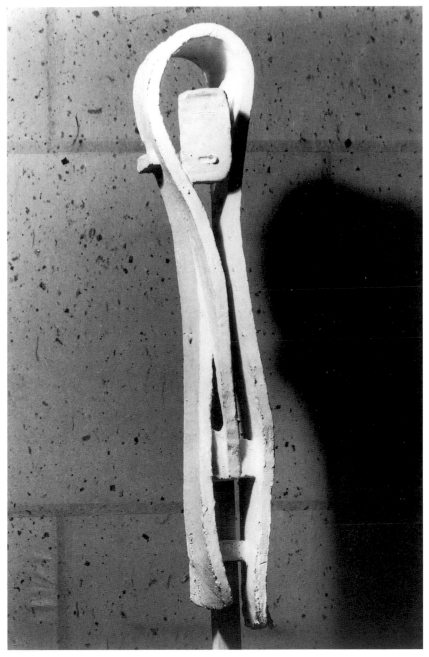

66

66. *Mrs. White,* 1952
Shigaraki ceramic, 42¼ x 9½ x 8⅞ in.
(107.3 x 24.1 x 22.6 cm)
The Isamu Noguchi Foundation, Long Island
City, New York

rejected, and his new ceramic work was meeting resistance. Within months his marriage would run into difficulty, when Yamaguchi was denied a United States visa because her casual contacts with some blacklisted Hollywood figures had put her under suspicion of Communist affiliation.[50] At the same time Noguchi embarked on a peripatetic course, engaged in an enterprise prompted by his earlier Bollingen-funded travels. In a statement written for the Kamakura exhibition he pointed beyond "the museum conscious pedestal and its false horizons": "The sculpture I have in mind has to do with walking man . . . and his leisure. It seeks to give an order and significance to living. Against the rising chaos—how to catch the tones of existence and give it shape?—a fence against the dark?"[51] He would find the answer to this question in the garden.

The Sculpture of Spaces

Because Noguchi had incorporated social concerns in the form and not only in the subject matter of his work during the 1930s, he was able to readily reengage such issues after the war. In this he took a very different tack than his New York School colleagues such as David Smith and Willem de Kooning, whose moves into abstraction remained focused on aesthetic matters. Of course this had something to do with financial survival, for Noguchi had difficulties with art dealers and was successful in the world of architecture and design, though his income in these areas was modest.[52] Yet even though his status within the community of artists suffered from his design work outside the studio, for Noguchi, the creation of public spaces and useful objects was essential to his new conception of sculpture.

Noguchi's notion of sculpture had evolved since its origin in the 1930s, enriched by his work in stage design and by his tour of the great public spaces of the premodern world. Early on, Fuller's lecturing had inculcated in him an environmental perspective as well as a commitment to science and technology. After his political faith was shaken during the war, he needed a new context for such holism, which was supplied by a form of existentialist conviction. For Noguchi, in the chaotic void of the modern world—a world without religion and threatened with nuclear destruction—meaning must be created, and its creation required spaces that would encourage social ritual. The structuring of those spaces was to be the new calling of sculpture, and its reigning metaphor was the garden.

It is no surprise that Japan provided the first opportunity for Noguchi to give form to these ideas. In addition to the small garden at Keiō University, in 1951 he proposed a garden to architect Antonin Raymond for the new Tokyo building of Reader's Digest, prestigiously located across from the Imperial Palace. Constructed with funds saved by eliminating part of a cement parking lot, Noguchi's modest effort features minimal landscaping—shaped areas of grass and a pile of stones—along with a tall metal fountain-sculpture above a pool of water circulated from the heat pump. It was here that Noguchi first worked with traditional

61

68

68

Japanese gardeners, who introduced him to attitudes toward stone that would play an important role in his subsequent work, both gardens and individual sculptures. The experience was to be especially useful five years later in his first major landscape project, the gardens for UNESCO (United Nations Educational Scientific and Cultural Organization) headquarters in Paris.

The UNESCO project began relatively small, but Noguchi successfully pressed for a significant increase in its scale and scope, as would be his frequent practice. In the fall of 1956 the architect Marcel Breuer proposed Noguchi for the design of a Delegates' Patio alongside his new secretariat building. After visiting the site and noticing an adjacent lower area where a Calder mobile was to be placed, Noguchi gradually convinced UNESCO officials to construct a full-scale garden, to be known as the *Jardin Japonais*. His project would eventually bring gardeners, plantings, and eighty-eight tons (80 metric tons) of stone from Japan, and it engaged Noguchi in two spheres that would preoccupy him during the next thirty years—the operational and bureaucratic complexities of a major construction project and the aesthetic and metaphysical dimensions of the Japanese garden.

Although Noguchi's *Jardin Japonais* contains such traditional elements as *tobi-ishi* (stepping-stones) traversing a pond, a *hōrai* (symbolic sacred mountain) with large natural stones, and two old *chozubachi* (water basins), along with trees imported from Japan, it is by no means a standard Japanese garden. In fact, during its construction he argued constantly with the master gardener who

68. Detail of garden for Reader's Digest Building, Tokyo, 1951
Destroyed

69. *Model for Delegates' Patio*, UNESCO Headquarters, Paris, 1956–58
Location unknown

came from Kyoto to assist him, as Noguchi broke rule after rule of traditional garden design. In addition to general expressions of his Western sensibility—needing to fill every empty space, insisting on the prominent display of his sculptural elements—the overall plan of the garden employs the curvaceous forms of the 1940s.[53] It uses the Japanese tradition of the ambulatory garden, meant to be experienced through movement and changing points of view, but its outlines are biomorphic—an appropriate approach for Paris, the birthplace of Surrealism.

Another Parisian reference is a more personal one: the seating that Noguchi designed for his Delegates' Patio pays homage to Brancusi, who died while Noguchi was working on the project, in March 1957. Grouped asymmetrically, these simple cylindrical and cubic forms encapsulate Noguchi's aesthetic more than any other part of the garden, utilizing Brancusian imagery to create a modern setting for the tea ceremony. The centerpiece of the patio, however, directly evokes Japan, situated at the top of the long ramp leading up from the *Jardin Japonais*. Here a tall "source stone" is set in a rectangular pool, with water cascading over Noguchi's mirror-image calligraphy for *peace* (*heiwa*).[54]

With great effort Noguchi raised the funds to buy all of the stones in Japan, going to consult with the master garden designer Mirei Shigemori in Kyoto. Shigemori took him to the island of Shikoku, where Noguchi would later establish a studio and create the major granite and basalt works of his last two decades. In a

69

70

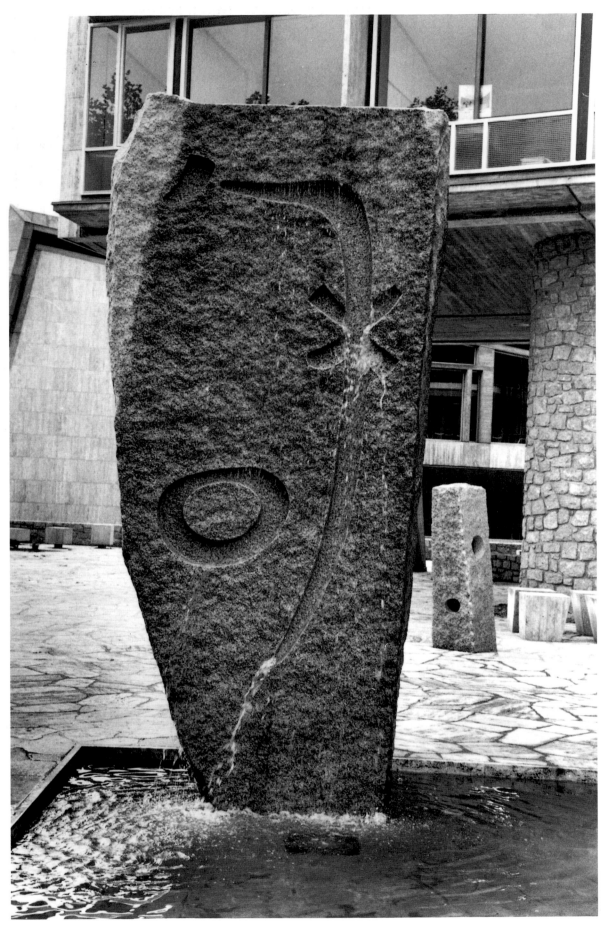

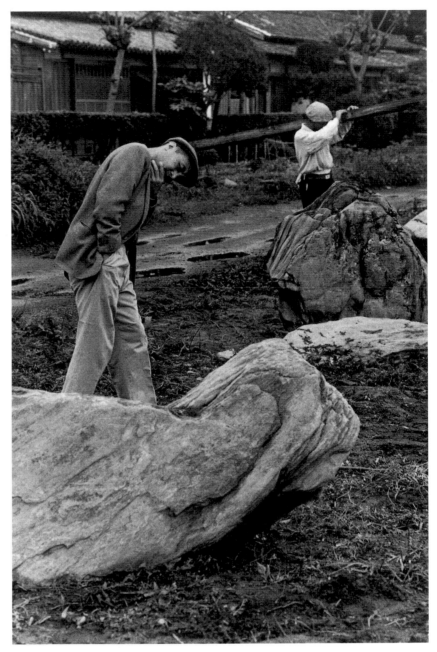

71

70. *Waterfall Rock,* Delegates' Patio,
UNESCO Headquarters, Paris, 1958

71. Noguchi with stones for the UNESCO
Headquarters garden, in Tokushima, Japan,
c. 1957

mountain river Noguchi selected great stones in nature for the first time, an activity that later became a passion. Using a scale model of the UNESCO site, Noguchi tested his arrangement of natural stones in the city of Tokushima on Shikoku before shipping them off to Paris. The quarrying and carving of the sculptural pieces was also done in Japan, giving Noguchi significant experience in working with craftsmen who knew stone as did few others. Equally important was his serious study of Zen garden theory, which designates the centrality of rocks as the "bones" of the garden and the secondary nature of the plantings—a metaphor for the relationship between permanence and transience in nature.[55] Not only would these concepts play into his subsequent garden designs, but they also point toward Noguchi's late evocations in basalt and granite of geological, historical, and experiential time.

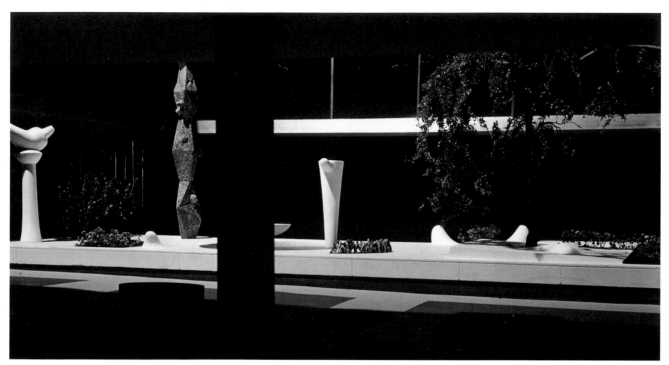

72

Apart from UNESCO's *Jardin Japonais,* Noguchi's gardens
rarely were Japanese in feel, and his ideas regarding public space
were realized primarily in the American corporate mode. It was
during the great postwar construction boom that he gained access
to corporate capital, access that allowed him to embody dreams
born in the leftist 1930s. In this, his first and most important
patron was Gordon Bunshaft, chief architect of Skidmore, Owings
and Merrill.

Bunshaft initially approached Noguchi late in 1951 to redesign
the outdoor court and seating areas of the new Lever Brothers
building on Park Avenue, Lever House. Noguchi proposed to cover
with marble a large rectangular area meant for plantings, leaving
just two small beds for plants and adding a circular pool. In
1952–53 he created two designs for this project, each placing
sculptural elements both in the pool and on the marble stage. Nei-
ther of these theaters for sculpture was realized, but Noguchi later
recycled some of the elements as independent works.

His first successful project with Bunshaft was the design of four
interior courts and one long plaza for the rural headquarters of the

72. Detail of *Model for Lever House Garden,*
New York, 1952

73. *The Family,* 1956–57
Granite, 3 elements, heights: 16, 12, and 6 ft.
(4.9, 3.7, 1.8 m)
CIGNA Corporation (formerly Connecticut
General Life Insurance Company)
Bloomfield, Connecticut

72

70

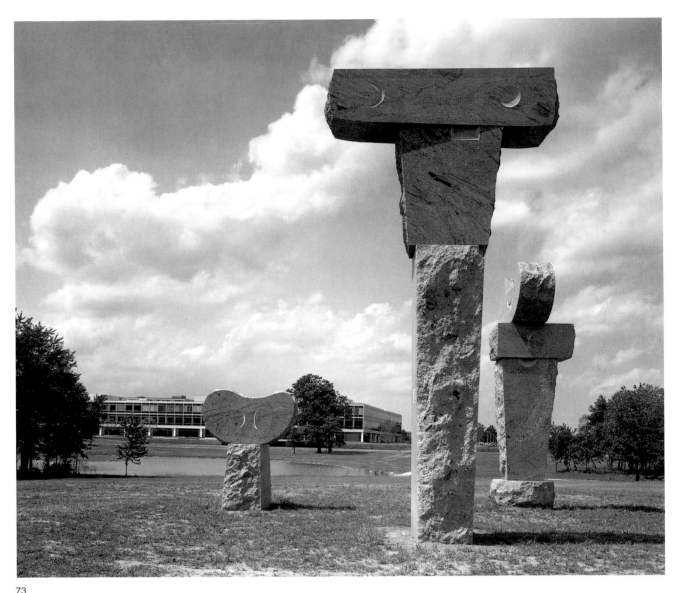

73

Connecticut General Life Insurance Company (now CIGNA Corporation). In three courtyards Noguchi employed elements also used at UNESCO, which he began the same year: ground plans with biomorphic curves, punctuated by *tobi-ishi*—stepping-stones originally devised to control the pace and visual perspective of those moving through small gardens toward the tea ceremony. The other court and the plaza featured patterns of rectangular forms that evoked both the checkerboard wall at the Katsura Imperial Villa in Kyoto and the corporate International Style of Bunshaft. The model for the plaza includes a number of large sculptures, but as Noguchi worked on these pieces they grew in size until their scale no longer fit the site. A decision was made to try placing them across a pond far from the building, where they became the best-known feature of the project—three granite totems known as *The Family.* 73

In 1964 Noguchi worked with Bunshaft on two courtyard gardens for the new IBM Headquarters in Armonk, New York. Set on either side of the glass escalator bank that divides the building, these symbolic gardens are entirely different in feel from one

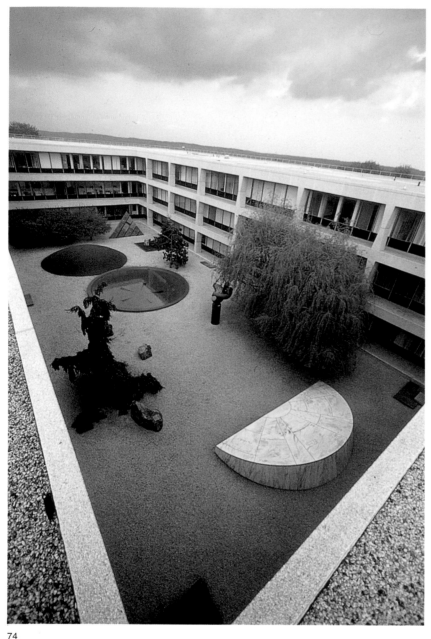

74

another. One court represents the past with a meditative natural garden. A quiet pool is set in a condensed landscape of grass and raked gravel, with an elegant placement of rocks that Noguchi recycled from the excavation of the parking lot. The other court is a more austere garden that denotes the future—the future as science. On this open gravel plane sit a black pyramid representing an atomic pile, a red concave fountain like the dish of a radio telescope, a low black dome, and a marble curve incised with characters from celestial mechanics and nuclear physics. Nearby stands a Noguchi sculpture abstractly representing a double helix, placed there at the insistence of Bunshaft, who also added trees to which the sculptor objected.

The scientific garden at IBM illustrates an important aspect of Noguchi's work: the appropriation of forms from other cultures and, occasionally, from other artists. In addition to his early Bran-

74. Garden for IBM Headquarters, 1964
Armonk, New York

75. *Model for Jefferson Memorial Park,*
Saint Louis, 1945
Designed in collaboration with Edward Durrell Stone
Plaster
Location unknown

cusi-like sculptures, which display the imitation of a youthful acolyte, Noguchi expanded the two-dimensional imagery of the Surrealist painters to three dimensions in his interlocking works of the 1940s, and he later played a number of variations on Brancusi's *Endless Column*. More often, however, he adopted forms from non-Western sources in his gardens and landscapes. The clearest example of this at IBM is the Egyptian pyramid, which Noguchi had initially used in his first proposal for an earthwork, *Monument to the Plow* (1933). A more obscure reference is the form of the IBM fountain, which was derived from an immense astronomical instrument at the eighteenth-century observatory created by Maharajah Jai Singh at Jaipur, India. Noguchi had visited the observatory on his Bollingen travels, and it is difficult to imagine a place more likely to incite his enthusiasm than this array of huge stone instruments—a monumental public space of stone that combines science, ritual, and abstract formal elegance.[56] An even more evocative use of premodern imagery can be seen in another project, Noguchi's abstraction of Ohio's Great Serpent Mound in his

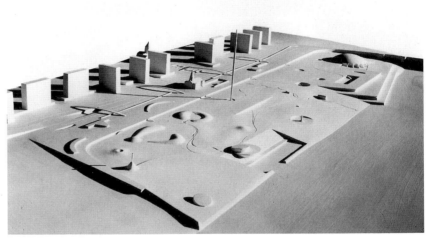

75

unsuccessful 1945 proposal, with architect Edward Durrell Stone, for Jefferson Memorial Park in Saint Louis.

More interesting than his appropriation of particular images, however, is Noguchi's transformation of an entire architectural form, the enclosed Zen meditation garden. Epitomized by Ryō-anji—whose raked white sand and subtle positioning of fifteen rocks make it for many the most sublime of Kyoto sites—these gardens are viewed from outside and are not to be entered. During the early 1960s Noguchi utilized this basic concept in two sunken gardens created simultaneously for Bunshaft projects, one at the Beinecke Rare Book and Manuscript Library of Yale University, and the other at New York's Chase Manhattan Bank Plaza. Both are designed to be seen from two levels, each constituting, in a way, a pair of works. But these are two very different creations, set in two very different contexts.

In the white marble garden at the Beinecke library, Noguchi exercised the symbolic imagination that had brought him such success with Martha Graham. Originally intending a variant on the white sand mounds often featured in Zen contemplation gardens, he modified this initial conception to create another kind of purist space featuring three symbolic forms. Now his thoughts moved to Jai Singh's astronomical gardens, with their geometrical instruments evoking the cosmos, and to the patterned pavements of the Italian piazza. Conceived as a single sculpture, the Beinecke's three elements rest on a floor incised with lines that allude to both astronomical pattern and the modernist grid. A low pyramid represents the earth, or matter; a circular form symbolizes the sun, or pure energy, viewed as the source of all life. For Noguchi the meaning of the Beinecke elements was multiple, and he wrote that the circular form also represents "the zero of nothingness from which we come, to which we return," as well as youth's questioning, to which education is dedicated. The product of ten studies done between 1959 and 1964 (the year of the garden's completion), the Beinecke sun developed into a series of sculptures that culminated in the large *Black Sun* carved for the Seattle Art Museum. The third element at the Beinecke, a cube on its end, symbolizes the human condition—ruled by chance, like the roll of the die—and man's interaction with nature through material, science, and technology. When

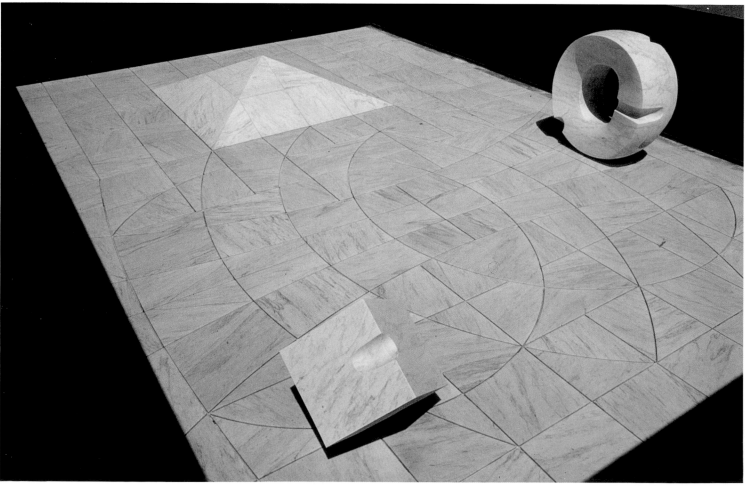

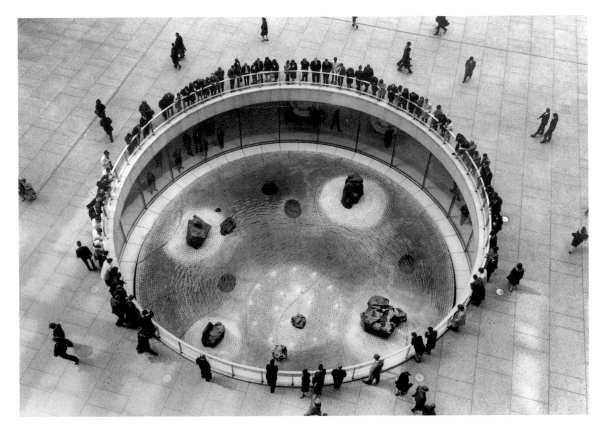

77

seen from the reading room around the garden, these forms rise from the floor as great sculptures; viewed through the frame of the balustrade above, the whole is a cosmic tableau—a "drama," the artist would intone, "being silently enacted, inexorably."[57]

Noguchi maintained an equally romantic view of his circular water garden for the Chase Manhattan Bank Plaza, which he referred to as "my Ryōanji." This subterranean space sits within bank offices below a pedestrian plaza in downtown Manhattan. Noguchi placed seven large stones asymmetrically on an undulating bed of granite blocks, sixty feet (eighteen meters) in diameter. He had fished the stones from the Uji River near Kyoto, on an enthusiastic excursion begun before obtaining Chase approval for the project. When permission was delayed, he lost the greatest of the stones and had to exert all of his influence to buy it back. As at the Beinecke, the scene below is radically different from that above, and it equally changes with the itinerant perspective of the viewer. But there also is a seasonal difference, as the dry winter garden becomes wet and active in the summer, with recessed jets spouting water that plays around the exotic river stones.

Noguchi wrote of the marble garden at the Beinecke that "its size is fictive, of infinite space or cloistered containment." In the

77

76. *Sunken Garden for Beinecke Rare Book and Manuscript Library,* 1960–64
Yale University, New Haven, Connecticut

77. *Sunken Garden for Chase Manhattan Bank Plaza,* 1961–64
New York

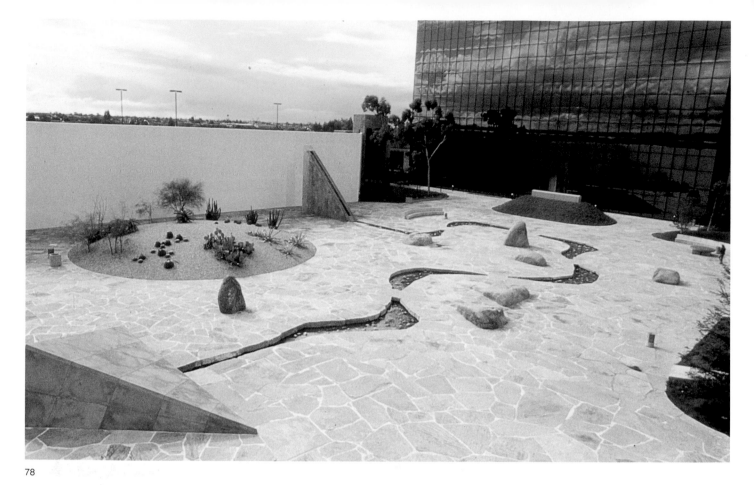

78

early 1980s he built another symbolic garden that achieved an even
more impressive spatial concentration—more impressive because
the illusion is maintained as one walks through the garden. *Cali-
fornia Scenario* transforms a 1.6-acre (.65-hectare) plot within an
Orange County mall into a Western version of the miniaturized
landscapes of the Zen garden. The garden contains seven elements
that represent the topographic diversity of California, the most
dramatic being a twelve-foot (3.7-meter) pile of fitted granite boul-
ders entitled *Spirit of the Lima Bean,* named to honor the crop that
had once covered the land of Noguchi's patron for this garden, the
developer Henry Segerstrom. The disposition of these symbolic ele-
ments creates a secluded meditative space, bordered in a surreal
way by two glass office towers and the blank white walls of a
parking garage. Beginning small, as with UNESCO, Noguchi con-
vinced Segerstrom to go far beyond the single fountain that he
originally proposed, eventually creating one of his most successful
ambulatory gardens.

By allowing the viewer to circumambulate his updated contem-
plation gardens at Yale and in lower Manhattan, Noguchi trans-
formed that largely static form into a dynamic one, providing
pictorial change through movement. The other Japanese garden
tradition, that of the ambulatory garden, is based on this principle
of changing perspective and physical engagement with the land-
scape, and its use enabled Noguchi to build on his extensive expe-
rience with the theater, where movement is programmed through
sculpted space. His greatest achievement in this form is the garden
that meant the most to him, *The Billy Rose Sculpture Garden* at
the Israel Museum in Jerusalem.

78. *California Scenario,* 1980–82
Two Town Center, South Coast Plaza,
Costa Mesa, California

79, 80. *The Billy Rose Sculpture Garden,*
1960–65
Israel Museum, Jerusalem

Noguchi began work on this project about the same time that he started the Beinecke and Chase gardens, but after his first visit to Jerusalem in January 1961 he was engaged in a more personal way. He was immediately enthralled with the dramatic site on a barren hill overlooking the city, a response intensified by his identification with the Jews and their homelessness. He has stated that the Jew is like the artist, a "continuously expatriated person who really does not belong anywhere."[58] That connection, however, had more private meaning for Noguchi, whose memories of early rejection were reinforced by his failure to find full acceptance in either America or Japan.

The Jerusalem project also gave Noguchi an opportunity to sculpt the earth on a grand scale, bringing him as close as he would ever come to realizing his dreams of 1933. To display the theatrical producer Billy Rose's collection of twentieth-century sculpture, he designed a monumental series of five curved retaining walls. The 79

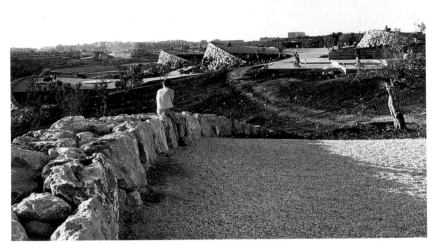

79

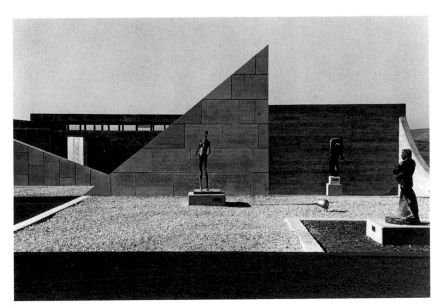

80

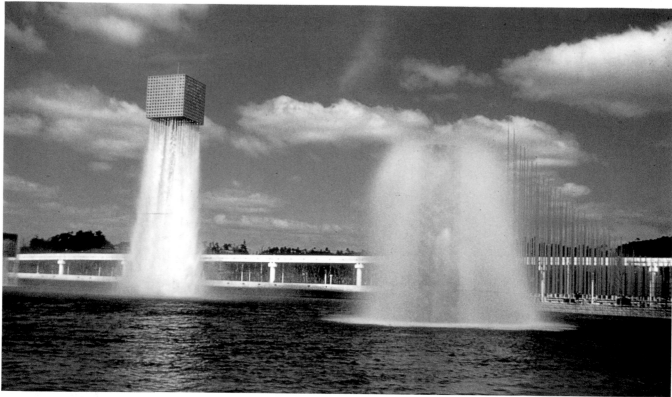

81

top of each curve was gently sloped, dramatically placing sculpture against the hills and sky. As at IBM, Noguchi used the rock exposed in construction, building his walls and paving a hill with the rough local stone. On top of this hill he set a long carved fountain, compressing to a horizontal format his use, at UNESCO, of water flowing down the face of hewn stone. This fountain developed into the series that Noguchi later carved in Japan: six granite fountains made for the Supreme Court Building in Tokyo and the rough basalt fountains at his museum in Long Island City and at the Metropolitan Museum of Art, New York.

When it became clear that many of Rose's sculptures would be dwarfed by the great spaces that Noguchi had created, he designed a more intimate area of concrete walls whose geometry provides a transition from the rectilinear museum building to the asymmetrical curves of earth and stone. But for Noguchi, the essence of this garden was the earthwork curves and the landscaping that choreographed visual and bodily movement, "a sculpture fifty meters high, twenty dunams (five acres) wide, weighing a million tons. . . . a piece of the earth itself, extending all the way to China."[59]

Although he had built eight corporate and institutional gardens by 1965, Noguchi still sought to realize a great public space on the same scale as those of the premodern world, an urban space for social interaction. Certainly he had created a number of public sculptures in large cities, including an inverted steel torii in front of the National Museum of Modern Art, Tokyo, and *Red Cube*—a rhomboid variation of the Beinecke cube, around the corner from his sunken water garden in New York. But these single works were not social spaces. In 1971 an invitation came from Detroit to

82

81. *Fountains for Expo 70*, 1970
Stainless steel
Osaka, Japan

82. *Red Cube*, 1968
Painted steel, height: 24 ft. (7.3 m)
Marine Midland Bank Building, New York

83. *Horace E. Dodge Fountain*, 1972–79
Philip A. Hart Plaza, Detroit

83

design a fountain for Philip A. Hart Plaza, Noguchi's name having been proposed after a member of the selection committee saw his nine playful fountains commissioned by Kenzo Tange for Expo 81 70 in Osaka. The budget was immense—two million dollars— prompting Noguchi's ambitious, futuristic design for the computer-controlled *Horace E. Dodge Fountain*, the largest expression of his 83 desire to employ water as a sculptural medium.[60] Most important,

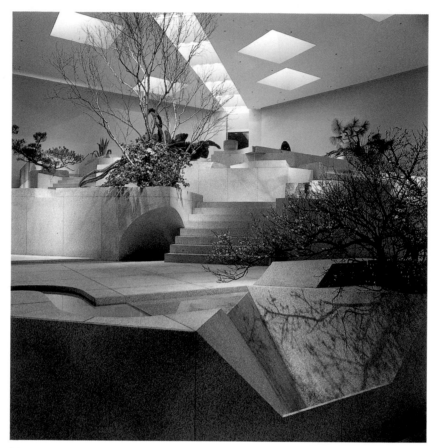

84

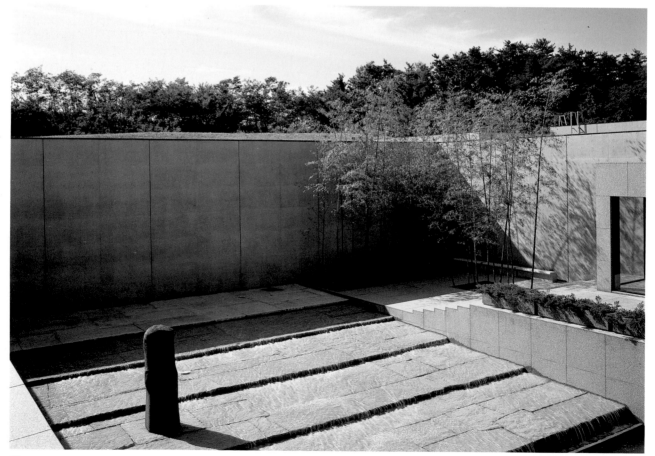

85

the fountain gave Noguchi an entrée into the plaza project, eventually leading to his developing a plan for the entire eight acres (3.2 hectares), which included his 120-foot- (36.6-meter-) tall stainless-steel *Pylon,* a torqued monument ambivalently seeking to honor and to eclipse Brancusi's great cast-iron column at Tîrgu-Jiu.

Hart Plaza took seven years to complete (1972–79). Assisted by his architectural partner, Shoji Sadao, who coordinated Noguchi's public projects in the 1970s and 1980s, he worked through the maze of political and physical difficulties that attend a major urban construction project. And in the end, at age seventy-five, he had his "environment of leisure," a space for the social rituals that unify a community. Originally prompted by the riots of 1968, Hart Plaza gave Noguchi an opportunity to renew the utopian aspirations of his early years.

Such opportunities were rare, however, and the sculpture of spaces more often served institutional prestige and embellishment. Two such projects are especially noteworthy, both for their brilliance and for their eccentricity. The first is a dramatic interior landscape, a series of stone terraces connected by flowing water in the lobby of the Sōgetsu Flower Arranging School in Tokyo. Commissioned in 1977 by the school's founder, ikebana master Sōfū Teshigahara, and architect Kenzo Tange, Noguchi's *Tengoku (Heaven)* utilizes the stepped balconies of the basement auditorium to form a mountain for the display of avant-garde flower arrangement and contemporary art. With intimate nooks as well as dramatic elevations, *Tengoku* provides a platform for both personal interaction and cultural happenings, and it has become one of the major exhibition sites in the city.

In the north of Japan, in Sakata, stone and water also constitute one of Noguchi's most beautiful gardens. Here the architect Yoshirō Taniguchi, son of Noguchi's collaborator at Keiō University, asked Noguchi in 1983 to design a garden for his new museum of work by the photographer Domon Ken.[61] The Domon Ken Museum is set next to a lake, and Noguchi's garden is situated on the shore, surrounded by Taniguchi's modernist structure. The garden consists simply of four stone terraces over which water flows into the lake, with a single basalt monolith positioned off-center. Two small groups of bamboo are planted in a corner, in organic counterpoint to the gray of water and stone. In its meditative synthesis of form, sound, and texture, this water garden seems to be intensely Japanese, yet it is like nothing else in the country. The Domon Ken garden is the product of fifty years spent thinking about space and sculpture, thoughts born on the American avant-garde stage and in utopian vision, then developed with corporate and institutional support after World War II. But this garden also issues from what Noguchi had more recently accomplished 450 miles (724 kilometers) to the southwest, in a stonecutting village on the Inland Sea.

84. *Tengoku (Heaven),* 1977–78
Sōgetsu Flower Arranging School, Tokyo

85. Domon Ken Museum garden, 1984
Sakata, Japan

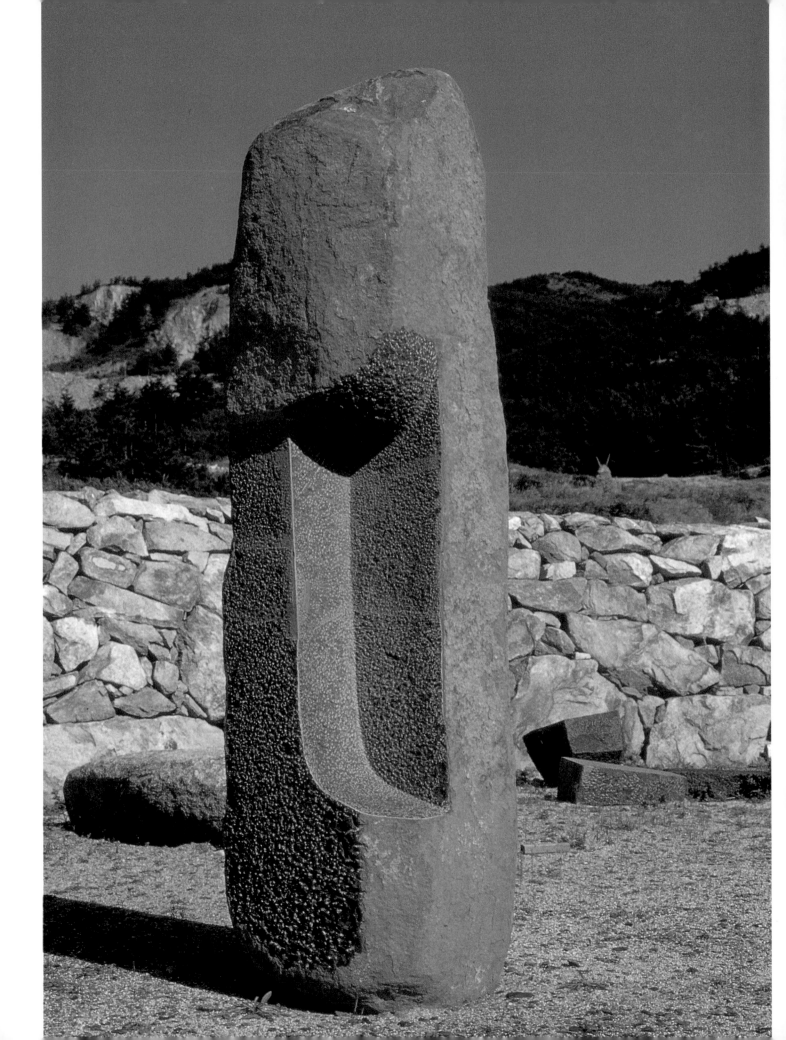

Deepening Knowledge

Having found in the garden a socially productive role for sculpture, Noguchi returned to work on individual objects unencumbered by moral qualms. He had never abandoned freestanding sculpture, but in the late 1950s he engaged this traditional mode with new vigor. This was partly prompted by a reorientation toward New York after concentrating his efforts in Japan and France and by the attendant desire to reenter the American art world. Now he felt free to do so, with the promise of future projects of social consequence. From this point on, Noguchi would essentially divide his efforts in two, between the garden and freestanding sculpture. Eventually, New York would become his base for architectural and landscape projects, and he would make his objects elsewhere. This bifurcation was the result of a new involvement with stone.

In 1958, however, when Noguchi returned to New York after making the UNESCO gardens, carving stone appeared to him completely out of place in the modern American city.[62] Seeking a material and a mode of working that would represent this new world—and that would symbolize his return to America—he chose sheet aluminum. As was his frequent practice, he first experimented with small maquettes, in this case modernist origami of folded paper. With the help of the lighting designer Edison Price and his machinery for bending light metals, Noguchi fabricated each of these works from a single sheet of aluminum. He was assisted by Buckminster Fuller's young associate, Shoji Sadao, who, as we have seen, would eventually become the sculptor's architectural collaborator on large-scale projects. Abstract representations of both the natural and the social world—from the sun to paper kites to *Noh* [87] *Musicians* (an evocation of Picasso's Cubist music makers)—the folded-aluminum works also recall Noguchi's bent-metal sculptures done under the influence of Brancusi. But these were contemporary works of a very different time, adopting—long before it was an accepted sculptural practice—the industrial methods that Noguchi now associated with the real America.

This new beginning was promptly dismissed by Noguchi's dealer Eleanor Ward, who rejected the aluminum cutouts as unsalable.

86. *Deepening Knowledge,* 1969
Basalt, 91¼ x 28 x 27 in. (231.7 x 71 x 68.6 cm)
The Isamu Noguchi Foundation, Long Island City, New York

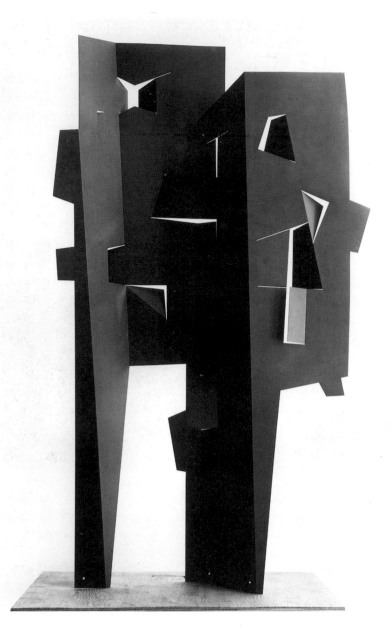

For Noguchi's next show at the Stable Gallery, she insisted on more traditional pieces readily associated with his previous work. Accepting the inevitable with some bitterness, he returned to Edison Price's factory and threw himself into feverish activity. While working for UNESCO, Noguchi regularly stopped in Greece en route between France and Japan, and there he found a source for white Pentelic marble, cut to the dimensions of contemplated sculptures. He had these shipped to New York for future use, and as his spring 1959 show approached he took them up as his material. A number of the resulting works employed forms developed for the Lever House garden, executed at one-half scale. Variations on Brancusi's motifs of bird and column, these were dedicated to Noguchi's early teacher. Elevated on thin posts were additional sensuous abstractions—more bird mutations, cruciform images, carvings evocative of the figure—which were placed in an elegant installation with works in cast iron and bell bronze that he had made in Gifu a few years earlier.

88

87. *Noh Musicians*, 1958
Painted aluminum, 70¼ x 39 x 7¾ in.
(178.4 x 99 x 19.7 cm)
The Isamu Noguchi Foundation, Long Island City, New York

88. Noguchi exhibition at Stable Gallery, New York, 1959

89. *Woman with Child*, 1958
Greek marble, 43 x 9 x 9¼ in.
(109.2 x 22.9 x 23.5 cm)
Cleveland Museum of Art

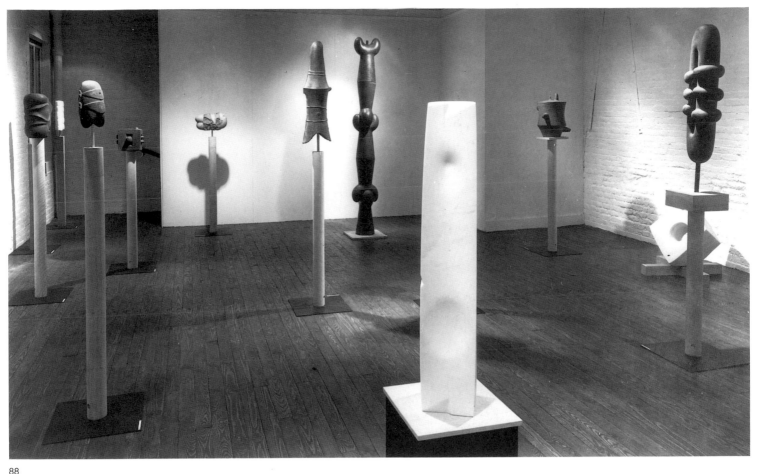

88

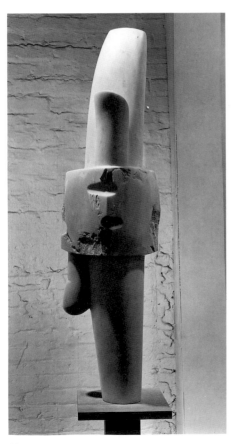

89

Although Noguchi fully polished most of the marbles, one sculpture, *Woman with Child*, juxtaposed smooth surfaces with the rough face of broken stone. At first a beautiful—if eccentric—aspect of a few works, this feature would become one of the most radical of Noguchi's late work, leading to the conversations with stone that would be his crowning sculptural achievement. Two years earlier, in 1957, he had cracked a rock to begin a piece that took him nine years to complete—*Myō*—a work that prefigured his late sculptures in its manner of construction and its natural surface. But Noguchi identified as his breakthrough two sculptures done in 1966 in Italy. First in the two-part sculpture *Euripides*, and then in *The Roar*, he accomplished on a grand scale what had been suggested in the central section of *Woman with Child*: selecting rock from the same quarry used by Michelangelo, intruding only minimally on its raw shape and surface, accepting the accidents of process. Noguchi's efforts were grounded in all that he had learned of stone in Japan, but there also was the background of Italy.

Noguchi began working in Italy in 1962, as an artist-in-residence at the American Academy in Rome. There he completed a series of balsa-wood sculptures, started three years before, in which carved elements were hung from vertical structures. These investigations of gravity were "a metaphor," Noguchi wrote, "to define our precarious and pendulous existence."[63] Continuing the exploration of suspended sculpture begun in 1928, which became figurative with his lynched *Death* and delicate *Lunar Infant*, these

89

90

91

30, 56

85

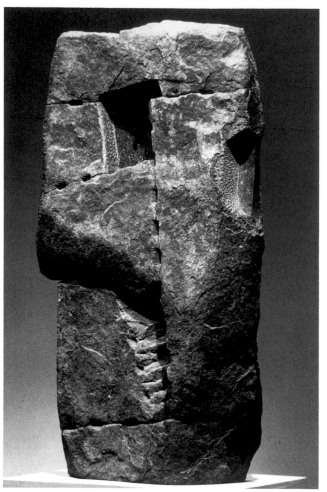

90

pieces further abstracted the figure to serve a metaphysical purpose. He had initially used balsa in the last piece done for the 1949 Egan Gallery exhibition, *Cronos*, in which the subject was mythological.[64] Ten years later Noguchi's point of reference was existential, with works like *Mortality* suggesting the threads by which life and human significance were suspended. At an Italian foundry Noguchi had these sculptures cast in bronze, playing with the formal contrast of the light and the heavy but also accommodating himself to an art world in which fragile works of balsa could not be sold.

In Rome he addressed gravity in another way, on the floor—molding clay with his feet, physically and metaphorically working with humanity's fundamental connection to the earth. (These pieces were cast in bronze as well, with the unhappy effect of distancing Noguchi from their source and intent.) Appropriately enough, each of the sculptures recalls Japan, from *Lessons of Musokukoshi* (1962), which pays homage to the great Zen garden master, to *Seen and Unseen* (1962), which makes private allusion to Yone Noguchi, whose first book was titled *Seen and Unseen, or Monologues of a Homeless Snail* (1897).

Unlike his father, Isamu never would break his itinerant habits, and for more than a decade he returned to Italy from New York to

90. *Myō*, 1957–66
Kurama granite, 65 x 35 x 15½ in.
(165.1 x 88.9 x 39.4 cm)
Private collection

91. *The Roar*, 1966
Arni marble, 52¼ x 91 x 24 in.
(132.7 x 231 x 61 cm)
The Isamu Noguchi Foundation, Long Island City, New York

92. *Ding Dong Bat*, 1968
White statuary and pink Portuguese marble,
23¼ x 92 x 14½ in. (59 x 233.7 x 36.8 cm)
The Isamu Noguchi Foundation, Long Island City, New York

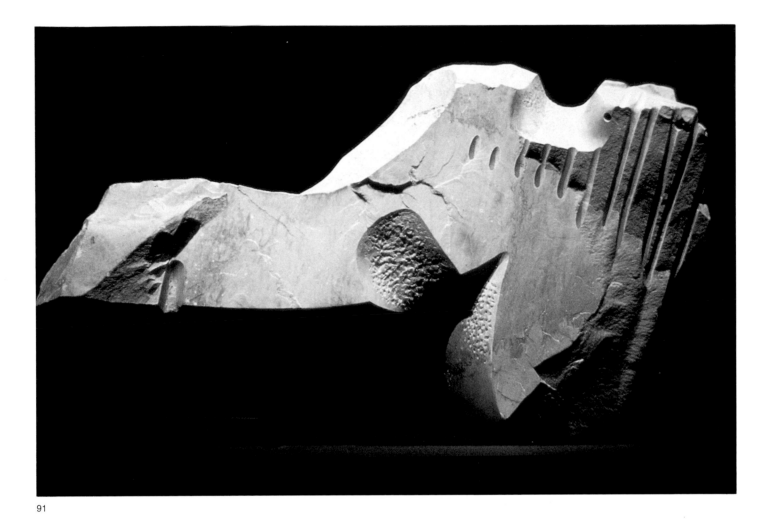

91

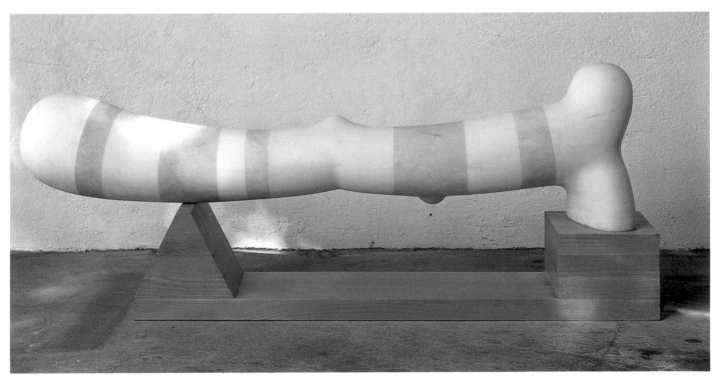

92

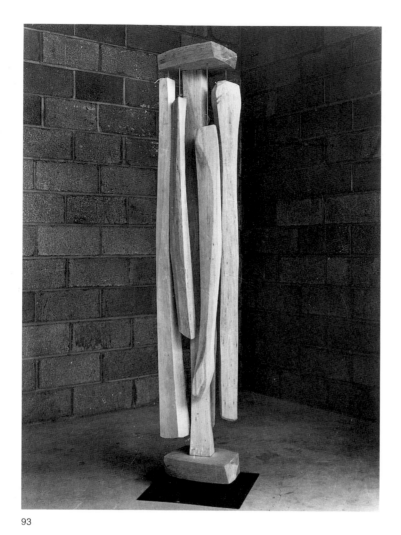

93

work every year. Henry Moore had suggested that he visit the Henraux quarries in Querceta, and there he established a regular summer residence and studio. Walking through the quarries that bore into Michelangelo's mountain, Altissima, Noguchi experienced the thrill of finding great stones. He also had at his disposal the newest power tools, especially the diamond saws that allowed him to work with huge pieces of marble in a way that would have been unimaginable during his time with Brancusi. Noguchi associated such power tools with contemporaneity, and his many romantic views about sculpture certainly did not include a prohibition against their use. Yet his embrace of new technology was as much idealistic as pragmatic, inspired by the utopianism of Fuller and its modernist counterparts.

Noguchi's infatuation with new methods of construction prompted his most idiosyncratic body of work, the banded marble pieces made at Querceta and Pietrasanta from 1968 to 1973. He had become fascinated with post-tensioning—a variation on the tension-compression structure extolled by Fuller—in which elements were threaded along a rod or cable that was tightened at the ends to hold the parts together. The continuous tension on the connecting rod gives the whole assembly incredible strength, which allowed Noguchi to put heavy blocks of marble together in ways 92 impossible using only posts and adhesives. A work such as *Ding*

93. *Mortality*, 1959
Balsa wood, 75 x 20 x 18 in.
(190.5 x 50.8 x 45.7 cm)
Isamu Noguchi Foundation,
Long Island City, New York

Dong Bat could not support the weight of its parts without this structure, although the technical seriousness of its construction is belied by the priapic humor of its form. Another prominent feature of the post-tension works is their colored banding, which Noguchi claimed to be a natural offshoot of his construction technique. Hard as it is to believe, he always denied any influence of the multicolor marble stripes of the Tuscan churches so close to his Italian workplace.

Even though Noguchi spent much time and effort on his post-tension sculptures, they were tangential to his primary sculptural development, which was more closely tied to the rough stones ripped from Monte Altissima. At about the same time that he broke through the refined surface with *Euripides* and *The Roar,* 91 Isamu returned to Japan and met the young stone carver Masatoshi Izumi, in the village of Mure on Shikoku. Izumi would create the conditions for Noguchi's last stage of sculptural evolution, providing him with the stones, the workers, and the machinery—in fact, with a whole environment at Mure—that allowed him to work with basalt and granite on a grand scale. More than furnishing practical means, however, the studio complex that Izumi con- 94 structed there gave Noguchi a home to which he could return during his last two decades. This he did for about six months each year, three in the spring and three in the fall. Without Izumi's deep knowledge of stone, and without their strong, intuitive working relationship, Noguchi never would have made the outstanding works of his last years. No doubt he would have created great sculptures, but not works of this kind.[65]

Noguchi returned to Shikoku, where in 1956 he first had sought stones for UNESCO, looking for a place to fabricate the nine-foot (2.7-meter) *Black Sun* for Seattle. His old friend Genichiro 2 Inokuma, who was from the city of Takamatsu, suggested that he investigate the nearby stonecutting village of Mure; he also introduced Noguchi to the energetic Governor Kaneko, an enthusiast for modern architecture who was interested in local artistic development. The prefect's official architect, Tadashi Yamamoto, recommended Izumi to Noguchi, and they began a three-year collaboration on *Black Sun*—one of the first commissions of the United States government's new public-art program.

Although *Black Sun* was pointed up in Brazilian granite from a thirty-inch (seventy-six-centimeter) granite sculpture that Noguchi had done while working on the Beinecke garden, during the course of its fabrication he began carving more freely in Izumi's workshop. Being back in Japan amid the nature that he so loved seemed to free Noguchi's imagination to explode in stone. Overlooking the Inland Sea, reminiscent of the seaside Chigasaki of his childhood, the studio is set against the subtle drama of the peaks of Yakuri Gokkenzan and Mount Yashima. Here he worked in material much harder and more difficult to carve than the marble he had known in Italy. This change brought new ideas into his late sculpture.

The slow pace of carving granite and basalt concentrated Noguchi's attention and directed his thinking to time. Personal time and cultural time, the pace of a day's work and that of a life's work, historical time, geological time, the time of scientific

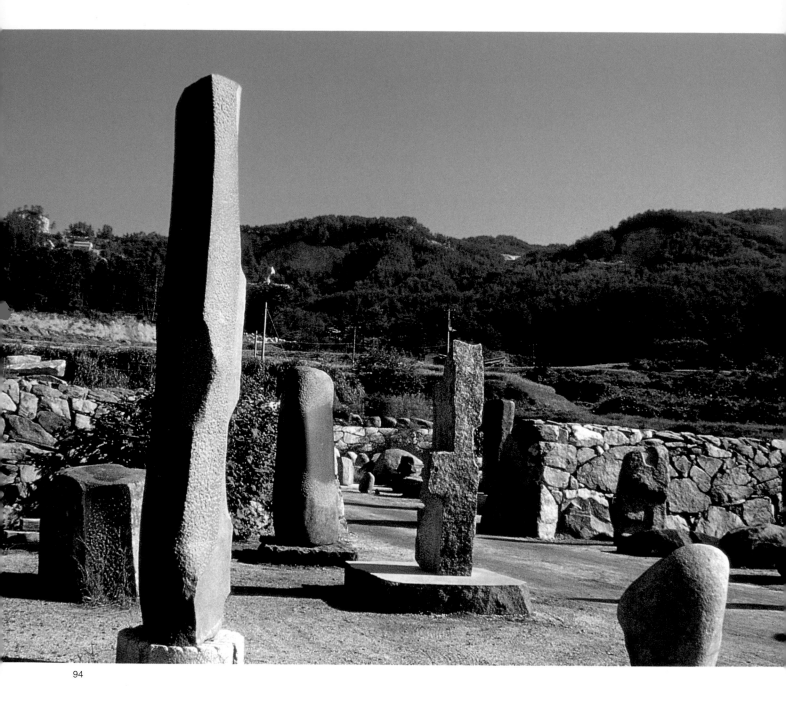

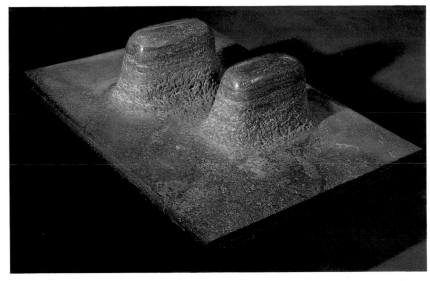

95

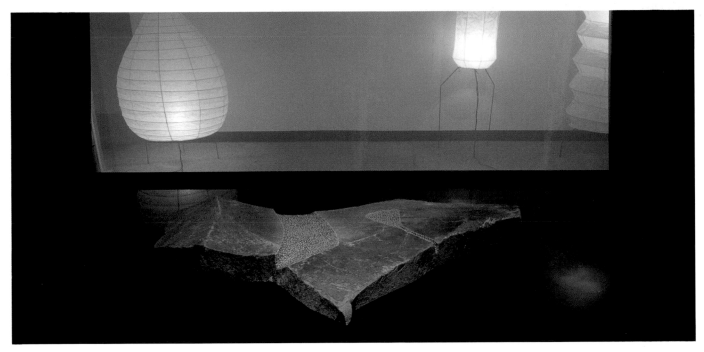

96

94. Work yard of Noguchi's studio, Shikoku, Japan, 1981

95. *Double Red Mountain,* 1969
Persian red travertine, 13 x 40 x 20 in.
(33 x 101.6 x 50.8 cm)
The Isamu Noguchi Foundation, Long Island City, New York

96. *Far Land,* 1984
Andesite, 6½ x 74½ x 40½ in.
(16.5 x 189.2 x 102.9 cm)
The Isamu Noguchi Foundation, Long Island City, New York

cosmology and that of religious cosmology—all became subject to reference in stone. This interest was primed by Noguchi's long fascination with science and by his extensive travel to ancient sites, especially the great temple complexes of India and Southeast Asia, where the vast time spans of Hinduism and Buddhism are palpable. Eventually, he referred to his great stones as "congealments of time."[66] This was very different from the expression of metaphysical concerns in his work with Graham, for he addressed these issues in stone through abstraction, without narrative context or referential image. His material itself became symbolic.

For Noguchi, stone became the preeminent representative of nature and a symbol of humanity's relationship with the environment, both local and cosmic. Nature had been a concern for him since his Paris abstractions of 1928, a concern that expanded into the environment with his earth projects. But its embodiment in

stone did not start until his work with Japanese gardeners during the 1950s. By the late 1960s stone was no longer just one among many possible materials for Noguchi; it was becoming the focus of his work. It was less a means to an end than the end itself—the subject of sculpture concentrated in material form. He expressed this with the claim that he now worked with stone "simply as stone."[67] The reversal is suggested by the name of his first monu-
86 mental basalt sculpture completed at Mure, *Deepening Knowledge.*[68]

Although Noguchi associated just about every subject of interest to him with his approach to stone as material, many of his sculptures utilized forms that focus attention on particular aspects of
97 nature.[69] *Origin,* initially placed behind the old samurai house that had been moved from Marugame to Mure for his use, suggests primordial creation rising from the earth, as well as the density and
95 weight of stone. A large body of table sculptures—such as *Double*
96 *Red Mountain* and *Far Land*—are miniature landscapes of great power, compressing distance in the manner of the Zen garden but remaining portable objects for display. And like Brancusi, Noguchi worked with a vocabulary of forms that took many guises, recycled over years of sculptural activity.[70] The bulbous dome of *Origin* is one such form; others include the torqued column, which also was used horizontally; the circular image evoking both the sun and the round *ensō* of Zen painting; the cube and the pyramid.
91 Even the shape of *The Roar* reappeared in other works.

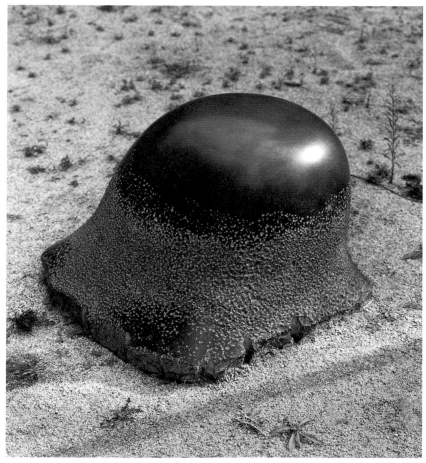

98

One particular image led to Noguchi's most ambitious stone sculptures—the magnificent black Voids. He began the Void series in Italy in 1970 with an evocation of the figure, *In Silence Walking*. Such references populate every period of Noguchi's abstract work, for he never wholly escaped from the figure, and the interaction of abstraction and figuration connects stylistically disparate sculptures—from the interlocking-slab pieces of the 1940s, through the marble and cast-iron works of the 1950s, to the late Personage series and many rough works in basalt. With the Voids, however, Noguchi moved away from figuration to an abstract image that incorporated themes from three of his central areas of interest. He connected the image of the void with the immense energies of particle physics, envisioning a circular flow of energy as the source of physical reality.[71] The concept of emptiness was also important to Noguchi in its Zen context, as in *Mu,* his image of Buddhist nothingness at Keiō University.[72] And he employed emptiness aesthetically, for the Void series played subtle and powerful variations on the use of negative space as a positive formal element, a staple of modernist sculpture since Alexander Archipenko. The force of

97. *Origin,* 1968
Black African granite, 23 x 30 x 32 in.
(58.4 x 76.2 x 81.3 cm)
The Isamu Noguchi Foundation, Long Island City, New York

98. *In Silence Walking,* 1988–89
White botticino marble, height: 63 in. (160 cm)
Estate of Isamu Noguchi

93

99

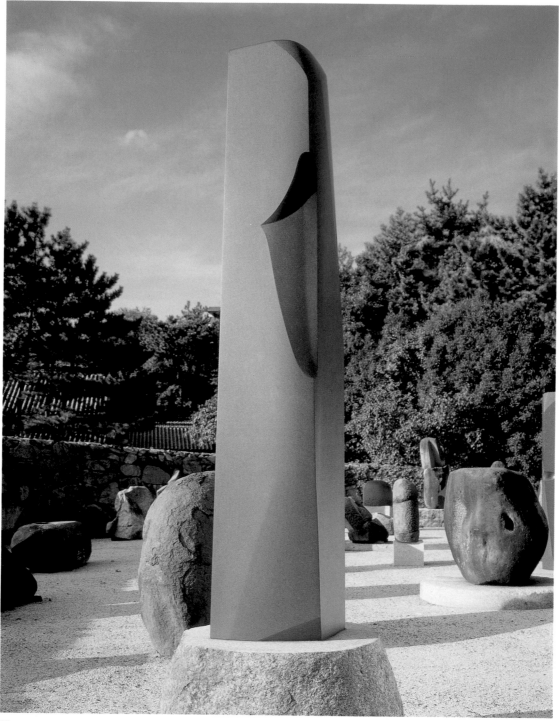

99. *Awakening,* 1983–86
Basalt, 76 x 12⅝ x 14 in. (193 x 32 x 35.6 cm)
The Isamu Noguchi Foundation, Long Island
City, New York

100. *Energy Void,* 1971–73
Swedish granite, height: 12 ft. (3.7 m)
The Isamu Noguchi Foundation, Long Island
City, New York

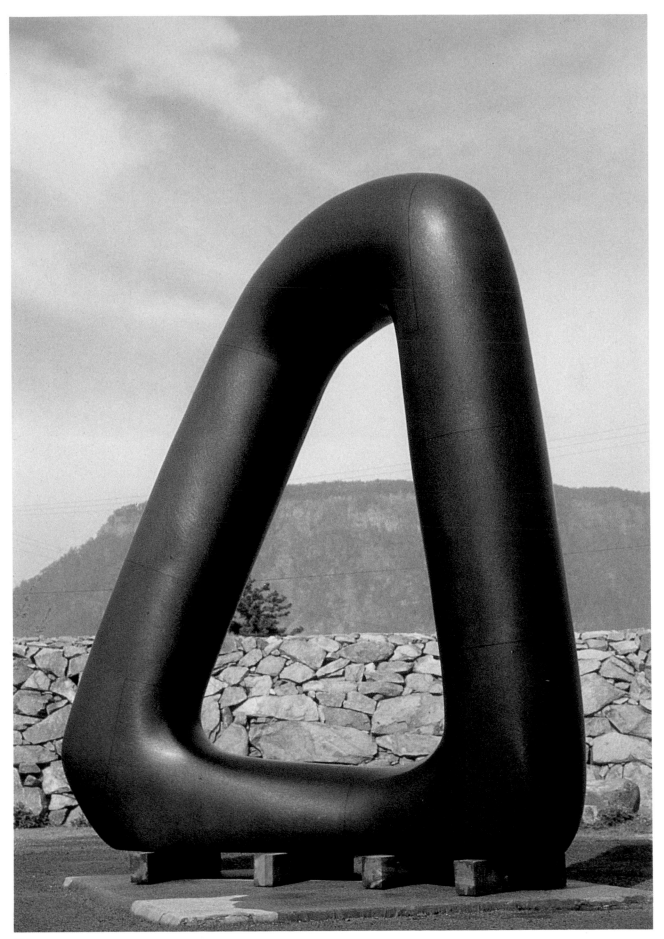

these associations was additive, with Asian themes reinforcing scientific metaphor and modernist formal innovation, culminating in two of the masterworks of Noguchi's career.

The opportunity to create these was provided by a commission from Pepsico in 1972 for a major work for its sculpture park in Purchase, New York. A small plaster model, with which Noguchi refined a twisted triangular form that subtly bends the space around it, was enlarged to a twelve-foot (3.7-meter), seven-part granite sculpture assembled by Izumi and his workers. The majestic black form, polished to a high finish, was called *Energy Void*. Noguchi decided to keep this sculpture with him at his studio, and it now sits in the old sake warehouse that was moved to Mure to house a display of his completed works. He then created another granite Void—this one with a rough surface, and composed of five elements—that was shipped to America for assembly at Pepsico.

Textural subtlety is basic to the aesthetics of old Japan, a world that Noguchi continued to seek in his historic samurai house in a stone-working hamlet. The defining of surface, a lesson learned from the obsessive Brancusi, was particularly critical for Noguchi in his late stone works. In these sculptures he often combined surface treatments, regularly leaving large areas of the stone in its natural state. He was a master at deciding where to leave the exterior untouched, how much to polish a section of stone, which kind of marks to use for a texture best suited to a particular form, when to disguise and when to emphasize the cuts of chisel or drill. In some of his most powerful pieces, there is only minimal intrusion on the skin of his beautiful granites and basalts, adapting to modernist ends the use of natural rocks in Chinese and Japanese gardens.

This minimal transformation of natural stone did not always translate well from its Asian source to an American setting. For a General Services Administration commission in Seattle, Noguchi composed a five-element work of rough granite boulders, *Landscape of Time*. To an Oklahoma congressman who attacked the piece in the *National Enquirer* as a rip-off of the American taxpayer, it seemed to be a case of the pet-rock craze writ large.[73]

Noguchi laid out the elements of *Landscape of Time* in his circular work yard in Mure, surrounded by the magnificent stone wall that Izumi had constructed for him. Here he established the relations among the elements, testing and refining his intuitions as he had years earlier with the natural stones for UNESCO. He would do the same for two other multipart works: *Momo Taro*, made for a hilltop at the Storm King Art Center in upstate New York, and *Constellation (For Louis Kahn)*, created to honor Louis Kahn at the architect's Kimbell Art Museum in Fort Worth, Texas. In each of these projects Noguchi employed the skills that he had developed working on the stage and in the garden, creating an environment for the viewer as participant in the coalescence of space.

In such late stones Noguchi seemed to be far from his New York School colleagues, but in fact these sculptures—with their undisguised marks of facture and accidental fracture—embody a process analogous to that of contemporary gestural painting. (And they raise the question of completeness just as obviously. Noguchi's

101. *To Darkness*, 1965–66
Miharu granite, 66 x 70 x 30 in.
(167.6 x 177.8 x 76.2 cm)
The Isamu Noguchi Foundation, Long Island City, New York

102. *Mountain Breaking Theater*, 1984
Basalt, 2 elements: 52 x 56 x 30 in.
(132.1 x 142.2 x 76.2 cm); 62 x 37 x 26 in.
(157.5 x 94 x 66 cm)
The Isamu Noguchi Foundation, Long Island City, New York

101

102

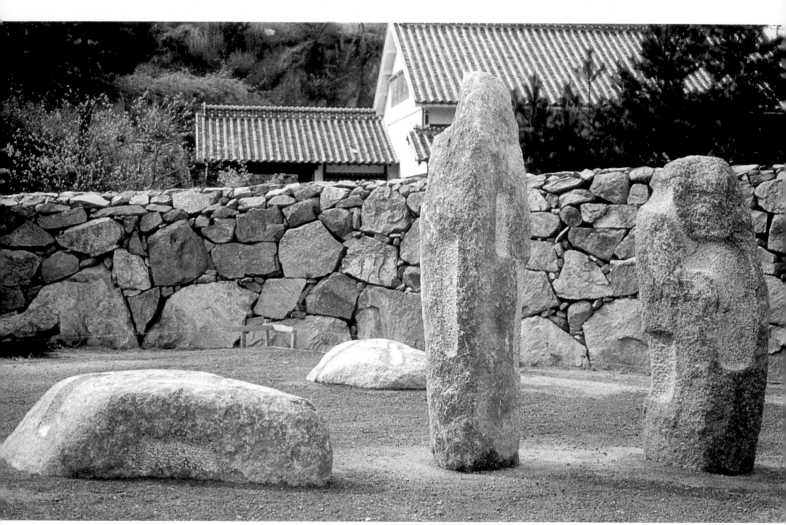

103

friend de Kooning was notorious for his struggle to determine when a picture was finished, and at Mure, Noguchi could work for years on a single sculpture.) Until the mid-1960s Noguchi worked primarily from models—apart from his ceramics done for Kamakura—executing what had been perfected in maquette. But beginning in the mid-1960s he began to work improvisationally, interacting with his material and with the unforeseen consequences of his process. Looking a long time before cutting and then working with the accidents of his carving, he seemed more and more to adopt the classic Abstract Expressionist description of an artwork as a collection of mistakes. And like the groundbreaking paintings of Pollock and de Kooning, Noguchi's late sculptures—great stones apparently so close to their natural state—still are apt to prompt the question central to the modernist enterprise: Why consider this object a work of art at all?[74]

103. Detail of *Landscape of Time* at Noguchi's Shikoku studio, 1975
Granite, 5 elements
Permanently installed at Jackson Federal Building, Seattle

104. Detail of *Momo Taro*, 1977–78
Granite, 9 elements
Storm King Art Center, Mountainville, New York

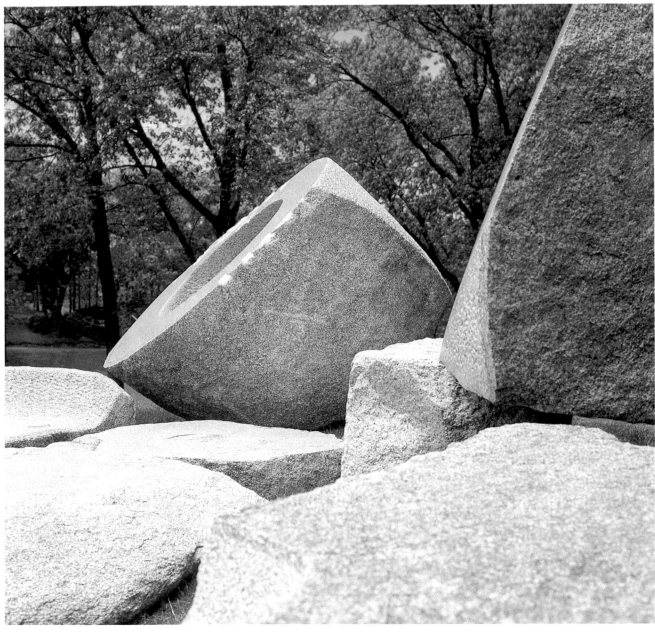

104

This is not surprising, for aesthetically Noguchi was a consummate modernist, despite the fact that many aspects of his career point beyond modernism. Surveying Noguchi's work yields a unique compendium of themes and techniques that have been essential to various manifestations of this tradition: elimination of the inessential through formal reduction; truth to materials and honesty of structure; utopian aspiration; production of art from technology; the use of non-Western sources; and, in his late sculpture, a collaboration with chance and accident.

It is worth recapitulating Noguchi's artistic odyssey. Aesthetic dispositions developed during a Japanese youth were given a modernist home and justification in the Paris studio of Brancusi. Friendship with R. Buckminster Fuller and the political consciousness of the 1930s inspired a commitment to technology and to the social responsibility of art. Work on the ritualistic stage of Martha

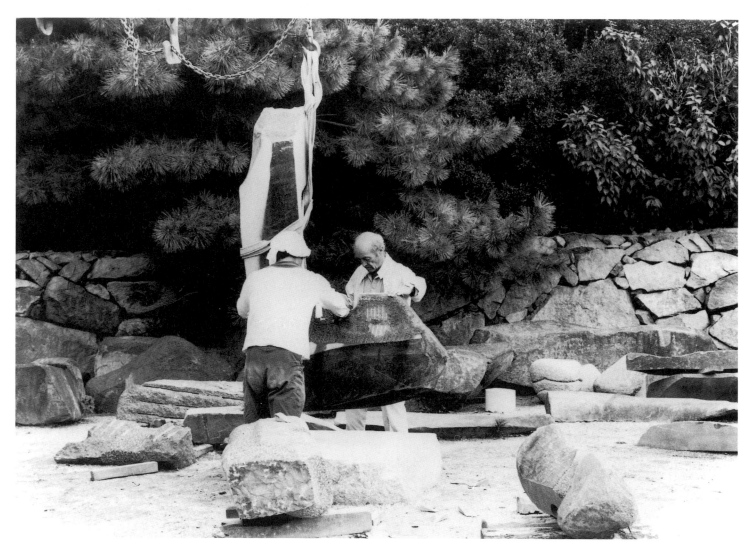

105

Graham reinforced earlier thinking about the earth as material and
site, expanding the conception of sculpture to focus on the lived
environment. Political disillusionment drove Noguchi back into the
studio, resulting in an art-world success that prompted personal
crisis and an escape to ancient sites of monumental sculpture. This
travel, and the return to Japan, concentrated his thought on the
garden and the landscape—renewing his perspective of the 1930s
—and the growing postwar economy provided the opportunity to
realize his ambitions for the sculpture of spaces. This freed him to
return to the traditional sculptural object, developing in Italy and
in Japan a new way of working with stone. In a studio complex on

105. Noguchi working at his Shikoku
studio, 1984

106. *Helix of the Endless,* 1985
Aji granite and Brazilian granite, height:
15 ft. (4.6 m)
The Isamu Noguchi Foundation, Long
Island City, New York

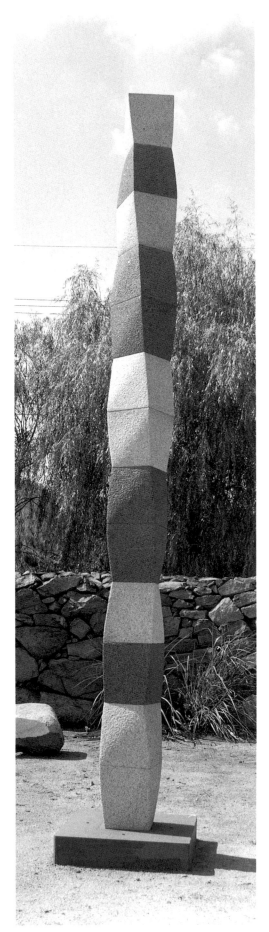

106

the Japanese island of Shikoku, this stonework allowed Noguchi to integrate his metaphysical concerns with modernist sculptural practice, through the twin themes of time and nature.

Yet even while Noguchi focused in the late 1980s on his great works of basalt and granite, he did not abandon the sculpture of spaces. At his death in December 1988 he was engaged in designing a four-hundred-acre (162-hectare) park in Sapporo in northern Japan. And on the hill above his house in Mure, he was building a garden. He cut into the hillside, holding back the earth with a wall of rock inspired by what he and Izumi had seen together in Peru at Machu Picchu. Over a rock platform he placed a huge stone, left over from the Sōgetsu Flower Arranging School project, its shape like a great bird's head surveying the bay—a place to watch the moon rise over Tsukiyama. A natural stone, sculpted by river water into a fantastic shape, was set off to the side. Running down the hill toward the studio was a stream of great boulders that Noguchi had thrown there to arrange themselves by chance, a randomized version of the "dry cascade" of Saihōji in Kyoto. And now, farther up the hill, above works finished and unfinished, sits a large ovoid stone, inside of which rests a portion of his ashes.

It is a very peaceful spot for this most frenetic of artists, a man whose long career encompassed such an astonishing number of pursuits. Here Noguchi had found a kind of home, successfully resurrecting a bit of the old Japan to heal the wounds of his early rejection. Like Claude Monet at Giverny, Noguchi at Mure created the ideal—and the necessary—conditions for his extraordinary late work.

Around the world, facing the island of Manhattan, Noguchi created another place of repose. In an old factory building across the street from his studio in Long Island City, he presented a retrospective of his career in a museum of his own. As Brancusi had donated his studio to the people of Paris, fixing the installation that he had come to consider a work in its own right, so Noguchi assured that his work would be seen as he intended. And at the heart of the museum he encapsulated his life in a garden. Here he combined plants indigenous to Japan with those native to the United States, and he honored his triumvirate of influences. He set out his *Helix of the Endless*—Brancusi's *Endless Column* torqued with the twist of the double helix, à la Fuller. He placed his great stones as he had placed his props for Graham, on a stage of physical and emotional experience. And in a studio above his museum, he planned his public projects and managed their implementation.

In the end, it took two homes to achieve what Noguchi had sought from his early years, his peripatetic course having led in the two directions that came to be represented by Japan and America. He required two environments to satisfy his longing, one devoted to the contemplative object and the other to the grand social project. Together these places achieved for Noguchi what he identified as the aim of art—"bringing order out of chaos, a myth out of the world, a sense of belonging out of our loneliness."[75] When we look beyond his personal yearning, we see that Isamu Noguchi had found his order and his myth in the garden and in stone, and his belonging in the art of our time.

NOTES

1. Their letters, with Yone imploring and Leonie resisting, are published in Ikuko Atsumi, *Yone Noguchi: Collected English Letters* (Tokyo: Yone Noguchi Society, 1975), pp. 191–202.

2. For the text of Noguchi's Guggenheim proposal, see Isamu Noguchi, *A Sculptor's World* (New York: Harper and Row, 1968), pp. 16–17.

3. Although in his published statements Noguchi stated that he worked with Brancusi for six months, an unidentified contemporary newspaper article, dateline Paris, in the Archives of the Isamu Noguchi Foundation states that he spent about three months with Brancusi. The c. 1928–29 article by Ruth Green Harris is entitled "Paintings and Sculpture Shown in Paris," and it contains extensive quotations from Noguchi about his work.

4. For the location of Noguchi's first Paris studio, see Billy Klüver and Julie Martin, *Kiki's Paris: Artists and Lovers 1900–1930* (New York: Harry N. Abrams, 1989), map 3. In 1928 Noguchi moved to another studio, at 11, rue Dedouvre in Gentilly, to which he returned for two months in 1930.

5. For a discussion of Noguchi's work from 1928, all but six pieces of which are lost, see Nancy Grove, *Isamu Noguchi: A Study of the Sculpture* (New York: Garland Publishing Company, 1985), pp. 75–76. For illustrations of works mentioned here, see Noguchi, *A Sculptor's World*, pp. 41–43.

6. Noguchi, in Harris, "Paintings and Sculpture Shown in Paris," n.p.

7. Noguchi later attributed his turning away from abstraction to a lack of inner strength as well as the need to make money. His comments also suggest depression occasioned by the lack of widespread enthusiasm for his first exhibition. "I was too poor inside to insist upon it. How presume to express something from within when it was empty there?" (Noguchi, *A Sculptor's World*, p. 19.)

8. For a detailed account of Noguchi's portrait heads, see Nancy Grove, *Isamu Noguchi: Portrait Sculpture* (Washington, D.C.: National Portrait Gallery; Smithsonian Institution Press, 1989).

9. Noguchi, 1984, in Dore Ashton, *Noguchi East and West* (New York: Alfred A. Knopf, 1992), p. 42.

10. Noguchi, *A Sculptor's World*, p. 22.

11. For example, the suggestion that the park's elevations could cover interior spaces later appeared in Noguchi and Edward Durrell Stone's 1945 proposal for the Jefferson Memorial Competition in Saint Louis and in the five designs that Noguchi developed with Louis I. Kahn for a playground in New York's Riverside Park (1961–66).

12. Noguchi, *A Sculptor's World*, p. 22.

13. This playground equipment was not built in Hawaii, either, due to the death of Lester McCoy, the park commissioner who had commissioned it. Noguchi's designs were published in the "Design Decade" number of *Architectural Forum*, October 1940. Variants of some of these works were finally built in 1975–76 for Noguchi's *Playscapes* in Atlanta's Piedmont Park, commissioned by the High Museum of Art.

14. T.B.H. [Thomas B. Hess], "The Rejected Playground," *Artnews* 51 (April 1952): 15.

15. Only two Noguchi playgrounds have been built: the playground at Kodomo No Kuni (Children's Land), near Tokyo (1965–66), and *Playscapes*, in Atlanta. Before he died, Noguchi created the master plan for a 400-acre (162-hectare) park in Sapporo, Japan, which incorporates elements from earlier designs, including a version of *Play Mountain*. This park currently is under construction.

16. Noguchi's outrage at McBride's review lasted for decades, and in 1968 he reprinted virtually the entire piece in his autobiography, *A Sculptor's World*, pp. 22–23.

17. The photograph of the lynched body appeared in A. Jakira, "As If to Slaughter," *International Labor Defense*, June 1930, p. 210. The exhibition was held at the Arthur U. Newton Galleries, New York, February 1935. Given the uniqueness of this subject for Noguchi, it seems likely that the piece was created for inclusion in the group exhibition.

18. Noguchi flew first to California, where he raised some money doing portrait sculpture, including the head of the actress Helen Gahagan Douglas. There, at the request of architect Richard Neutra, he also designed a biomorphic swimming pool for the new house of film director Josef von Sternberg; the elegant design was never used.

19. Isamu Noguchi, "What's the Matter with Sculpture?" *Art Front* 16 (September–October 1936): 13–14.

20. On the Artists' Union and the February 1936 American Artists' Congress, which Noguchi attended on returning to New York, see Dore Ashton, *The New York School: A Cultural Reckoning* (New York: Viking, 1973), pp. 62–64.

21. Noguchi said that he also designed a plastic clock in 1926, *Measured Time*, but no examples are known. *Radio Nurse* appeared in 1938 and received significant coverage in the industry press: "Radio Nurse," *Modern Plastics* (June 1938): 94; "Zenith's Radio Nurse," *Radio News* 19 (June 1938): 30.

22. Noguchi sets were used in twenty-one different Graham productions, with the 1953 set for *Voyage* being reused in 1963 for *Circe*. For Noguchi's own account of many of his stage designs, see Noguchi, *A Sculptor's World*, pp. 123–31.

23. For a discussion of the influence of Noh on Noguchi's set for *Frontier*, see Ashton, *Noguchi East and West*, pp. 55–61.

24. It was Gilmour who had introduced Noguchi to Graham in 1929, when she was helping with the dancer's costumes. From 1930 to 1933 Isamu's half-sister, Ailes, danced with the Graham company, and he often spent time watching rehearsals.

25. On the Noguchi-Graham collaborative process, see Noguchi, *A Sculptor's World*, p. 123; Grove, *Isamu Noguchi*, p. 122; Martin Friedman, *Noguchi's Imaginary Landscapes* (Minneapolis: Walker Art Center, 1978), p. 29; Robert Tracey, "Noguchi: Collaborating with Graham," *Ballet Review* 13 (Winter 1986): 9–17.

26. Noguchi wrote about his experience in Poston in his "Trouble among Japanese-Americans," *New Republic* 108 (February 1, 1943): 142.

27. Bert Winther, *Isamu Noguchi: Conflicts of Japanese Culture in the Early Postwar Years* (Ann Arbor: University of Michigan Press, 1993), p. 132.

28. These names were later changed to *Tsukuru (To Build)* and *Yuku (To Depart)*. Noguchi says that this was occasioned by Akira Kurosawa's having named a popular movie *Ikiru*. (Isamu Noguchi, *The Isamu Noguchi Garden Museum* [New York: Harry N. Abrams, 1987], p. 154.)

29. Winther, *Isamu Noguchi*, p. 258.

30. According to a recent interview with Tange, Noguchi also used as a source Japanese *magatama* fertility beads. (Ibid., p. 225.)

31. Noguchi, in Dorothy C. Miller, ed., *Fourteen Americans* (New York: Museum of Modern Art, 1946), p. 39. In *Fourteen Americans*, Noguchi presented twelve sculptures, including one Paris abstraction, the model for *Contoured Playground*, and his new slab constructions of marble and slate. While in Poston, Noguchi had been told that the museum was hoping to do a Noguchi exhibition "as soon as it becomes feasible," but there was nothing until *Fourteen Americans*. (Monroe Wheeler to Isamu Noguchi, July 28, 1942, Archives of the Isamu Noguchi Foundation.)

32. Noguchi, *A Sculptor's World*, p. 26.

33. Implausibly, Noguchi denied the influence of Surrealist imagery on these works, citing precedents in Japanese culture instead. (Ashton, *Noguchi East and West*, pp. 71–73.)

34. Sam Hunter, *Isamu Noguchi* (New York: Abbeville Press, 1978), p. 83.

35. This connection with calligraphy was reported by Thomas B. Hess in *Artnews* and was mentioned in the Japanese press at the time. (Thomas B. Hess, "Isamu Noguchi '46,"

Artnews 45 [September 1946]: 35; Winther, *Isamu Noguchi*, pp. 65–68.)

36. Noguchi, *A Sculptor's World*, p. 28.

37. For more detail on Noguchi's furniture designs, see Martin Eidelberg, ed., *Design 1935–1965: What Modernism Was* (Montreal: Musée des Arts Décoratifs; New York: Harry N. Abrams, 1991), pp. 107–8, 125–26, 216–17.

38. For illustrations of some of Noguchi's prototype light fixtures, as well as the Lightolier models and some early Akari lanterns, see "New Shapes for Lighting: Sculptor's Lamps Are Dim, Decorative," *Life,* March 10, 1952, pp. 114–17.

39. At this writing the American Stove Company piece, in a building now owned by U-Haul Corporation, is unfortunately covered by a drop ceiling.

40. "Isamu Noguchi Defines the Nature and Enormous Potential Importance of Sculpture—'The Art of Spaces,'" *Interiors* 109 (March 1949): 118. For this article *Night Land* was photographed in the studio as a horizontal work, very much like a landscape model, rather than tilted to one corner, as it appeared in the exhibition.

41. Isamu Noguchi, "A Dramatic Stage: The Tokyo Exhibition," p. 2 of the translated catalog essay for *The Isamu Noguchi Exhibition*, Mitsukoshi, Ltd., Tokyo, August 18–27, 1950. (Archives of the Isamu Noguchi Foundation.)

42. Ibid. Photographs and an account of the exhibition appear in "Noguchi: Traveling Sculptor Pauses in Japan," *Interiors* 110 (April 1951): 140–45.

43. For Noguchi's own account, see Isamu Noguchi, "Japanese Akari Lamps," *Craft Horizons* 14 (October 1954): 16–18. The Akari logo, designed by Isamu's half-brother Michio, represents the sun and the moon.

44. Noguchi, *A Sculptor's World*, p. 33.

45. Betty Pepis, "Artist at Home," *New York Times Magazine*, August 31, 1952, pp. 26–27. "Noguchi in Kitakamakura [*sic*]," *Interiors* 112 (November 1952): 116–21, 171–72. In "Isamu Noguchi: Projects in Japan," *Arts and Architecture* 69 (October 1952), Noguchi gave his own account of the studio and its construction, emphasizing its unique design elements.

46. Winther, *Isamu Noguchi*, p. 250.

47. Ibid., pp. 248–51.

48. The exhibition also included one sculpture of cast iron, *Celebration (Holiday)*, a material that five years later Noguchi would use to great effect in a body of sculptures fabricated in Gifu.

49. On the critical reaction to the Kamakura exhibition, see Winther, *Isamu Noguchi*, pp. 264–70.

50. Isamu spent much of 1953 attempting to get the authorities to allow Shirley to enter the United States, without success. His travel schedule and her shooting schedule made it difficult for them to find time together—though they did spend the summer of 1953 in Europe and December of that year in Hong Kong—and they were officially divorced in January 1957.

51. Noguchi, typescript, August–September 1952, p. 2, Archives of the Isamu Noguchi Foundation.

52. At the time of *Fourteen Americans,* Thomas B. Hess wrote that Noguchi had a reputation as a "gallery trotter" (his first six shows were in five galleries) and was unpopular with dealers. (Hess, "Isamu Noguchi '46," p. 47.) Noguchi remained suspicious of dealers, often playing one off another, feeling that he was better able to handle his own career. While this worked for his landscape projects, lacking a dealer with a long-term investment in his work kept Noguchi's prices low relative to those commanded by other artists of comparable stature.

53. Noguchi had used biomorphic imagery in the basic landscaping of his Keiō University garden, and simultaneously with his garden for UNESCO, he employed these forms in his courtyards for the Connecticut General Life Insurance Company.

54. There was much discussion of what should be written on the nine-ton (8.2-metric-ton) fountain stone. The original suggestion that the inscription be *love* was rejected as a Christian concept by the Japanese Buddhists working on the project. They proposed *mu* (nothingness), *kokoro* (feeling), and *yorokobi* (gladness), before the character for *peace* was adopted.

55. Noguchi, *A Sculptor's World,* p. 168. For Noguchi's account of the entire project, see pp. 165–68.

56. A selection of Noguchi's photographs of the Jaipur and Delhi observatories was published in "Astronomical City," *Portfolio: A Graphic Arts Quarterly,* 1951.

57. Noguchi's explanation of the Beinecke symbolism can be found in Noguchi, *A Sculptor's World*, pp. 170–71.

58. Noguchi, in Friedman, *Noguchi's Imaginary Landscapes*, p. 67.

59. Noguchi, *A Sculptor's World*, p. 174.

60. The futuristic look of the *Dodge Fountain* and its resemblance to some sort of spaceship were intentional: "I wanted to make a new fountain, a fountain which represents our times and our relationship to outer space." (Noguchi, in Friedman, *Noguchi's Imaginary Landscapes,* p. 80.) The fountain's computer controlled eighty possible combinations of water and light.

61. For more detail on this project, see Ashton, *Noguchi East and West,* pp. 278–83.

62. "It seemed absurd to me to be working with rocks and stones in New York, where walls of glass and steel are our horizon, and our landscape is that of boxes piled high in the air." (Noguchi, *A Sculptor's World*, p. 36.)

63. Ibid., p. 38.

64. Created less than two years after Yone Noguchi died, *Cronos* also suggests much psychologically—Cronos being the father who devoured all of his sons except Zeus, who would become the most powerful of the Greek gods.

65. For an account of Noguchi's life at Mure, see Ashton, *Noguchi East and West,* pp. 242–51.

66. Noguchi, *Isamu Noguchi Garden Museum*, p. 11. He also wrote: "Through the artist's hand we arrive at a different epoch in the history of the primordial stone. All that I do is to provide the invasion of a different time element into the time of nature." (Quoted by Sam Hunter in introduction to *Isamu Noguchi: Seventy-fifth Birthday Exhibition* [New York: André Emmerich Gallery and Pace Gallery, 1980], n.p.)

67. Noguchi, in Tatsuo Kondo, "A Conversation with Isamu Noguchi," *Geijitsu Shincho* 19 (July 1968): 15–20, translation in the Archives of the Isamu Noguchi Foundation.

68. This sculpture, completed in 1969, initially was named *Discovery*.

69. For a sense of how comprehensive Noguchi's view of stone could be, witness his remarks at a 1976 sculpture conference: "To me, that object I work on, with stone, I work on not alone but with history, with everything that I know and can call sculpture, that is to say, nature, the wind and the stars, you know, where we come from, where we go to, whatever you will. Ecology, anthropology, all of the factors that have to do with our being on earth are to me, close to stone." (Quoted in Hunter, *Isamu Noguchi,* p. 164.)

70. Martin Friedman presents one way of grouping these forms in *Noguchi's Imaginary Landscapes*, pp. 91ff.

71. Milton Esterow and Sylvia Hochfield, "Isamu Noguchi: The Courage to Desecrate Emptiness," *Artnews* 85 (March 1986): 108.

72. Although Noguchi did not engage in Zen practice, he had seriously studied Zen garden theory and maintained close relations with a number of Buddhist thinkers and Zen teachers.

73. Ted M. Risenhoover, "Govt. Bureaucrats Wasted $100,000 of Your Tax Money on Sculptor's Masterpiece—Five Ordinary Granite Rocks!" *National Enquirer,* February 3, 1976. Later in 1976 Noguchi provoked an even stronger public outcry in Cleveland, with his thirty-five-foot- (eleven-meter-) tall *Portal* outside the Cuyahoga Justice Center, a symbol of both hope and despair. His brilliant solution of using industrial sewer pipe to remain within a very tight budget was taken as an insult and as a joke.

74. For this question as definitive of modernism, see Stanley Cavell, *Must We Mean What We Say?* (Cambridge, England: Cambridge University Press, 1976), pp. 188–89, 218–20.

75. Isamu Noguchi, "Towards a Reintegration of the Arts," *College Art Journal* 9 (Autumn 1949): 60.

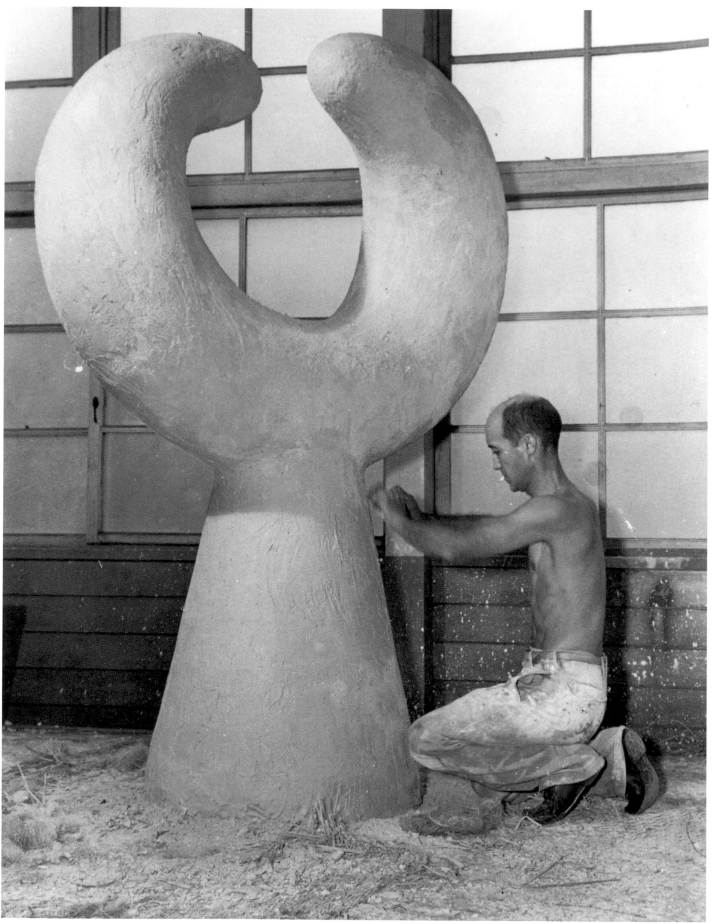

107

Artist's Statements

It is my desire to view nature through nature's eyes, and to ignore man as an object for special veneration. There must be unthought of heights of beauty to which sculpture may be raised by this reversal of attitude.

An unlimited field for abstract sculptural expression would then be realized in which flowers and trees, rivers and mountains, as well as birds, beasts and man, would be given their due place. Indeed, a fine balance of spirit with matter can only concur when the artist has so thoroughly submerged himself in the study of the unity of nature as to truly become once more a part of nature—a part of the very earth, thus to view the inner surfaces and the life elements. The material he works with would mean to him more than mere plastic matter, but would act as a coordinant and asset to his theme. In such a way may be gained a true symphony in sculpture.

It is difficult to visualize sculpture in words, especially that kind for which there are but few similes. Some sculptors today appreciate the importance of matter, but are too much engrossed with symbolism. Others who are undoubtedly artists are interested only in the interpretation of strictly human forms. May I therefore, beg to recognize no antecedents with this declaration of intentions?

> From the artist's Guggenheim Fellowship application, 1926; in Isamu Noguchi, *A Sculptor's World* (New York: Harper and Row, 1968), p. 16.

The essence of sculpture is for me the perception of space, the continuum of our existence. All dimensions are but measures of it, as in the relative perspective of our vision lie volume, line, point, giving shape, distance, proportion. Movement, light, and time itself are also qualities of space. Space is otherwise inconceivable. These are the essences of sculpture and as our concepts of them change so must our sculpture change.

Since our experiences of space are, however, limited to momentary segments of time, growth must be the core of existence. We are reborn, and so in art as in nature there is growth, by which I

107. Noguchi working on *Mu* for the garden at Shin Banraisha, Keiō University, Tokyo, 1950

mean change attuned to the living. Thus growth can only be new, for awareness is the everchanging adjustment of the human psyche to chaos. If I say that growth is the constant transfusion of human meaning into the encroaching void, then how great is our need today when our knowledge of the universe has filled space with energy, driving us toward a greater chaos and new equilibriums.

I say it is the sculptor who orders and animates space, gives it meaning.

Artist's statement in Dorothy C. Miller, ed., *Fourteen Americans* (New York: Museum of Modern Art, 1946), p. 39.

In the creation and existence of a piece of sculpture, individual possession has less significance than public enjoyment. Without this purpose, the very meaning of sculpture is in question. By sculpture we mean those plastic and spatial relationships which define a moment of personal existence and illuminate the environment of our aspirations. Our knowledge of this definition is found in the temple sculpture of the past. There the forms, communal, emotional, and mystic in character, fulfill the larger purpose. It is apparent, therefore, that the function of sculpture, as here defined, is more than merely the decoration of architecture, or the treasure of museums. Both of these outlets, worthy though they may be, are an extension in kind of private ownership. It is not necessary to draw here on the decline of the third, the original and most potent outlet, religion. In the technological order alive today, another channel must be opened for sculpture, if that art is to fulfill its larger purpose.

The tragic aftermath of two wars is a moral crisis from which there is no succor for the spirit. Where once each man's work found some expression through his hands, through his religion and his temple, now there is only mechanization and the concepts of power. The blight of industrialism has pushed man into a specialized corner, and more and more he is assuming the role of spectator. We may say that the critical area of creativity out of which the individual finds his ethos has become so neglected as to jeopardize his survival. In the extremity of this spiritual want, there is a renewed search for the meaning of existence, a recreative process which demands the utmost from artists of every kind in order to build an environment equal to our needs. A reintegration of the arts toward some purposeful social end is indicated in order to enlarge the present outlet permitted by our limiting categories of architects, painters, sculptors, and landscapists.

From Isamu Noguchi, "Towards a Reintegration of the Arts," *College Art Journal* 9 (Autumn 1949): 59–60.

In Japan the rocks in a garden are so planted as to suggest a protuberance from the primordial mass below. Every rock gains enormous weight, and that is why the whole garden may be said to be a sculpture, whose roots are joined way below. We are made aware of this "floating world" through consciousness of sheer invisible mass. At times I am deluded into thinking that the meaning of

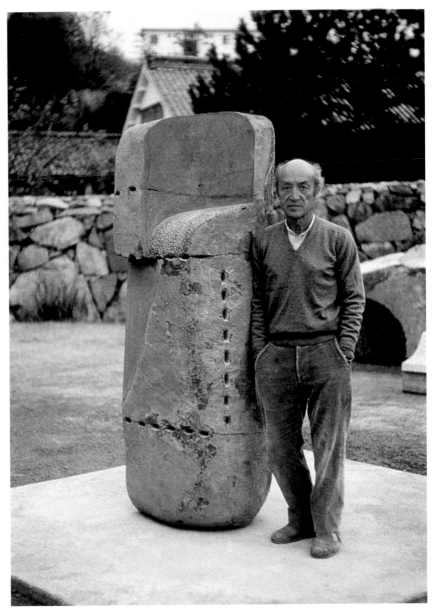

108

sculpture may be defined. Is it not the awareness of an inner reality, such as this, of which sculpture is a reflection and a sign? The heavenly bodies floating in the firmament are all connected, by gravitational forces that link them one to the other to attract and repel. Earthbound though we are, we are free to move about its surface, like filings on a magnet.

New concepts of the physical world and of psychology may give insights into knowledge, but the visible world, in human terms, is more than scientific truths. It enters our consciousness as emotion as well as knowledge; trees grow in vigor, flowers hang evanescent, and mountains lie somnolent—with meaning. The promise of sculpture is to project these inner presences into forms that can be recognized as important and meaningful in themselves. Our heritage is now the world. Art for the first time may be said to have a world consciousness.

From Noguchi, *A Sculptor's World*, p. 40.

108. Noguchi at his Shikoku studio with *Break Through Capestrano*, 1982

107

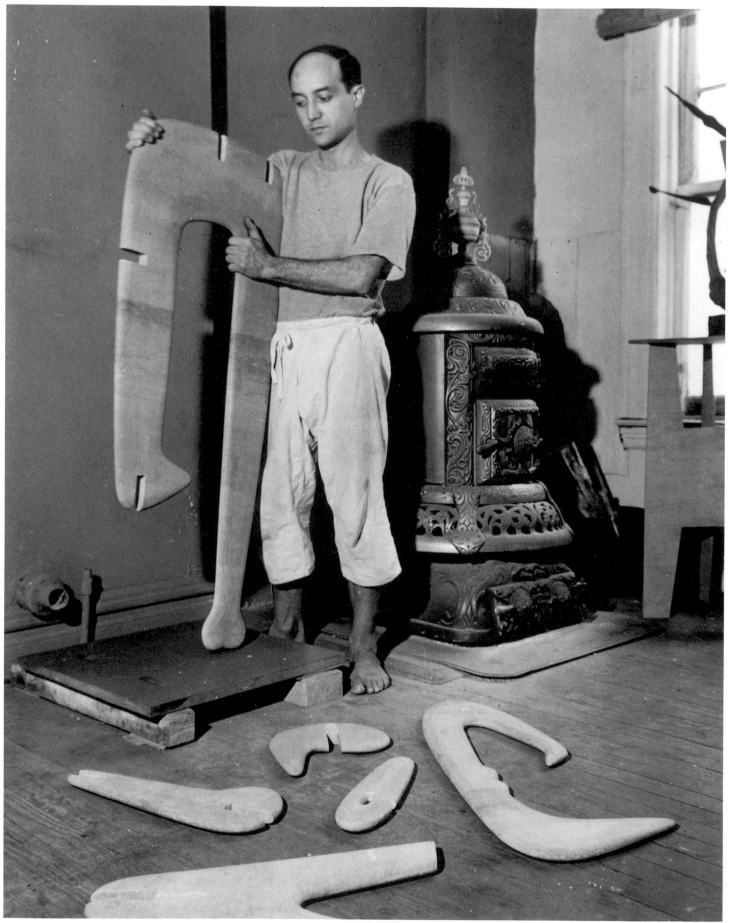

Notes on Technique

110

111

109. Noguchi assembling *Figure* at his MacDougal Alley studio, 1946
Photograph by Eliot Elisofon

110. Maquettes for sculptures in Noguchi's MacDougal Alley studio, mid-1940s
Photograph by André Kertész

111. *Work Sheet for Sculpture,* 1946
Pencil on graph paper mounted on black paper, 23¼ x 26¼ in. (59 x 66.7 cm)
The Isamu Noguchi Foundation, Long Island City, New York

Noguchi embraced the aesthetic of direct carving during his time with Brancusi, and he never ceased to value it above other sculptural means. But throughout his career he also enthusiastically adopted new methods of making sculpture. Factory machinery, industrial fabrication, the use of power tools for cutting and grinding, and, in the sculpture of spaces, bulldozers for moving earth—all of these became tools for the sculptor. For Noguchi, any means that would accomplish the task at hand should be available to the artist, and new devices were always being invented.

There was one element that was a constant in each of these processes, and that was the small maquette, often preceded by series of sketches. Although Noguchi had made models in the 1930s—his earthworks existed solely in that form—it was in his studio on MacDougal Alley that he began to employ them in earnest. On a little stage he would arrange models of his dance sets, and he also worked out his furniture designs in miniature. More unexpectedly, Noguchi made small maquettes for his free- 110 standing sculptures. He modeled clay and plaster images for pieces to be carved in solid stone. He cut and assembled cardboard minia- 111 tures for his interlocking-slab sculptures, using graph-paper construction drawings to work out elements. Thus testing his ideas before starting to carve or to cut, Noguchi adapted the scientist's experimental method for his own use.

Models became extremely important for his work during the 1950s and 1960s, as Noguchi became increasingly involved in architectural and landscape projects. Here the activity was analogous to that of his theatrical design, deploying diminutive works to refine spatial relations among the elements, as well as using the site model to experiment with landscape and architectural forms. He continued to perfect his ideas by this means for his freestanding sculptures, utilizing paper cutouts for the sheet-aluminum works that were created in 1958–59 and making plaster maquettes for sculptures that would be enlarged and machined by skilled workers in Italy and, later, in Japan.

In the 1970s and 1980s Noguchi also employed tiny models in

generating forms for the rough stone works made in Mure. Once he had chosen a particular stone, he used models to sketch in plaster, determining the main features that he wanted to define in basalt and granite. One example is *The Great Rock of Inner Seeking*, a basalt sculpture almost eleven feet (3.4 meters) tall. The small plaster model reveals how Noguchi planned the central channel and general form, which Masatoshi Izumi's stoneworkers roughed out before the artist began to attack the stone himself. Noguchi's involvement was an extremely active one even at this early stage, collaborating closely with Izumi through the cracking and shaping of the stone. It was important to Noguchi that the stone break along its natural lines, and he would work with the natural features of the stone in realizing what he had modeled in plaster. Izumi's knowledge was critical here, and their close interaction would continue through the entire carving process.

Once the rough shape had been achieved, Noguchi would take chisel to stone, often assisted by workers whom he would have break off additional sections that he marked on the rock. Noguchi would decide, often in discussion with Izumi, whether the rock should be cut with a saw, drilled in a line and broken, or cracked with chisels. He would determine how the surface should be treated, generating a dialogue among different textures. New possibilities also were produced by chance developments—particularly the unforeseen ways in which the stone would break, revealing new surface qualities and creating unanticipated forms. This interaction with recalcitrant material was a process that required slow cutting after long looking, and it involved serious thought. Sometimes Noguchi would work for many years on a sculpture—setting a piece aside for extended observation, returning once he knew how to go on, then interrupting the work again, and so on. At his death many great stones sat unfinished in the work yards at Mure, frozen in the midst of creation.

The work on sculpture at Mure began with the selection of the stones, with Noguchi and Izumi visiting natural sites and quarries to choose boulders that seemed right to them both. Back at the studio, Noguchi often played with the orientation of the stone, having Izumi's workers set it up both vertically and horizontally. The process of moving these big stones—many weighing five or six tons—did not stop once the rock was oriented, for Noguchi carved these boulders in a yard some distance from the shed that housed the diamond saw and other tools. Pieces were transported back and forth many times, and multipart works were assembled, disassembled, moved, and reassembled in an ongoing process. Thus not only Izumi's deep knowledge but also his equipment and workers were essential to Noguchi's greatest achievements in stone. While the sculptor's late working procedure was fundamentally an improvisational one, it required serious organization and a significant supporting cast.

Noguchi's materials at Mure were not only retrieved from nature but also were recovered from his working process. Sections of rock broken from works in progress would suggest ideas to the artist, who then set upon these former discards. The most dramatic basalt in the Noguchi Museum garden is *Behind Inner Seeking Shiva*

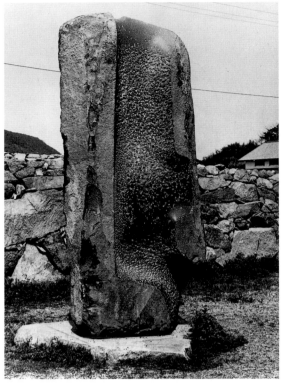

113

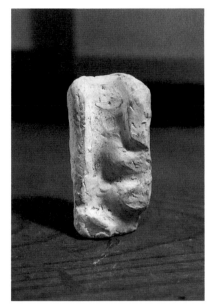

112

Dancing (1976–81), so named because it was begun two years after being detached from the back of the *Great Rock of Inner Seeking*—emerging out of destruction like the dancing Hindu god. Noguchi fashioned sculptures out of the cylindrical cores removed in the making of larger works, his frugal disposition and a strong visual imagination uniting to exploit much that otherwise would have gone to waste. Among his most inspired moves of this kind was to salvage the practice rocks on which the stoneworkers learned particular chisel marks. Recovering from a back operation in 1978 and unable to work on a large scale, Noguchi made some of his most poignant sculptures with these egglike stones of pale gray Aji granite.

Noguchi was known as an artist especially sensitive to materials, and as one who imbued his materials with symbolic significance. His association of stone with nature, and with our fundamental relationship to the natural world, surfaces throughout his own remarks and those of others about his late work. Yet it was not stone itself but the process of carving the basalts and granites at Mure that prompted some of the deepest thinking in his last years. Here the slow pace of carving very hard stone—so different from the marble he had known in Italy—brought into focus the different temporal frames of cultural life, from the quotidian to the art historical to that of world history. Moving into the stone engaged the still greater time of geological process, leading toward that of cosmological formation. The phenomenology of carving became, for Noguchi, an engagement with metaphysics and a means of situating himself within the cosmos. In addition to realizing his great forms in stone, Noguchi's late technique allowed him to move toward a resolution of his deepest personal and existential quandaries, placing him finally at home in the world.

Chronology

1904 November 17—Isamu Noguchi is born in Los Angeles to Leonie Gilmour, an American writer. Isamu's father, Japanese poet Yonejirō (Yone) Noguchi, had returned to Tokyo earlier in the year.

1906 February—Gilmour takes Isamu with her to Japan, to join Yone in Tokyo.

1910 December—Gilmour and Isamu move out of Tokyo to Ōmori.

1912 Gilmour and Isamu move to seaside town of Chigasaki. Ailes, his half-sister, is born.

1913 November—Gilmour builds a new home in Chigasaki, and Isamu is informally apprenticed to help the carpenter.

1916 September—Isamu leaves Japanese school to attend Saint Joseph's College in Yokohama.

1917 January—Gilmour, Isamu, and Ailes move to Yokohama.

1918 Isamu is sent alone to Rolling Prairie, Indiana, to attend the Interlaken School, which closes a few months later for wartime use. The school's founder, Dr. Edward Rumely, places him with a Swedenborgian minister, Dr. Samuel Mack, in La Porte, Indiana.

1922 Graduates from La Porte High School as Isamu Gilmour (nicknamed Sam). Rumely arranges a summer apprenticeship with sculptor Gutzon Borglum in Connecticut and raises funds for Isamu to begin premedical studies at Columbia University. Fall—moves to New York and enters Columbia University.

1923 Gilmour returns to California.

1924 Gilmour moves to New York and encourages Isamu to take an evening sculpture class at the Leonardo da Vinci Art School. The head of the school, Onorio Ruotolo, is enthusiastic and after three months gives Isamu his first exhibition. Leaves Columbia to devote himself to sculpture. Begins using Noguchi instead of Gilmour. Sets up first studio, at 127 University Place, with assistance from Rumely. Elected member of National Sculpture Society.

1925–26 Exhibits academic figurative sculpture at National Academy of Design and Pennsylvania Academy of the Fine Arts. Creates masks for a Michio Itō performance of William Butler Yeats's *At the Hawk's Well*, Noguchi's first work for the theater. November–December 1926—sees Brancusi exhibition at Brummer Gallery.

1927 Awarded John Simon Guggenheim Fellowship for travel to Paris and the Far East. April—arrives in Paris. Soon is introduced to Brancusi and works as his assistant each morning for three to six months. Draws in the afternoons at Académie de la Grande Chaumière and Académie Colarossi. After leaving Brancusi, begins first stone and wood sculpture in his own studio in Montparnasse, at 7, rue Belloni (now rue d'Arsonval).

1928 Works in Paris on abstract sculpture and abstract gouache drawings. Moves studio to 11, rue Dedouvre, Gentilly.

1929 Guggenheim Fellowship is not renewed; returns to New York. Establishes studio on top floor of Carnegie Hall. April—has first one-person exhibition, of Paris abstractions, at Eugene Schoen Gallery. Meets R. Buckminster Fuller and Martha Graham. Moves studio to Madison Avenue and Twenty-ninth Street. Supports himself with portrait sculpture,

which he will continue to do through the next decade.

1930 February—exhibits portrait sculpture at the Marie Sterner Gallery, New York, then travels with Fuller on an exhibition-lecture tour to Cambridge, Massachusetts, and Chicago. April—returns to Paris for two months. Travels to Beijing via Moscow. Remains in Beijing for seven months; studies ink-brush technique with Ch'i Pai-shih, creating series of large figurative brush paintings.

1931 March—arrives in Japan to a difficult reunion with his father. Befriended by his uncle Totaro Takagi. May—travels from Tokyo to Kyoto; first sees Zen gardens and ancient *haniwa* sculpture. Works in Jinmatsu Unō's pottery. September—exhibits ceramic sculpture at eighteenth Nikaten Exhibition, Tokyo. October—returns to New York. November—*Ruth Parks* acquired by Whitney Museum of American Art, New York.

1932 February—exhibits Beijing brush drawings and Chinese ceramic sculpture. Evicted from Sherwood Studios at 58 West Fifty-seventh Street; moves to storefront at 446 East Seventy-sixth Street. *Agnes Enters* acquired by Metropolitan Museum of Art, New York.

1933 January—publication of first full-length essay on Noguchi, written by Julien Levy. Moves to better quarters at the Hotel des Artistes, 1 West Sixty-seventh Street. Summer—travels to London and exhibits Beijing brush drawings. Designs first large-scale public projects—*Monument to the Plow, Play Mountain* (plates 23, 24), and *Monument to Ben Franklin*—as well as *Musical Weathervane* (all unrealized). November or December—Leonie Gilmour dies in New York.

1934 Taken by critic Murdock Pemberton to present proposal for *Play Mountain* to Robert Moses, New York City parks commissioner, who rejects it with sarcasm. Dropped from government Public Works of Art Project due to nontraditional sculpture submitted for review. Summer—works in Woodstock, New York, to prepare exhibition for winter. Moves studio to 239 East Forty-fourth Street.

1935 January–February—exhibits public projects and political works, including *Death (Lynched Figure)* (plate 30). Creates *Frontier* (plate 37), his first stage design for Martha Graham. Leaves New York for California. Sculpts portrait heads in Hollywood and designs swimming pool for Josef von Sternberg at the request of Richard Neutra (unrealized).

1936 Travels to Mexico. Works for seven months on *History Mexico* (plates 31, 32), a seventy-two-foot- (twenty-two-meter-) long political mural in high relief at the Abelardo Rodriguez Market, Mexico City. Designs set for Graham's *Chronicle*.

1937 Returns to New York, with studio at 211 East Forty-ninth Street. Designs first mass-produced object, *Radio Nurse* intercom for Zenith Radio Corporation (plate 34).

1938 Designs first fountain (plate 35), to be constructed of magnesite for the Ford Motor Company Building, New York World's Fair. October—awarded commission for stainless-steel relief, *News* (plate 36), for Associated Press Building, Rockefeller Center (completed 1940).

1939 Travels with other artists to Hawaii, at the invitation of Dole. Designs his first playground equipment for Ala Moana Park, Honolulu (unrealized). Moves studio to 52 West Tenth Street. Designs first table (plate 53), for A. Conger Goodyear, president of the Museum of Modern Art. Works in Boston on casting and finishing of Associated Press Building commission.

1940 Designs set for Graham's *El Penitente*.

1941 Makes model of *Contoured Playground* (unrealized; plate 25) and presents the design to New York City Parks Department. *Capital* acquired by Museum of Modern Art, New York. Summer—drives to California with Arshile Gorky and friends. December 7—living in Hollywood when Japanese attack Pearl Harbor.

1942 January—organizes Nisei Writers and Artists Mobilization for Democracy. March—travels to Washington, D.C., in attempt to mitigate hardships of Japanese-American relocation. May—voluntarily enters Colorado River Relocation Center in Poston, Arizona, to improve environment of internees. November—leaves Poston, disillusioned. Establishes studio at 33 MacDougal Alley, New York.

1943 Makes first Lunar illuminated sculptures, and designs three-legged cylinder lamp to be manufactured by Knoll (in 1944). Creates mixed-media sculptures; carves stone and wood.

1944 Begins series of interlocking-slab sculptures of slate and marble. Designs sets for three works by Graham: *Appalachian Spring, Herodiade,* and *Imagined Wing.* Designs set and costumes for Ruth Page's *The Bells.* Designs biomorphic coffee table and a dinette set (manufactured by Herman Miller in 1947).

1945 Designs plan with Edward Durrell Stone for Jefferson Memorial Park, Saint Louis (unrealized; plate 75). Designs set for Erick Hawkins's *John Brown.*

1946 September—represented in *Fourteen Americans* at the Museum of Modern Art, New York. First important account of his work is written by Thomas B. Hess. Designs set for Graham's *Dark Meadow.*

1947 Creates Lunar ceilings for American Stove Company Building, Saint Louis (plate 57), and Time-Life Building, New York. Herman Miller begins production of Noguchi furniture designs. Creates model for *Memorial to Man,* later called *Sculpture to Be Seen from Mars* (plate 45). Designs sets for two Graham works, *Errand into the Maze* (plate 39) and *Night Journey.* Designs set for Hawkins's *Stephen Acrobat.* Designs set and costumes for Merce Cunningham–John Cage work, *The Seasons.* July—Yonejirō (Yone) Noguchi dies in Tokyo.

1948 Designs sets and costumes for George Balanchine's *Orpheus* (plate 40), and sets for Graham's *Diversion of Angels* and Yuriko Amemiya's *Tale of Seizure.* Creates Lunar stairwell for S.S. *Argentina* (destroyed 1959; plate 58). Designs park and memorial for Gandhi at Raj-gat, India (unrealized).

1949 March—his first one-person show in New York since 1935 held at the Charles Egan Gallery. Awarded fellowship from Bollingen Foundation for a book on "environments of leisure" (not completed). May—begins Bollingen-funded travel to France, England, Spain, Italy, Greece, Egypt, India, Cambodia, and Indonesia.

1950 May 2—arrives in Japan; welcomed by young artists and architects, including Kenzo Tange. Asked to design memorial room and garden for his father at Keiō University (completed 1952; plates 60, 61). August—at Mitsukoshi department store, Tokyo, exhibits new ceramics, furniture, model of Hiroshima memorial bell tower, and sculpture and models for Keiō University project. September 4—departs

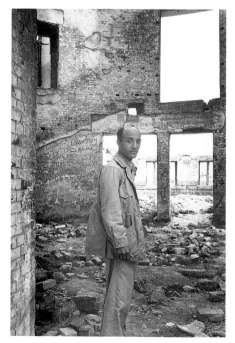

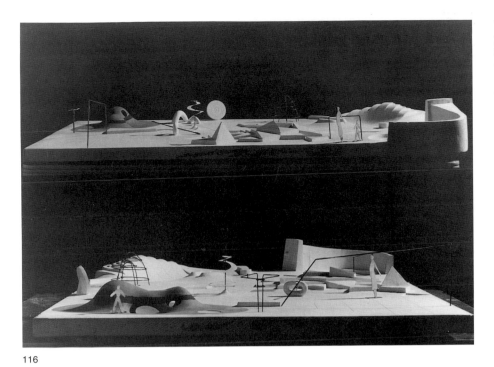

116

for New York. November—meets future wife, actress Yoshiko (Shirley) Yamaguchi, in New York. Designs set for Graham's *Judith*.

1951 March—returns to Japan. June—visits Hiroshima to see the two bridges into Peace Park, in connection with possible commission to design their railings. July—awarded the Hiroshima bridges commission (completed 1952; plates 47, 48). Travels to Gifu; creates the first Akari lantern designs. Designs garden for new Reader's Digest Building in Tokyo (plate 68). Returns to Hollywood with Shirley Yamaguchi; does preliminary design for United Nations playground (unrealized; plate 116). Included in first São Paulo Bienal, Brazil. Winter—returns to New York and begins work on garden for Lever House (plate 72), the first of many projects with Gordon Bunshaft of Skidmore, Owings and Merrill.

1952 Spring—returns to Japan. Asked by Tange and mayor of Hiroshima to design large *Memorial to the Dead* (unrealized; plate 49). May—marries Shirley Yamaguchi in formal ceremony. (Official date of marriage recorded as December 18 at U.S. Embassy, Tokyo.) Establishes house and studio in Kita Kamakura in traditional structure belonging to potter Kitaoji Rosanjin; works in clay. Proposal for

115. Noguchi at building destroyed by atomic blast, Hiroshima, c. 1951–52

116. *Model for United Nations Playground*, 1952 Plaster, 3 x 19¼ x 27¼ in. (7.6 x 48.9 x 69.2 cm) Private collection

Hiroshima cenotaph rejected. September—ceramic works and Akari exhibited in second one-person exhibition at the new Museum of Modern Art, Kamakura. First Akari lanterns become available in Japan.

1953 January–February—returns to New York; works to reverse government denial of U.S. visa to Shirley Yamaguchi for her past association with suspected Communists in Hollywood. Designs set for Graham's *Voyage* (set reused for *Circe*, 1963). July–December—spends much of time outside of U.S. with Yamaguchi, including stays in Paris, Greece, and Hong Kong.

1954 Knoll International manufactures his rocking stools and table. November—exhibits ceramic sculpture from Japan at the Stable Gallery, New York.

1955 April—first Akari exhibition held in New York. Designs sets and costumes for Royal Shakespeare Company production of *King Lear* (plate 38). Designs set for Graham's *Seraphic Dialogue*.

1956 Begins gardens for UNESCO headquarters, Paris (completed 1958; plate 67), and for Connecticut General Life Insurance Company (now CIGNA Corporation), Bloomfield, Connecticut (completed 1957; plate 73). Begins waterfall wall and ceiling for 666 Fifth Avenue, New York (completed 1958; plate 59). Creates cast-iron sculptures in Japan.

1957 January—divorced from Yamaguchi. Designs memorial commemorating the 2,500th birthday of Buddha for New Delhi competition (unrealized). Travels to Japan to search for stones for UNESCO gardens.

1958 Settles in New York again after completion of UNESCO gardens. Creates sheet-aluminum sculpture at factory of lighting designer Edison Price, with assistance of Shoji Sadao. Designs sets for Graham's *Clytemnestra* and *Embattled Garden*.

1959 Creates white marble sculptures when Eleanor Ward refuses to exhibit his aluminum sculptures at his spring Stable Gallery exhibition. Begins a series of balsa-wood sculptures (cast in bronze in Italy in 1962), and a series of stone sculptures using the circular image of the sun.

1960 Begins sculptures for First National City Bank Building Plaza, Fort Worth, Texas (completed 1961). Begins *Sunken Garden for Beinecke Rare Book and Manuscript Library*, Yale University, New Haven, Connecticut (completed 1964; plate 76); and *The Billy Rose Sculpture Garden*, Israel Museum, Jerusalem (completed 1965; plates 79, 80). Designs sets for Graham's *Acrobats of God* and *Alcestis*. July—included in Documenta II, Kassel, West Germany.

1961 Establishes studio and living quarters in former factory building in Long Island City, Queens, across the East River from Manhattan. Begins *Sunken Garden for Chase Manhattan Bank Plaza*, New York (completed 1964; plate 77). Begins five-year collaboration with Louis I. Kahn, issuing in five designs for Riverside Drive playground, New York (unrealized; plates 27, 28). Begins *Mississippi Fountain* for John Hancock Insurance Company Building (now Kaig and Besthoff Building), New Orleans (completed 1962).

1962 As artist-in-residence at the American Academy in Rome makes balsa-wood and clay sculptures to be cast in bronze. Begins working in marble quarries of the firm of Henraux in Querceta, Italy. Will return to work in Italy each year for a decade. Designs set for Graham's *Phaedra*.

1964 Creates gardens for IBM Headquarters, Armonk, New York (plate 74). Designs tomb for John Fitzgerald Kennedy (unrealized). Included in Documenta III, Kassel, West Germany.

1965 Begins his first playground to be realized, at Kodomo No Kuni (Children's Land), near Tokyo (completed 1966).

1966 Creates last set design, for Graham's *Cortege of Eagles*. Creates large painted-steel sculpture for installation outside National Museum of Modern Art, Tokyo. At Henraux quarries in Italy makes large works of rough marble. Establishes the Akari Foundation, New York, to support artistic exchange between the United States and Japan. Begins working, on the island of Shikoku, on *Black Sun* for the Seattle Art Museum (plate 2); this project initiates his collaboration with Masatoshi Izumi.

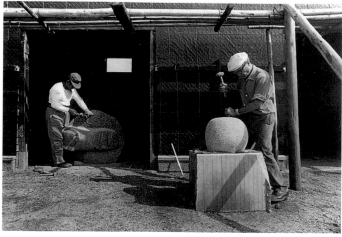

117

118

1968 April—retrospective held at the Whitney Museum of American Art, New York. Publishes autobiography, *A Sculptor's World*. Submits design for United States Pavilion, Expo 70, Osaka, Japan (unrealized). Creates *Red Cube* for 140 Broadway, New York (plate 82); and *Octetra* play sculpture for Spoleto, Italy. Begins series of stone table sculptures and series of marble posttension sculptures.

1969 Creates *Skyviewing Sculpture* for Western Washington University, Bellingham. Establishes studio in village of Mure on Shikoku in collaboration with Izumi; completes first of ongoing series of large-scale basalt sculptures there. *Black Sun* installed in Seattle.

1970 Begins series of Void sculptures. Realizes nine fountains for Expo 70, Osaka, Japan (plate 81).

1972 Begins the *Horace E. Dodge Fountain* and Philip A. Hart Plaza (plates 83, 118), Detroit, with Sadao (completed 1979). Creates sculptures for Bayerische Vereins Bank, Munich.

1974 Begins *Shintō*, Bank of Tokyo Building, New York (completed 1975, destroyed 1980), and *Intetra, Mist Fountain,* for Society of the Four Arts, Palm Beach, Florida, with Sadao (completed 1975). *Void* installed at Pepsico, Purchase, New York. May—acquires building across the street from his Long Island City studio and begins renovating it for display and storage of his sculpture.

1975 Creates *Landscape of Time* (plate 103), Jackson Federal Building, Seattle. Begins *Playscapes* playground, Piedmont Park, Atlanta, with Sadao (completed 1976).

1976 Creates *Portal*, Cuyahoga Justice Center, Cleveland, and begins *Sky Gate*, Honolulu (completed 1977). Begins fountain for the Art Institute of Chicago, with Sadao (completed 1977). Designs 150-foot (48.3-meter) *Friendship Fountain* for Missouri River between Nebraska and Iowa, with Sadao (unrealized). Designs Martha Graham Dance Theater, New York, with Sadao (unrealized).

1977 Begins *Momo Taro* for Storm King Art Center, Mountainville, New York, and *Tengoku (Heaven)* for Sōgetsu Flower Arranging School, Tokyo (both completed 1978; plates 104, 84). Designs landscape for Sacred Rocks of Kukaniloko, Honolulu (unrealized).

1978 Begins Lillie and Roy Cullen Sculpture Garden, Museum of Fine Arts, Houston, with Sadao (completed 1986). Noguchi's *Imaginary Landscapes* exhibition organized by the Walker Art Center, Minneapolis. *Isamu Noguchi* by Sam Hunter published, first monograph on the artist.

1979 Designs Piazza, Finanziaria Fiere di Bologna, Bologna, Italy. Begins design of Bayfront Park, Miami, with Sadao (construction continues, 1994).

1980 Installs *Passage of Seasons* at the Cleveland Art Museum and *Unidentified Object* at the Metropolitan Museum of Art. Begins *Constellation (For Louis Kahn)* for the Kimbell Art Museum, Fort Worth, Texas (completed 1983). Begins redesign of *Bolt of Lightning . . . Memorial to Ben Franklin*, Philadelphia (installed 1984; plate 22). Begins *California Scenario*, South Coast Plaza, Costa Mesa, California (completed 1982; plate 78); and *To the Issei* and Japanese-American Cultural and Community Center Plaza, Los Angeles (completed 1983), both with Sadao. Exhibition, *The Sculpture of Spaces,* held at Whitney Museum of American Art.

1981 Purchases land next to Long Island City building and begins design and construction of the Isamu Noguchi Garden Museum, with Sadao. Begins series of galvanized-steel sculptures with Gemini G.E.L., Los Angeles (completed 1983).

1983 April—Isamu Noguchi Garden Museum opens, by appointment. Noguchi begins construction of garden at studio in Mure, with Izumi.

1984 Completes water garden for Domon Ken Museum, Sakata, Japan (plate 85). Eightieth-birthday celebration held at Sōgetsu Flower Arranging School, Tokyo.

1985 May—Isamu Noguchi Garden Museum officially opens.

1986 June—represents the United States at the Venice Biennale. November—receives Kyoto Prize from Inamori Foundation, Japan. Creates *Tsukubai* fountain for the Metropolitan Museum of Art .

1987 June—receives National Medal of Arts in Washington, D.C.

1988 Creates master plan of 400-acre (162-hectare) park for Sapporo, Japan (under construction, 1994), and designs large sculpture for Takamatsu Airport, Shikoku, Japan (completed 1991). July—awarded Third Order of the Sacred Treasure by the Japanese government. December—receives Award for Distinction in Sculpture from the Sculpture Center, New York. December 30—dies in New York.

117. Noguchi carving *Childhood* at his Shikoku studio, c. 1969–70

118. Philip A. Hart Plaza, 1972–79 Detroit

Exhibitions

1929

Isamu Noguchi, Eugene Schoen Gallery, New York, April.

1930

Fifteen Heads by Isamu Noguchi, Marie Sterner Gallery, New York, February 1–14.

Sculpture by Isamu Noguchi, Arts Club of Chicago, March 26–April 9.

1931

An Exhibition of Drawings by the Sculptor Isamu Noguchi, John Becker Gallery, New York, March 3–27.

1932

Brush Drawings by Isamu Noguchi, Demotte Galleries, New York, February–March.

Sculpture by Isamu Noguchi, John Becker Gallery, New York, February 15–March 10.

Brush Drawings and Sculpture by Isamu Noguchi, Arts Club of Chicago, March 4–30.

Sculpture and Drawings by Isamu Noguchi, Reinhardt Gallery, New York, December.

1933

Drawings and Small Sculptures by Isamu Noguchi, Honolulu Academy of Arts, January 3–29, and tour to the California Palace of the Legion of Honor, San Francisco; Fine Arts Society, Pasadena, California; Pasadena Art Institute.

Sculpture and Drawings by Isamu Noguchi, Mellon Galleries, Philadelphia, February 25–March 14.

1934

Isamu Noguchi, Sidney Burney Gallery, London, Summer.

1935

Isamu Noguchi, Marie Harriman Gallery, New York, January 29–February 16.

1940

Isamu Noguchi, Honolulu Academy of Arts, May 14–26.

1942

Isamu Noguchi, San Francisco Museum of Art, July.

1949

Isamu Noguchi, Charles Egan Gallery, New York, March 1–26.

1950

Isamu Noguchi, Mitsukoshi, Ltd., Tokyo, August 18–27.

1952

Isamu Noguchi, Museum of Modern Art, Kamakura, Japan, September 23–October 19.

1954

Isamu Noguchi, Stable Gallery, New York, November 23–January 8, 1955.

1955

Akari, Bonniers, New York, April. Also in 1962, 1964.

Sculpture and Drawings by Noguchi, Arts Club of Chicago, November 11–December 7.

1959

Isamu Noguchi, Stable Gallery, New York, April 29–May 30.

1961

Isamu Noguchi, Fort Worth Art Center, May–July.

Noguchi: Weightlessness, Cordier and Warren Gallery, New York, May 16–June 17.

1963

Isamu Noguchi, Cordier and Ekstrom Gallery, New York, April 2–April 27.

1965

Isamu Noguchi, Cordier and Ekstrom Gallery, New York, March 30–April 24.

1967

Isamu Noguchi, Cordier and Ekstrom Gallery, New York, April 4–29.

1968

Isamu Noguchi Retrospective, Whitney Museum of American Art, New York, April 17–June 16.

Brush Drawings 1930, Cordier and Ekstrom Gallery, New York, April 23–May 18.

Isamu Noguchi, Gimpel Fils Gallery, London, July 9–August 24.

Isamu Noguchi, Galerie Gimpel und Hanover, Zurich, October 12–November 19.

1970

Isamu Noguchi, Cordier and Ekstrom Gallery, New York, November 4–28.

1972

Strange Birds, Cordier and Ekstrom Gallery, New York, May 9–June 17.

Isamu Noguchi, Gimpel Fils, London, September 14–October 7.

Isamu Noguchi, Galerie Gimpel und Hanover, Zurich, November.

1973

Isamu Noguchi, Minami Gallery, Tokyo, May 14–June 9.

1975

Noguchi: Steel Sculptures, Pace Gallery, New York, May 10–June 20.

1977

Noguchi: The Sculptor as Designer, Museum of Modern Art, New York, November–January 8, 1978.

1978

Noguchi's Imaginary Landscapes, Walker Art Center, Minneapolis, April 23–June 18, and tour to the Denver Art Museum, Cleveland Museum of Art, Detroit Institute of Art, San Francisco Museum of Modern Art, Philadelphia Museum of Art.

1980

The Sculpture of Spaces, Whitney Museum of American Art, New York, February 5–April 6.

Seventy-fifth Birthday Exhibition, Landscape Tables, 1968–79, Emmerich Gallery, New York, February 16–March 15.

Seventy-fifth Birthday Exhibition, Recent Stones 1978–1979, Pace Gallery, New York, February 16–March 15.

1981

Granits, Basaltes, Obsidiennes, Galerie Maeght, Paris, May 6–July 10.

1982

Isamu Noguchi, Gallery Kasahara, Osaka, October 16–December 28.

1983

Noguchi—New Sculpture, Pace Gallery, New York, May 6–June 4.

Isamu Noguchi, Gallery Kasahara, Osaka, November 7–30, and tour.

1985

Isamu Noguchi—Stones, Gallery Kasahara, Osaka, January 10–31.

Space of Akari and Stone, Yurakucho Art Forum, Tokyo, February 9–20.

Isamu Noguchi: Bronze Sculpture, 1959–1962, Arnold Herstand Gallery, New York, October 30–December 14.

1986

Seven Stones, Pace Gallery, New York, March 28–April 26.

Isamu Noguchi: What Is Sculpture? Venice Biennale, June 29–September 28.

1988

Isamu Noguchi: The New Bronzes, 1987–1988, Arnold Herstand Gallery, New York, May 6–June 18.

Isamu Noguchi: Bronze and Iron Sculpture, Pace Gallery, New York, May 13–June 11.

1989

Isamu Noguchi: The New Bronzes, 1987–1988, Gallery Kasahara, Osaka, February 21–March 18.

Isamu Noguchi Portrait Sculpture, National Portrait Gallery, Washington, D.C., April 15–August 20, and tour to Whitney Museum of American Art at Phillip Morris, New York.

1990

Isamu Noguchi: Sculpture, Earl McGrath Gallery, Los Angeles, March 17–April 11.

1992

Isamu Noguchi Retrospective 1992 Japan, National Museum of Modern Art, Tokyo, March 13–May 10, and tour to the National Museum of Modern Art, Kyoto.

Akari: Sculpted Light by Isamu Noguchi, Sheldon Memorial Art Gallery, University of Nebraska, Lincoln, November 17–January 13, 1993.

Dear Heartfelt Friend, Isamu Noguchi, Marugame Genichiro Inokuma Museum, Marugame, Japan, November 23–March 14, 1993.

Selected Group Exhibitions

1926

101st Annual Exhibition, National Academy of Design, New York, March 20–April 11. Also included in 1927.

Winter Exhibition, National Academy of Design, New York, November 27–December 19.

121st Annual Exhibition, Pennsylvania Academy of the Fine Arts, Philadelphia, December 31–March 31, 1927. Also included in 1927.

1930

Watercolors by a Group of Five and Bronzes by Isamu Noguchi, Harvard Society for Contemporary Art, Cambridge, Massachusetts, February 27–March 15.

An Exhibition of the Work of 46 Painters and Sculptors under 35 Years of Age, Museum of Modern Art, New York, April 12–April 26.

An Exhibit of Bronzes and Drawings by Isamu Noguchi and a Group of Bronzes by Chana Orloff, Buffalo Fine Arts Academy and Albright Art Gallery, Buffalo, New York, December 24–January 25, 1931, and tour.

1931

Eighteenth Nikaten Exhibition, Ueno Art Gallery, Tokyo, September.

1932

American Painting and Sculpture, Museum of Modern Art, New York, October 31–January 31, 1933.

1933

International Exhibition of Contemporary Sculpture, Philadelphia Museum of Art, May 14–September 16.

1934

Modern Works of Art: Fifth Annual Exhibition, Museum of Modern Art, New York, November 20–January 20, 1935.

1935

An Art Commentary on Lynching, Arthur U. Newton Galleries, New York, February.

1936

Fantastic Art, Dada, Surrealism, Museum of Modern Art, New York, December 7–January 17, 1937.

1939

Sculpture Annual, Whitney Museum of American Art, New York, January 24–February 17. Also included in 1940, 1945, 1947, 1948, 1949, 1950, 1951, 1952, 1956, 1957, 1959, 1961, 1963, 1965, 1967, 1971.

Art in Our Time, Museum of Modern Art, New York, May 10–September 30.

1942

Twentieth-Century Portraits, Museum of Modern Art, New York, December 9–January 24, 1943.

1944

Art in Progress, Museum of Modern Art, New York, May 24–October 15.

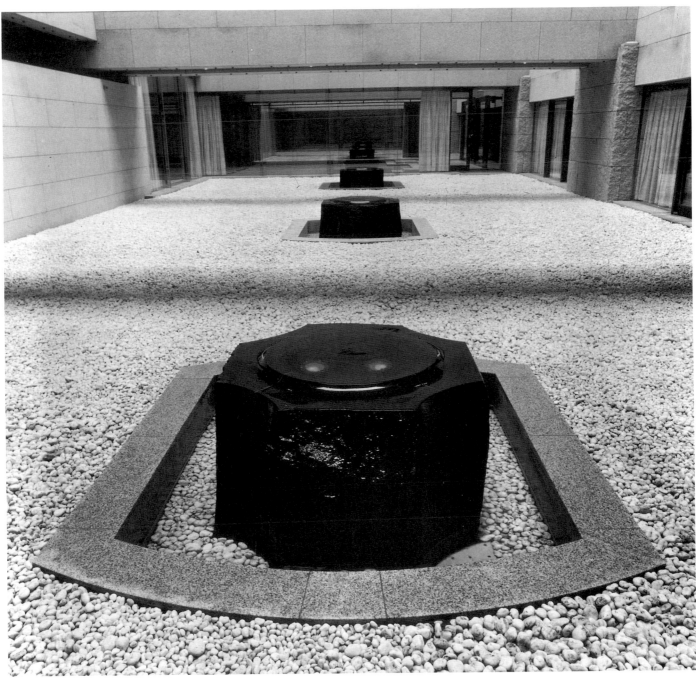

119

119. *Supreme Court Building Fountains,* 1974
Granite, 6 fountains, approximately 34 x 32 x 32 in.
(86.4 x 81 x 81 cm), each
Tokyo

1946
Fourteen Americans, Museum of Modern Art, New York, September 10–December 8.

1947
Bloodflames, Hugo Gallery, New York.
 Exposition internationale du surréalisme, Galerie Maeght, Paris.

1949
Sculpture since Rodin, Yale University Art Gallery, New Haven, Connecticut, January 14–February 13.

1951
Bienal I, Museu de Arte Moderna, São Paulo, Brazil.

Abstract Painting and Sculpture in America, Museum of Modern Art, New York, January 23–March 5, and tour.
 Modern Relief, Museum of Modern Art, New York, June 20–July 15.

1954
American Painting, 1754–1954, Metropolitan Museum of Art, New York.

1955
Fifty Years of American Art, Museum of Modern Art, New York, February–June, and tour.

1956
Abstract Art, 1910 to Today, Newark Museum, Newark, New Jersey, April 27–June 10.

1958

Nature in Abstraction, Whitney Museum of American Art, New York, January 14–March 16.

Pittsburgh International Exhibition, Carnegie Institute, Pittsburgh, December 5–February 8, 1959. Also included in 1962, 1964, 1967, 1971.

1959

Documenta II, Kassel, West Germany, July 11–October 11. Also included in 1964.

1961

American Art of Our Century, Whitney Museum of American Art, New York, November 14–December 10.

1962

Continuity and Change, Wadsworth Atheneum, Hartford, Connecticut, April 11–May 27.

1964

Painting and Sculpture of a Decade, Tate Gallery, London, April 22–June 28.

1965

Etats-Unis: Sculptures du XXe siècle, Musée Rodin, Paris, Summer.

1966

5e Internationale beeldententoonstelling Sonsbeek '66, Sonsbeek, The Netherlands, May 27–September 25.

Art in the United States, 1670–1966, Whitney Museum of American Art, New York, September 28–November 27.

1967

American Sculpture of the Sixties, Los Angeles County Museum of Art, April 28–June 25.

1968

Opening Exhibition, National Collection of Fine Arts, Smithsonian Institution, Washington, D.C., May.

1969

Contemporary Art Dialogue between the East and the West, National Museum of Modern Art, Tokyo, June–August.

New York Painting and Sculpture, 1940–70, Metropolitan Museum of Art, New York, October 18–February 1, 1970.

1970

Noguchi and Rickey and Smith, Indiana University Art Museum, Bloomington, November 8–December 18.

1971

Middelheim Biennale, Kunsthistorische Musea, Antwerp, Belgium, June 6–October 3.

1972

Venice Biennale, June 11–October 1.

1973

American Art at Mid-Century, National Gallery of Art, Washington, D.C., October 28–January 6, 1974.

1974

Inaugural Exhibition, Hirshhorn Museum and Sculpture Garden, Smithsonian Institution, Washington, D.C., October 4–September 15, 1975.

Masters of Modern Sculpture, Solomon R. Guggenheim Museum, New York, November 19–January 12, 1975.

1975

Sculpture: American Directions 1956–1975, National Collection of Fine Arts, Smithsonian Institution, Washington, D.C., October 3–November 30.

1976

Two Hundred Years of American Sculpture, Whitney Museum of American Art, New York, March 16–September 26.

1977

The Public Monument and Its Audience, Cleveland Museum of Art, December 13–March 8, 1978.

1978

William Carlos Williams and the American Scene, 1920–1940, Whitney Museum of American Art, New York, December 14–February 4, 1979.

1979

A Century of Ceramics in America, 1878–1978, Everson Museum of Art, Syracuse, New York, May 5–September 23.

Drawings and Sculptures: Noguchi, Calder and Smith, Storm King Art Center, Mountainville, New York, May 19–October 29.

Vanguard American Sculpture, Jane Voorhees Zimmerli Art Museum, Rutgers University, New Brunswick, New Jersey, September 16–November 4, and tour.

1980

The Figurative Tradition, Whitney Museum of American Art, New York, June 25–September 28.

1982

Twenty American Artists, San Francisco Museum of Modern Art, July 22–September 19.

1984

The Third Dimension: Sculpture of the New York School, Whitney Museum of American Art, New York, December 6–March 3, 1985, and tour.

1985

Transformations in Sculpture: Four Decades of American and European Art, Solomon R. Guggenheim Museum, New York, November 22–February 16, 1986.

1986

Qu'est-ce que c'est la sculpture moderne? Centre Georges Pompidou, Musée National d'Art Moderne, Paris, June 1–October 13.

The Machine Age in America, 1918–1941, Brooklyn Museum, October 16–February 15, 1987, and tour.

Le Japon des avant-gardes, Centre Georges Pompidou, Musée National d'Art Moderne, Paris, December 9–March 2, 1987.

Individuals: A Selected History of Contemporary Art, 1945–1986, Museum of Contemporary Art, Los Angeles, December 10–January 10, 1988.

1987

Fifty Years of Collecting: An Anniversary Selection—Sculpture of the Modern Era, Solomon R. Guggenheim Museum, New York, November 13–March 13, 1988.

1988

Viewpoints: Postwar Painting and Sculpture, Guggenheim Museum, New York, December–January 22, 1989.

1990

Buckminster Fuller, Harmonizing Technology, Humanity, and Nature, Edith C. Blum Art Institute, Bard College Center, Annandale-on-Hudson, New York, April 1–June 17.

1991

Abstract Sculpture in America, 1930–1970, American Federation of Arts, New York, February 7–March 31, and tour.

1992

American Masters, Whitney Museum of American Art at Equitable, New York, April 16–June 17, and tour.

1993

Rolywholyover: A Circus for Museum by John Cage, Museum of Contemporary Art, Los Angeles, September 12–November 28, and tour.

Public Collections

Albany, New York, Nelson A. Rockefeller
Empire State Plaza
Ann Arbor, Michigan, University of Michigan
Museum of Art
Armonk, New York, IBM Headquarters
Atlanta, Georgia, High Museum of Art
Atlanta, Georgia, Piedmont Park
Baltimore, Maryland, Baltimore Museum of
Art
Belfast, Northern Ireland, Ulster Museum
Bellingham, Washington, Western Washington
University
Bloomington, Indiana, Indiana University Art
Museum
Bloomfield, Connecticut, CIGNA Corporation
Bologna, Italy, Finanziaria Fiere di Bologna
Bridgeport, Connecticut, Housatonic Museum
Brooklyn, New York, Brooklyn Museum
Buffalo, New York, Albright-Knox Art
Gallery
Cambridge, Massachusetts, Fogg Art
Museum, Harvard University
Canton, New York, Richard F. Brush Art
Gallery, Saint Lawrence University
Carbondale, Illinois, Southern Illinois
University Museum
Chicago, Illinois, Art Institute of Chicago
Chicago, Illinois, Arts Club of Chicago
Cleveland, Ohio, Cleveland Museum of Art
Cleveland, Ohio, Cuyahoga Justice Center
Columbus, Ohio, Columbus Museum of Art
Corning, New York, Corning Museum of
Glass
Costa Mesa, California, South Coast Plaza
Dallas, Texas, Meadows Museum of Art
Denver, Colorado, Denver Art Museum
Des Moines, Iowa, Des Moines Art Center
Detroit, Michigan, Detroit Institute of the
Arts
Detroit, Michigan, Philip A. Hart Plaza
Duisburg, Germany, Wilhelm Lehmbruck
Museum der Stadt
Fort Dodge, Indiana, Bladen Memorial Art
Museum

Fort Worth, Texas, First National City Bank
Fort Worth, Texas, Kimbell Art Museum
Fukui-ken, Japan, Miyazaki Town Hall
Gunma, Japan, Okawa Museum of Art
Haddon Heights, New Jersey, Post Office
Building
Hakone, Japan, Hakone Open-Air Museum
Hartford, Connecticut, Wadsworth Atheneum
Hiroshima, Japan, Kure Municipal Museum
of Art
Hiroshima, Japan, Peace Park
Honolulu, Hawaii, Honolulu Academy of Art
Honolulu, Hawaii, Honolulu Municipal
Building
Houston, Texas, Houston Museum of Fine
Arts
Humlebaek, Denmark, Louisiana Museum of
Modern Art
Ichinomiya, Japan, Ichinomiya Municipal
Museum
Indianapolis, Indiana, Indianapolis Museum
of Art
Jerusalem, Israel, The Israel Museum
Kagoshima, Japan, Nagashima Cultural
Foundation
Kamakura, Japan, Museum of Modern Art
Kansas City, Missouri, Nelson-Atkins
Museum of Art
Kurashiki, Japan, Ōhara Museum of Art
Kyoto, Japan, Kawashima Textile School
Lincoln, Nebraska, Sheldon Memorial Art
Gallery, University of Nebraska
London, England, Tate Gallery
Long Island City, New York, Isamu Noguchi
Garden Museum
Long Island City, New York, La Guardia
Community College
Los Angeles, California, Frederick Weisman
Foundation of Art
Los Angeles, California, Japanese-American
Cultural and Community Center
Los Angeles, California, Lannan Foundation
Los Angeles, California, Los Angeles County
Museum of Art

Los Angeles, California, Wight Art Gallery, University of California at Los Angeles

Louisville, Kentucky, The J. B. Speed Museum

Mexico City, Mexico, Abelardo Rodriguez Market

Miami, Florida, Bayfront Park

Milwaukee, Wisconsin, Bradley Family Foundation

Minneapolis, Minnesota, Walker Art Center

Modena, Italy, Fondazione Umberto Severi

Mountainville, New York, Storm King Art Center

Munich, Germany, Bayerisches Vereins Bank

Nagoya, Japan, Nagoya City Museum

New Britain, Connecticut, New Britain Museum of American Art

New Haven, Connecticut, Beinecke Rare Book and Manuscript Library, Yale University

New Haven, Connecticut, Yale University Art Gallery

New Orleans, Louisiana, Kaig and Besthoff Building

New York, New York, Associated Press Building, Rockefeller Center

New York, New York, Chase Manhattan Bank Plaza

New York, New York, Japan Society

New York, New York, Marine Midland Bank Building

New York, New York, Metropolitan Museum of Art

New York, New York, Museum of Modern Art

New York, New York, New School for Social Research

New York, New York, New York Public Library of the Performing Arts at Lincoln Center

New York, New York, 666 Fifth Avenue

New York, New York, Solomon R. Guggenheim Museum

New York, New York, Whitney Museum of American Art

Oberlin, Ohio, Allen Memorial Art Museum, Oberlin College

Old Westbury, New York, New York Institute of Technology

Osaka, Japan, Expo 70

Osaka, Japan, National Museum of Art

Osaka, Japan, Perfect Liberty Church

Otterlo, The Netherlands, Rijksmuseum Kröller-Müller

Palm Beach, Florida, Society of the Four Arts

Palm Springs, California, Palm Springs Desert Museum

Paris, France, UNESCO

Pasadena, California, Norton Simon Museum of Art

Philadelphia, Pennsylvania, Fairmount Park Art Association

Philadelphia, Pennsylvania, Pennsylvania Academy of the Fine Arts

Philadelphia, Pennsylvania, Philadelphia Museum of Art

Pietrasanta, Italy, Museo dei Bozzetti

Pittsburgh, Pennsylvania, Carnegie Museum of Art

Portland, Oregon, Portland Art Museum

Poughkeepsie, New York, Vassar College Art Gallery

Princeton, New Jersey, Princeton University Art Museum

Purchase, New York, Neuberger Museum, State University of New York at Purchase

Purchase, New York, Pepsico

Richmond, Virginia, Virginia Museum of Fine Arts

Rochester, New York, Memorial Art Gallery of the University of Rochester

Sakata, Japan, Domon Ken Museum

San Antonio, Texas, Marion Koogler McNay Art Museum

San Francisco, California, Art Commission of San Francisco

San Francisco, California, San Francisco Museum of Modern Art

Santa Barbara, California, Santa Barbara Museum of Art

Sapporo, Japan, City of Sapporo

Seattle, Washington, Jackson Federal Building

Seattle, Washington, Seattle Art Museum

Shiga, Japan, Museum of Modern Art

Shizuoka-ken, Japan, Shizuoka Prefectural Museum of Art

Southborough, Massachusetts, Saint Marks School

Takamatsu, Japan, Kagawa Prefectural Cultural Center

Takamatsu, Japan, Takamatsu City International Airport

Takamatsu, Japan, Takamatsu City Museum of Art

Tokushima, Japan, Tokushima Modern Art Museum

Tokyo, Japan, Keiō University

Tokyo, Japan, National Museum of Modern Art, Tokyo

Tokyo, Japan, Sezon Museum of Art

Tokyo, Japan, Sōgetsu Flower Arranging School

Toledo, Ohio, Toledo Museum of Art

Washington, D.C., Hirshhorn Museum and Sculpture Garden, Smithsonian Institution

Washington, D.C., National Gallery of Art

Washington, D.C., National Museum of American Art, Smithsonian Institution

Washington, D.C., National Portrait Gallery, Smithsonian Institution

Waterville, Maine, Colby College Museum of Art

West Palm Beach, Florida, Norton Gallery and School of Art

Wilmington, North Carolina, Saint John's Museum of Art

Worcester, Massachusetts, Worcester Art Museum

Yokohama, Japan, Yokohama Museum of Art

Selected Bibliography

Interviews, Statements, and Writings

Cummings, Paul. *Artists in Their Own Words.* New York: St. Martin's Press, 1979, pp. 102–22.

Esterow, Milton, and Sylvia Hochfield. "Isamu Noguchi: The Courage to Desecrate Emptiness." *Artnews* 85 (March 1986): 102–9.

Floda, Livin. "An Interview with Isamu Noguchi on Brancusi." *American Rumanian Academy Journal* 8–9 (1989): 270–76.

Gruen, John. "The Artist Speaks—Isamu Noguchi." *Art in America* 56 (March–April 1968): 28–31.

Kuh, Katharine. "An Interview with Isamu Noguchi." *Horizon* 11 (March 1960): 104–12. Reprinted in Katherine Kuh, *The Artist's Voice*, pp. 171–87. New York: Harper and Row, 1962.

Noguchi, Isamu. "Shelters of the Orient." *Shelter* 2 (November 1932): 96.

———. "What's the Matter with Sculpture?" *Art Front* 16 (September–October 1936): 13–14.

———. "Trouble among Japanese-Americans." *New Republic* 108 (February 1, 1943): 142.

———. Statement in *Fourteen Americans*, edited by Dorothy C. Miller. New York: Museum of Modern Art, 1946, p. 39.

———. "Meanings in Modern Sculpture." *Artnews* 48 (March 1949): 12–15, 55–56.

———. "From an Interview with Isamu Noguchi." *League Quarterly* 20 (Spring 1949): 8–9.

———. "Towards a Reintegration of the Arts." *College Art Journal* 9 (Autumn 1949): 59–60.

———. "Art and the People." *Mainichi*, June 16, 1950.

———. "Isamu Noguchi." *Arts and Architecture* 67 (November 1950): 24–27.

———. "Isamu Noguchi: Projects in Japan." *Arts and Architecture* 69 (October 1952): 24–26.

———. "Project: Hiroshima Memorial to the Dead." *Arts and Architecture* 70 (April 1953): 16–17.

———. "Rosanjin, Potter and Cook." *Vogue* 123 (May 1, 1954): 170.

———. "Japanese Akari Lamps." *Craft Horizons* 14 (October 1954): 16–18.

———. "Designer's Note." In *The Tragedy of King Lear*, by William Shakespeare. London: Folio Society, 1956.

———. "The 'Arts' Called 'Primitive.'" *Artnews* 56 (March 1957): 24–27, 64.

———. "Garden of Peace." *UNESCO Courier* 11 (November 1958): 32–33.

———. "UNESCO Gardens." *Arts and Architecture* 76 (January 1959): 12–13.

———. "Sculpture Garden of the New National Museum of Jerusalem." *Arts and Architecture* 77 (October 1960): 20–21.

———. "Collaboration: Artist and Architect." *Arts and Architecture* 79 (September 1962): 23.

———. "New Stone Gardens." *Art in America* 52 (June 1964): 84–89.

———. "Sculpture Garden." *Arts and Architecture* 82 (September 1965): 27–29.

———. *A Sculptor's World.* Foreword by R. Buckminster Fuller. New York: Harper and Row, 1968.

———. "The Sculptor and the Architect." *Studio* 176 (1968): 18–20.

———. "A Reminiscence of Four Decades." *Architectural Forum* 136 (January–February 1972): 59.

———. Introduction to *Sculptures by Isamu Noguchi*. Tokyo: Minami Gallery, 1973.

———. "Noguchi on Brancusi." *Craft Horizons* 35 (August 1976): 26–29.

———. "On Washi." In Sukey Hughes, *Washi: The World of Japanese Paper*. Tokyo: Kodansha International, 1976, pp. 25–26.

———. *Isamu Noguchi: The Sculpture of Spaces*. New York: Whitney Museum of American Art, 1980.

———. Introduction to *Isamu Noguchi: Seven Stones*. New York: Pace Gallery, 1986.

———. *The Isamu Noguchi Garden Museum*. New York: Harry N. Abrams, 1987.

———. "On the Structure and Carving of Bronze Plate." In *Isamu Noguchi: The New Bronzes: 1987–88*. New York: Arnold Herstand and Company, 1988. Reprinted in *Isamu Noguchi: The Bronzes: 1987–1988*. Osaka, Japan: Gallery Kasahara, 1989.

Tracey, Robert. "Noguchi: Collaborating with Graham." *Ballet Review* 13 (Winter 1986): 9–17.

Yamada, Chisaburoh F., ed. *Dialogue in Art—Japan and the West*, pp. 289–93. Tokyo: Kodansha International, 1976.

Monographs and Solo-Exhibition Catalogs

Ashton, Dore. Introduction to *Noguchi*. New York: Pace Gallery, 1983.

———. Introduction to *Isamu Noguchi: Bronze and Iron Sculpture*. New York: Pace Gallery, 1988.

———. *Noguchi East and West*. New York: Alfred A. Knopf, 1992.

de Mandiargues, André Pieyre. Introduction to "Noguchi: Granits, basaltes, obsidiennes." *Derrière le miroir* 245. Paris: Galerie Maeght, 1981.

Friedman, Martin. *Noguchi's Imaginary Landscapes*. Minneapolis: Walker Art Center, 1978. Includes chronology, bibliography, and appendix on Noguchi's formal vocabulary.

Fuller, Buckminster. "Noguchi." *Palette* (Connecticut Arts Association) (Winter 1960): entire issue.

Geldzahler, Henry. *Isamu Noguchi: What Is Sculpture?* Venice: Forty-second Venice Biennale Exhibition, 1986. Includes chronology.

Gordon, John. *Isamu Noguchi*. New York:

Whitney Museum of American Art, 1968. Includes chronology, bibliography, and list of exhibitions.

Grove, Nancy. *Isamu Noguchi: A Study of the Sculpture*. New York: Garland Publishing Company, 1985.

———. *Isamu Noguchi Portrait Sculpture*. Washington, D.C.: National Portrait Gallery; Smithsonian Institution Press, 1989. Includes bibliography and list of exhibitions.

Grove, Nancy, and Diane Botnick. *The Sculpture of Isamu Noguchi, 1924–1979*. New York: Garland Publishing Company, 1980. Includes list of exhibitions and extensive bibliography.

Hunter, Sam. *Isamu Noguchi*. New York: Abbeville Press, 1978.

———. Introduction to *Isamu Noguchi: Seventy-fifth Birthday Exhibition*. New York: André Emmerich Gallery and Pace Gallery, 1980.

Inokuma, Genichiro. Introduction to *Dear Heartfelt Friend, Isamu Noguchi*. Marugame, Japan: Marugame Genichiro Inokuma Museum of Modern Art, 1992.

Inui, Yoshiaki. Introduction to *Isamu Noguchi: Stones*. Osaka, Japan: Gallery Kasahara, 1985.

"The Landscapes of Noguchi." *Landscape Architecture* 80 (April 1990): entire issue.

McClure, Michael. Introduction to *Isamu Noguchi at Gemini*. Los Angeles: Gemini G.E.L., 1982.

Michelson, Annette. Introduction to *Isamu Noguchi*. Paris: Claude Bernard Gallery, 1964. Reprinted as introduction to *Isamu Noguchi: Bronze Sculpture, 1959–1962*. New York: Arnold Herstand and Company, 1985.

Okada, Takahiko. Introduction to *Isamu Noguchi: Space of Akari and Stone*. San Francisco: Chronicle Books, 1986. Includes essays by Arata Isozaki and Isamu Noguchi.

Robertson, Bryan. Introduction to *Noguchi: Steel Sculptures*. New York: Pace Gallery, 1975.

Takahachi, Koji. *Isamu Noguchi Retrospective 1992*. Tokyo: National Museum of Modern Art, 1992. Includes chronology and list of exhibitions.

Threlfall, Tim. *Isamu Noguchi: Aspects of a Sculptor's Practice*. Sussex, England: Seagull Books, 1992.

Tobias, Tobi. *Isamu Noguchi: The Life of a Sculptor*. New York: Thomas Y. Crowell Company, 1974. Account of the artist's life written for children.

Warburg, Edward M. M. Introduction to *Isamu Noguchi*. Philadelphia: Mellon Galleries, 1933.

Winther, Bert. *Isamu Noguchi: Conflicts of Japanese Culture in the Early Postwar Years*. Ann Arbor: University of Michigan Press, 1993.

Periodicals, Books, and Group-Exhibition Catalogs

American Abstract Artists. *The World of Abstract Art*. New York: George Wittenborn, 1957.

Anzai. *Homage to Isamu Noguchi*. Tokyo: Galerie Tokoro, 1992.

Ashton, Dore. "Isamu Noguchi." *Arts and Architecture* 76 (August 1959): 14–15.

———. "Isamu Noguchi." *Arts and Architecture* 80 (June 1963): 6–7.

———. "New Sculpture Fresh in Old Techniques." *Studio* 169 (June 1965): 260–61.

"Astronomical City." *Portfolio: A Graphic Arts Quarterly* (1951). Presents Noguchi's photographs of astronomical gardens of Jai Singh in Jaipur and Delhi, India.

Beardsley, John. *Earthworks and Beyond*, pp. 80–87, 130–33. New York: Abbeville Press, 1989.

Beardsley, John, and David Finn. *A Landscape for Modern Sculpture: Storm King Art Center*, pp. 68–72. New York: Abbeville Press, 1985.

Cappadona, Diane Apostolos. "Stone as Centering: The Spiritual Sculptures of Isamu Noguchi." *Art International* 24 (March–April 1981): 79–97.

Dean, Andrea O. "Bunshaft and Noguchi: An Uneasy but Highly Productive Architect-Artist Collaboration." *AIA Journal* 65 (October 1976): 52–55.

Edgar, Natalie. "Noguchi, Master of Ceremony." *Artnews* 67 (April 1968): 50–52, 71–72.

Eidelberg, Martin, ed. *Design 1935–1965: What Modern Was*, pp. 107–8, 125–27, 216–17. Montreal: Musée des Arts Décoratifs de Montréal; New York: Harry N. Abrams, 1991.

Forgey, Benjamin. "Isamu Noguchi's Elegant World of Space and Function." *Smithsonian* 9 (April 1978): 46–55.

Frankfurter, Alfred. "The Controversial Noguchi Sets for Lear." *Artnews* 54 (December 1955): 42.

Friedman, B. H. "Useful Objects by Artists." *Art in America* 52 (December 1964): 54–56.

Fuller, Buckminster. "Colloidals in Time: Isamu Noguchi." *Shelter* 2 (November 1932): 111.

Graham, Martha. "From Collaboration: A Strange Beauty Emerged." *New York Times*, January 9, 1989.

Greenberg, Clement. "Art." *Nation* 168 (March 19, 1940): 341. Review of exhibition at the Charles Egan Gallery.

Grove, Nancy. "The Visible and the Invisible Noguchi." *Artforum* 17 (March 1979): 56–60.

———. "Isamu Noguchi, Shaper of Space." *Arts Magazine* 59 (December 1984): 111–15.

———. "Isamu Noguchi: The Image of Energy." *Arts Magazine* 60 (September 1985): 111–13.

———. "Noguchi and Drawing." *Drawing* 8 (March 1987): 121–24.

Hess, Thomas B. "Isamu Noguchi '46." *Artnews* 45 (September 1946): 34–38, 50. First important critical discussion of Noguchi's work.

———. "The Rejected Playground." *Artnews* 51 (April 1952). Editorial protesting Robert Moses's rejection of Noguchi design for the United Nations Playground.

Hunter, Sam. "I Know Nothing about Anything, and That's Why I'm So Free." *Artnews* 77 (May 1978): 24–28.

Huxtable, Ada Louise. "Art in Architecture." *Craft Horizons* 19 (January–February 1959): 10–15.

Jacobs, Jay. "Prophet without Honor." *Art in America* 55 (November–December 1967): 44–47.

"Japanese-American Sculptor Shows Off Weird New Works." *Life*, November 11, 1946, pp. 12–13, 15.

Jean Arp; Isamu Noguchi. New York: Cordier and Ekstrom, 1974.

Johnson, Jory. *Modern Landscape Architecture: Redefining the Garden*, pp. 22, 86–99. New York: Abbeville Press, 1991.

"Kahn-Noguchi Playground Proposed for New York." *Progressive Architecture* (March 1964): 67.

Lawrence, Sidney. "The Grand Old Man of Sculpture." *Landscape Architecture* 78 (June 1, 1988): 14–16.

Levy, Julien. "Isamu Noguchi." *Creative Art* 12 (January 1933): 29–35. First full-length article devoted to Noguchi's work.

"Lightolier's Light Fantastics." *Interiors* 112 (April 1952): 132.

"Lynching as a Japanese Sculptor Sees It." *Christian Century* 52 (February 13, 1935): 197. Exhibition review.

McBride, Henry. "Noguchi Has the Distinction of Two Exhibitions in New York This Week: Japanese Artist's Sculptures, Drawings in Separate Shows." *New York Sun*, February 20, 1932. Review of exhibitions at the Demotte and John Becker galleries.

Marter, Joan M. "Interaction of American Sculptors with European Modernists: Alexander Calder and Isamu Noguchi." In *Vanguard American Sculpture 1913–1939*, by Joan M. Marter, Roberta K. Tarbell, and Jeffrey Wechsler, pp. 105–18. New Brunswick, N.J.: Jane Voorhees Zimmerli Art Museum, Rutgers University, 1979.

Michelson, Annette. "Noguchi: Notes on a Theatre of the Real." *Art International* 8 (December 1964): 21–25.

Munro, Eleanor. "The Orient Express." *Artnews* 69 (Summer 1970): 48–51, 72–73.

"New Shapes for Lighting, Sculptor's Lamps Are Dim, Decorative." *Life*, March 10, 1952, pp. 114–17.

"Noguchi Defines the Nature and Enormous Potential Importance of Sculpture—'The Art of Spaces.'" *Interiors* 109 (March 1949): 118–23. Includes numerous quotations by the artist.

"Noguchi in Kitakamura [sic]." *Interiors* 112 (November 1952): 116–22.

"Noguchi: Traveling Sculptor Pauses in Japan." *Interiors* 110 (April 1951): 140–45.

Page, Addison Franklin. "Isamu Noguchi . . . the Evolution of a Style." *Art in America* 44 (Winter 1956–57): 24–26.

Porter, Fairfield. "Isamu Noguchi." *Artnews* 53 (December 1954): 55. Review of exhibition at the Stable Gallery.

Reif, Rita. "Noguchi's Rescue of a Samurai House." *New York Times*, July 13, 1971, p. 28.

Ritchie, Andrew C. *Abstract Painting and Sculpture in America.* New York: Museum of Modern Art, 1951.

Schonberg, Harold. "Noguchi, a Kind of Throwback." *New York Times Magazine*, April 24, 1968, pp. 24, 27, 29–30, 32, 34.

Schulze, Franz. "Noguchi's Multiplicities." *Art in America* 67 (January–February 1979): 126–32.

Sheffield, Margaret. "Perfecting the Imperfect: Noguchi's Personal Style." *Artforum* 18 (April 1980): 68–73.

Shinoyama, Kishin. "Time and Space: Isamu Noguchi in Takamatsu." *Mizue* (Tokyo) 949 (Winter 1988): 3–34. Photo essay on Noguchi's studio in Japan.

Smith, Glenn. "The Noguchi Garden as Theater." *Public Art Review* (Fall–Winter 1991): 22–23.

Spencer, Charles. "Martha Graham and Noguchi." *Studio* 173 (May 1967): 250–51.

Tomkins, Calvin. "Rocks." *New Yorker* 56 (March 24, 1980): 76–82.

Tracey, Robert. "Artist's Dialogue: Isamu Noguchi." *Architectural Digest* 44 (October 1987): 72.

Tuchman, Maurice. *American Sculpture of the Sixties.* Los Angeles: Los Angeles County Museum of Art, 1967.

Tyler, Parker. "Fourteen Minus One." *View* 7 (Fall 1946): 35–37. Review of *Fourteen Americans* at the Museum of Modern Art.

Wolfe, Ruth. "Noguchi Past and Present." *Art in America* 56 (March–April 1968): 32–35.

Films

Isamu Noguchi, 1971. Directed by Michael Blackwood for Blackwood Productions, New York. 28 minutes, color, 16 mm. Account of artist's career, featuring discussion with Noguchi at his UNESCO and IBM gardens, working in Italy, and with R. Buckminster Fuller and Ezra Pound.

A Sculptor's World, 1972. Directed by Arnold Eagle, New York. 27 1/2 minutes, color, 16 mm. Overview of Noguchi's career, including footage of the artist working in Italy and at his studio in Japan, and on site during construction of the fountains for Expo 70 in Osaka.

Portrait of an Artist, Isamu Noguchi, 1980. Directed by Bruce W. Bassett for Whitegate Productions, New York. 55 minutes, color, 16 mm and VHS. General account of Noguchi's career, showing him working at his studio in Japan, and featuring the creation of *Momo Taro* at the Storm King Art Center and work on Philip A. Hart Plaza in Detroit.

Index

Photography Credits